PROVENANCE

ALSO BY LANEY SALISBURY

The Cruelest Miles: The Heroic Story of Dogs and Men
In a Race Against an Epidemic
(coauthor Gay Salisbury)

PROVENANCE

HOW A CON MAN AND A FORGER REWROTE

THE HISTORY OF MODERN ART

LANEY SALISBURY
and ALY SUJO

THE PENGUIN PRESS

NEW YORK

2009

THE PENGUIN PRESS
Published by the Penguin Group
Penguin Group (USA) Inc., 375 Hudson Street, New York, New York 10014, U.S.A. •
Penguin Group (Canada), 90 Eglinton Avenue East, Suite 700, Toronto, Ontario M4P 2Y3,
(a division of Pearson Canada Inc.) • Penguin Books Ltd, 80 Strand, London WC2R 0RL,
England • Penguin Ireland, 25 St. Stephen's Green, Dublin 2, Ireland (a division of Penguin
Books Ltd) • Penguin Books Australia Ltd, 250 Camberwell Road, Camberwell,
Victoria 3124, Australia (a division of Pearson Australia Group Pty Ltd) • Penguin Books
India Pvt Ltd, 11 Community Centre, Panchsheel Park, New Delhi–110 017, India •
Penguin Group (NZ), 67 Apollo Drive, Rosedale, North Shore 0632, New Zealand
(a division of Pearson New Zealand Ltd) • Penguin Books (South Africa) (Pty) Ltd,
24 Sturdee Avenue, Rosebank, Johannesburg 2196, South Africa

Penguin Books Ltd, Registered Offices:
80 Strand, London WC2R 0RL, England

First published in 2009 by The Penguin Press,
a member of Penguin Group (USA) Inc.

Excerpt from *House of Cards* by David Mamet. Copyright © 1985, 1987 by David Mamet.
Used by permission of Grove/Atlantic, Inc.

LIBRARY OF CONGRESS CATALOGING IN PUBLICATION DATA
Salisbury, Laney.
Provenance: how a con man and a forger rewrote the history of modern art / Laney Salisbury
and Aly Sujo.
p. cm.
Includes bibliographical references and index.
ISBN 978-1-59420-220-9
1. Myatt, John, 1945– 2. Art forgers—England—Biography. 3. Drewe, John, 1948–
4. Impostors and imposture—England—Biography. I. Sujo, Aly. II. Title.
ND1662.M93S26 2009
364.16'3—dc22
[B]
2009003552

Printed in the United States of America
1 3 5 7 9 10 8 6 4 2

DESIGNED BY AMANDA DEWEY

CONTENTS

FOR ALY SUJO, WITH LOVE.

AUG. 26, 1949–OCT. 4, 2008

Dramatis Personae

The Genesis of a Scam

John Drewe
professor, physicist, man of many guises, and the brilliant mastermind of one of the great art frauds of the twentieth century.

Batsheva Goudsmid
Drewe's common-law wife; once loyal, she is eventually the key to his downfall.

John Myatt
impoverished painter and single father who sees Drewe as his savior.

The Guardians of the Archives

Bill McAlister

head of the Institute of Contemporary Arts; cannot believe his good fortune when Professor John Drewe shows up with an interest in funding the upkeep of the ICA's rich archive.

Sarah Fox-Pitt

formidable doyenne of archive acquisition at the Tate Gallery whom Drewe reels in with lunches at Claridge's and promises of historical documents.

The Art Dealers

Adrian Mibus

respected Australian gallery owner who falls for Drewe's smoke and mirrors and buys several of Myatt's fakes.

David Stern

Notting Hill dealer who unwittingly helps Drewe's scam reach across the Atlantic to New York.

Armand Bartos Jr.

debonair New York dealer who still insists the "Giacometti" he bought is the best he's ever seen.

Dominic Taglialatella

New York dealer who is taken in by one of the more expensive "Giacomettis."

Rene Gimpel

fourth-generation art dealer nagged by misgivings about a "Ben Nicholson" until his restoration expert, Jane Zagel, confirms his worst fears.

Peter Nahum
London dealer; among the first to alert Scotland Yard's Art and Antiques Squad that he's been hoodwinked by a rogue.

The Unwitting Providers of Provenance

John Sperr
elderly antiquarian bookstore owner whose shop becomes a source of material and inspiration for Drewe's elaborate provenance.

Father Paul Addison
head of a Roman Catholic religious order in England whose goodwill Drewe abuses to claim provenance of works from centuries-old priories.

Alan Bowness
former head of the Tate Gallery and son-in-law of the painter Ben Nicholson who innocently authenticates several fake Nicholsons.

Jane Drew
renowned British architect with close ties to Le Corbusier whom Drewe befriends, lending him a different kind of "provenance": personal cachet.

Terry Carroll
physicist sufficiently impressed by the "professor" that he never questions Drewe's professional provenance as a physicist until close to the end.

Daniel Stoakes
down-on-his luck childhood friend who agrees to pose as owner of a few works, only later to bemoan, "I was like a ripe plum ready to be picked from the tree."

Peter Harris

larger-than-life personality with an early morning paper route and a penchant for war tales who Drewe fictitiously transforms into a fabled arms dealer and art collector.

THE SALES FORCE

Danny Berger

neighbor recruited by Drewe to expand his operation who successfully sells "modern masters" out of his garage.

Clive Belman

unemployed former jewelry salesman and actor who joins Drewe's operation unaware that the product line he is hawking is the equivalent of costume jewelry.

Stuart Berkeley

a London-based runner who takes the operation worldwide.

Sheila Maskell

independent and reputable New York–based art runner who sends Armand Bartos the Giacometti *Standing Nude* that will eventually help break the case.

THE SKEPTICS

Mary Lisa Palmer

indefatigable director of the Giacometti Association whose persistent detective work puts her in conflict with the auction houses and galleries.

Jennifer Booth

Tate archivist who refuses to be swayed by Drewe's benefactor status.

THE SLEUTHOUNDS

Richard Higgs

London detective who cannot pin a case of arson on John Drewe but knows a scam artist when he sees one.

Miki Volpe

scrappy detective from the Yard's Organised Crime Unit who has never heard the word "provenance" but knows how to build a case, brush stroke by brush stroke.

Jonathan Searle

Scotland Yard detective with a Cambridge pedigree in art history who proves as skilled at spotting fakes as in tracking down thugs.

It's called a confidence game. Why? Because you give me your confidence? No. Because I give you mine.

—DAVID MAMET

House of Games

PROVENANCE

PROLOGUE

One sunny April afternoon in 1990 two Englishmen strode up the steps of London's Tate Gallery, passed beneath the imposing statues atop the pediment—Britannia, the lion, and the unicorn—and made their way through the grand portico into one of the world's great museums. Both men had recently been welcomed into the narrow circle of curators, historians, and benefactors who gave the Tate its cachet, and today they were the special guests at a reception in their honor, to be held in one of the museum's private conference rooms high above the galleries.

The more distinguished of the two was Professor John Drewe, a nuclear physicist with a pencil-thin mustache and gray-blue eyes. Drewe was often seen riding through London in a chauffeured Bentley and lunching at the most exclusive restaurants with members of the art world's aristocracy. It was said that he had amassed an extensive personal art collection, and that he lived extremely well.

Today, as always, the professor held his head high. Everything about him, from his bearing to his clothes, suggested not just a gentleman of style and substance, but someone who expected deference in all his dealings.

The other honored guest was John Myatt, a different sort altogether. A struggling painter and onetime pop musician with a peasant face straight out of Bruegel, he looked as though he would have been happier trudging through the moorlands of Staffordshire than standing awkwardly in the Tate's lobby in his charity-shop suit. Myatt, in attendance as Drewe's personal art historian, took his every cue from the professor, whom he considered not only a business partner but a mentor as well.

A senior Tate staff member in a dark-blue Savile Row suit welcomed them and ushered them to the conference room upstairs. It was a large and impressive space, with polished wood floors, white walls, and bay windows looking out on the Thames. Around a solid oak table sat several of the Tate's curators and senior staffers, including Nicholas Serota, the museum director, a slim, soft-spoken aesthete with rimless glasses, and Sarah Fox-Pitt, the formidable head of the Tate archives.

Like most other museums, the Tate was a privileged community run by a small army of art experts and archivists. Since 1988 it had been led with quiet imperiousness by Serota, who had taken over at a time when new funding was a priority. Along with every other British cultural institution under Prime Minister Margaret Thatcher's free-market policies, the museum had been forced to compete for sponsors, and while it still received government grants, these hardly covered the major purchases and expansions Serota planned. He was dedicated to reinvigorating an institution that the *Guardian* newspaper once described as stuffy and uninspired, "a bastion of sluggishness."

An economist as well as an art historian, Serota was not shy about forming ties with corporations, wealthy new patrons, and private col-

lectors. To float a single Cézanne exhibition, his accountants scheduled more than forty champagne receptions. Later Serota would inaugurate the Unilever Series, the Tate's first brand-marketing collaboration with a company, and museum patrons visiting the restrooms would find the cubicles "adorned with a discreet notice—similar to those underneath some of its most famous paintings—thanking an anonymous benefactor for donating the wherewithal to keep them in toilet rolls," as the *Guardian* reported.

The director did not have much choice. The art market was booming, and the Tate and many other art institutions were being priced out of the business. To keep the museum's goals and galleries afloat, its directors and trustees were forced to tango with any number of prospective donors.

John Drewe was the perfect dance partner. He had been cultivating his relationship with the Tate for weeks, organizing lunches at the restaurant at Claridge's Hotel for curators and senior staffers, including Fox-Pitt. If Serota embodied a new, less class-conscious Britain (he was known to wash his staff's teacups after meetings), Fox-Pitt was Old World. A slim and sophisticated aristocrat in her late forties, she had worked at the Tate as a curator and archivist for more than a decade and had carved out her own fiefdom. Her archives had become an important part of the museum, and she was always looking for ways to expand. She had a reputation as a fearsome gatekeeper with X-ray vision that allowed her to peer into the heart of anyone she suspected of harboring anything less than the most altruistic motives toward the Tate. One luckless acquaintance who failed to pass muster recalled how Fox-Pitt looked through him, then past him, as if she had determined with a single glance that he was useless for her purposes.

Drewe had piqued her interest from the start. He was versed in the archival arts and spoke eloquently about a cache of important letters, catalogs, and lecture notes that had passed through his hands over the years. He seemed to know a great deal about twentieth-century art

records, particularly those of the avant-garde Institute of Contemporary Arts and the British Council, and he boasted about his own private archive, which he said contained letters from Picasso, lecture notes from Ben Nicholson, and a trove of material from Dubuffet and other major artists.

In the course of his conversations with Fox-Pitt, Drewe talked at length about his background in the sciences. He had an impressive lineage: His father, a noted British physicist, had worked on the development of Britain's atomic energy program, and had split the atom in Cambridge in the early 1930s. Drewe had followed in his father's footsteps by going to work in the nuclear industry. In midlife he had become fascinated with art and its history, and as his collection grew he began to understand the importance of archives and documentation. He had developed a collector's gratitude for the role played by archivists in the safeguarding of art history, and he hinted to Fox-Pitt that parts of his collection, as well as some other valuable historical documents, might find their proper home at the Tate. He also hinted that he was considering a substantial monetary donation to the archives.

To the general public, museums are synonymous with the art that hangs on the walls. Few are aware that these institutions also take on the monumental task of assembling a record of an uninterrupted chain of ownership for each important work of art, from the moment of its creation to the sale of the work to its most recent owner. Exhibition catalogs help document the custodial history of the work, and receipts of sale show where and when it passed through private hands. Diaries, correspondence, and early drawings also shed light on the works themselves. Today, it is this documentary record of ownership, as much as any professional evaluation of quality or artistic style, that confirms the authenticity of a work of art. In the world of art, the process is known as establishing provenance.

In the early twentieth century museums began setting up archives to store these records. It was and remains the role of the archivist to make

sure that files are updated and, most importantly, that they are never corrupted. Access to museum archives is closely monitored, with entrée restricted to those having a legitimate need.

Despite the heavy burden archives bear in protecting the integrity of works of art, archivists are the beggars of the art world. It is far easier to persuade patrons to donate works from their private collections for display on the museum walls, or to write a check to fund the purchase of a new work or build a museum wing, than it is to convince them to fund the expansion or refinement of an archivist's database. Archivists are always on the lookout for the rare person of means who understands the importance of this side of the art world.

For Sarah Fox-Pitt, John Drewe was precisely that person: a wealthy, educated gentleman who valued the role of art in sensitizing society to beauty, and of archives in protecting art. She and the rest of the Tate's senior staff were delighted when Drewe signaled that he was prepared to take his interest in the arts to the next level and was contemplating his first donation, two 1950s works by the French painter Roger Bissière, from Drewe's own collection.

The Tate accepted the offer and promptly arranged a show of appreciation, inviting Drewe and Myatt to the museum's exclusive aerie for an afternoon reception to recognize Drewe's act of generosity. Those at the Tate knew from experience that given too much time to think it over, many donors lost their initial enthusiasm and failed to fulfill their promises. But Drewe was not that kind of man. Within days the paintings had been delivered to the Tate.

Now, in the elegantly appointed conference room above the public galleries, with the reception under way, Myatt sat quietly as Drewe, the principal guest of honor, chatted with his hosts and dropped names: Sir Alan Bowness, former head of the Tate; Bill McAlister, director of the Institute of Contemporary Arts; the art critic David Sylvester; and the pioneering architect Jane Beverly Drew.

Myatt watched, mesmerized. Drewe was a full-blown wonder, his

speech smoothly modulated, his fertile mind drawing upon his broad knowledge of a whole array of topics and interests. Even his occasional bad joke was rewarded with polite ripples of laughter. Even Drewe seemed charmed by his own persona and its power to command the attention of this influential and powerful group.

Two waiters poured tea. Myatt looked over his cup at Drewe. He had often wondered why a research scientist would immerse himself in the imprecise world of art appreciation. Did Drewe need a break from the tedium of physics research? Did he need validation, regular and open praise for his erudition? It didn't seem so. Drewe's house, his cars, his dining habits, his accomplishments all suggested a high level of self-confidence.

The grand moment of the reception finally arrived. Two Tate conservators wearing white gloves came in carrying a pair of five-foot-tall paintings jointly titled *Spring Woodland*. The works were beautifully composed, semiabstract figures resembling birds and vegetation, set against an electric-blue background. Conversation stopped as everyone at the table acknowledged the gifts. There was a moment of respectful silence.

"Ahh, the Bissières, how lovely," someone said, in a voice barely above a whisper.

Myatt was stunned. He had painted the two "Bissières" himself just two weeks before.

"I Want a Nice Matisse"

We are inclined to believe those whom we do not know
because they have never deceived us.
—SAMUEL JOHNSON

John Drewe and John Myatt, perpetrators of what Scotland Yard has called "the biggest art fraud of the twentieth century," had first met four years earlier, in 1986, when Myatt's life was in free fall. His wife had abandoned him, leaving him alone to care for their two children, Amy and Sam, both still in diapers, and he was desperate. The family lived on a narrow lane in the small rural community of Sugnall, Staffordshire, in a farmhouse that had once belonged to his parents. The house was old and run-down, with no central heating or hot water, and was warmed only by an ancient pale-blue Rayburn cooker, into which Myatt fed coal whenever he could afford it. The day's wash was usually draped over a drying rack above the kitchen table. The furniture, most of it threadbare, had belonged to his parents too. He lived frugally, but his meager earnings as a part-time art teacher hardly covered the bills, and he had been forced to go on the dole.

Myatt was not generally prone to self-pity, but these were hard

times. In the middle of the night he would wake, overcome by the feeling that he was washed up, trapped in the rolling hills of western central England.

Things hadn't always been so gloomy. As a boy, Myatt had shown musical and artistic promise, and had been encouraged by his parents to attend art school, where his teachers recognized his compositional skills. They were particularly impressed by his knack for copying the masters, a talent he attributed to an innate ability to "stand in someone else's shoes." Brush in hand, surrounded by art books he'd borrowed from the library, he would fall into a kind of empathetic trance and lunge at the canvas, stroking away and then stepping back to imagine how the artist might have pulled the painting off.

After college he won a grant for free studio space in nearby Lichfield, the hometown of Samuel Johnson. Myatt worked, ate, and slept in the studio. Like every other young artist, he was sure that he had one great canvas inside him, and that someday it would spring forth, fully articulated.

Myatt was intrigued by perspective, composition, and brushwork. Having grown up in a countryside dotted with ancient churches, he liked nothing better than to spend weeks concentrating on their pointed spires and flying buttresses, getting the tone down and putting each brushstroke in the right place. He once spent eight weeks painting a single building, down to every last brick of its facade. Occasionally, his works toured central England in group shows, and in the early 1970s he was chosen by Lichfield to paint a mural of Samuel Johnson.

But even Myatt had to admit that his work was overly traditional, passé, and uncommercial. The London art world of the time wasn't looking for inspiration in country churches and pastoral landscapes. Instead, pop artists like Peter Blake, Richard Hamilton, David Hockney, and Bridget Riley were all the rage, emulating their U.S. counterparts Andy Warhol, Jasper Johns, and Robert Rauschenberg. While the arbiters of the art world recognized that Myatt's work was

technically adept, they deemed it "academic," or dull, or worse, a bit of both.

After years of late nights in the tiny Lichfield studio, Myatt realized there was little chance that he would ever make a reasonable living as an artist. He gave the studio up, more an act of surrender than of financial necessity. He knew himself. He was too involved with the minutiae of his craft to hold out any hope that some breakout creative inspiration would rocket him to fame and fortune. Reluctantly, he put aside his paintbrushes and tried his hand at writing and recording pop songs at home, sending his three-minute novelty tunes to London by post.

To his astonishment, a music publishing company offered him a contract, and for the next several years he earned a living cranking out the tunes and working as a studio musician. In the evenings, whenever he could, he would paint portraits of his friends or members of the church choir or the local pastor. He had almost given up on producing a hit when in 1979, during an all-nighter at a London studio, a quirky little reggae number called "Silly Games" leaped out of the grand piano. Six months later, after he and a colleague had knocked it into shape, the song hit the charts. Its distinguishing feature was singer Janet Kay's thin voice straining to reach climactic ultrahigh notes in a catchy if mediocre melody that appealed to young Britons.

When the royalties began to stream in, Myatt split his time between the countryside, where his wife had founded a promising little herbal business, and the music company in London, where he came across an opportunity to put his extensive art training to use. His boss, who had been to dinner at the home of the owners of the megastore Marks & Spencer, had been impressed by a Raoul Dufy that the couple owned. Myatt's boss told him about the work and said he wished he had a spare hundred thousand pounds or so to buy a Dufy for himself. On a whim, Myatt offered to paint one or two for him. The boss was amused but unconvinced.

Myatt had educated himself broadly in art during the years when he aspired to a career as a painter, and he relished the challenge. The prospect of picking up a brush professionally, of making money doing what he most loved, energized him. He and his boss thumbed through books on Dufy until the man took a particular liking to two images, one of the great casino in Nice, the other of a landscape over a bay.

Dufy, a French fauvist, had specialized in bright, simple colors, and Myatt thought it would be relatively easy to copy the style. Dufy's fluid brushstrokes were something else altogether, and it turned out to be no small task to replicate them. Still, it gave him a feeling of kinship with the painter, of a collaboration across time.

When he was done with the first painting, he forged the artist's signature on the front and added a note on the back naming his boss as the person who had commissioned the work. It was all in good fun, and it made him a little money. Myatt's boss paid him £200 for each piece,* then spent £1,600 on the frames. After he'd hung them, he invited the Marks & Spencer pair over to dinner. Without mentioning Myatt, he showed them the two paintings.

"These are better than the one we've got!" they exclaimed.

Others too were fooled by Myatt's work, his boss told him. One art historian friend swooned when she saw the fake Dufys and swore she could detect Matisse's influence. Myatt roared when he heard this.

In the meantime, Myatt's brief career as a songwriter was hitting the skids. "Silly Games" turned out to be his only hit. He couldn't produce a follow-up. Within two or three years, the music company went under, and Myatt's royalties and retainers dried up. Soon after, his mother and father died, and then his wife had their second child, Sam, an event that had a drastically unsettling effect on her. She began to

*About $400 at the time. The exchange rate for U.S. dollars to British pounds varied widely from the late 1970s to the mid-1990s, ranging from highs of well over $2.00:£1.00 to lows of less than $1.10:£1.00. For much of the period, $1.50:£1.00 is a useful if rough rule of thumb, but readers interested in more exact conversion figures can find them on the Web site research.stlouisfed.org/fred2/data/EXUSUK.txt.

withdraw from the family, and several months after Sam's birth she fell in love with a man who cut a romantic figure and announced that she was leaving Myatt and the kids.

At forty-one, Myatt felt his life was over. A failed songwriter, portraitist, and landscape painter, he'd been reduced to part-time work teaching children how to draw, and now he was a failed husband too. His productive years gone, he could no longer define himself by the nobility of his aspirations. Though he had never been overly ambitious, he felt a crushing disappointment in himself. When he found himself with less than £100 in the bank in 1986, he decided he had no choice but to try the fake-art route again, knowing from his experience with his former boss that there was a market.

Myatt took out an ad in London's satirical biweekly *Private Eye,* a magazine with a cynical and well-heeled readership that he guessed would be drawn to his offer of "genuine fakes," facsimiles of "19th and 20th century paintings, from £150." To his relief, the ad brought in a trickle of interest and a few commissions. One client wanted a copy of his favorite Claude Monet landscape. Another wanted a Joseph Turner shipwreck. Most requests were a little more creative—a banquet or a woodland chase scene in the style of a particular artist, or a portrait of a client's father, a retired naval commander, in the grand style of the eighteenth-century British artist Joshua Reynolds. In an art book, Myatt found a picture of a serious-looking old salt with a chestful of medals, copied it, and gave it a new face. Then there was the odd commission for a portrait of a relative or a family pet in an unusual setting—an uncle dodging bombs in the aerial blitz of London during World War II, a puppy chewing a bone during the Battle of Agincourt. One joker wanted a portrait of himself as a skeleton having intercourse with a fat nun in the ruins of a Gothic abbey.

There was nothing illegal or improper in what Myatt was doing. For centuries, copying paintings had been standard practice for artists and art students. In the studios of Rembrandt and Rubens, young assistants

often copied the works of their masters to perfect their own technique and to aid the master painter. These studios functioned as workshops, producing paintings entirely by the master or sketched by him and then "filled in" by an assistant. Some assistants specialized in heads, others in backgrounds. When the work was complete, the master would study the canvas, make corrections, add a final detail, a glaze, and a signature. Art historians have devoted entire books to the task of categorizing the gradations of masters' paintings, differentiating between those done solely by the master and workshop "originals" painted or partially painted by assistants in the spirit of the auteur.

Myatt too had copied a variety of masters for his art studies, sitting for hours in museums, sketching in front of a Rembrandt or a Reynolds. Now he was simply trying to turn a profit from his copyist's gifts. As long as his clients were willing to pay £150 or more (the price depended on the size and complexity of the commission), he did his best to accommodate. Rarely did he hear from clients a second time, but he didn't take this as a measure of his talent. After all, they were not serious collectors. There was the occasional art lover who couldn't afford the real thing, but his clients for the most part were cultural tourists, mall safarians who weren't ashamed to buy a painting that would go nicely with the curtains. In the same vein, hundreds of reproductions of famous paintings were routinely made for high-end hotels, interior decorators, and château owners.

After Myatt's ad had run a few times, he picked up the phone one day to hear a polished voice speaking with perfect diction and a Cambridge accent that telegraphed the privilege of the English upper classes. The caller introduced himself as Dr. John Drewe, a London-based physicist who wanted to commission a piece.

"I want a nice Matisse," he said, without being too specific. "Something colorful, memorable, not too large."

Myatt said he could have one ready within a couple of weeks.

"Perfect," said Drewe. "Would you mind bringing it into the city for me?"

Myatt agreed to meet the professor at the Euston train station, one of London's main terminals, in a fortnight or so.

He finished the painting one day in late summer, a vivid little canvas with two colorful figures in the center. During the two-hour journey past farmlands and ruins and tidy backyards with minuscule gardens, through the outskirts of London and row upon row of cramped two-story brick houses, he could smell the varnish under the black plastic wrapper.

Soon after he sat down at the station pub with the Matisse, Myatt felt a tap on the shoulder. It was Drewe, a tall man wearing a good mohair coat and handmade leather shoes, and sporting a rather dated Dirk Bogarde haircut from the 1950s. Myatt thought it was peculiar and a bit showy.

"Pleasure to meet you, Dr. Drewe," he said.

"Call me John," said the professor.

Drewe ordered beers as Myatt pulled down the plastic wrapper and showed him the top half of the Matisse.

"Very nice," said Drewe. "Exactly what I was looking for." He handed Myatt an envelope containing his payment in cash and proposed a toast to Matisse.

Drewe said he was a university lecturer in nuclear physics and worked as a consultant for the Ministry of Defence. He was developing two new technologies for the military: One was a compressed-gas propulsion system for use on nuclear submarines, the other a landmine-proof, battle-ready fire-suppression packet that could be installed beneath military vehicles.

Despite his breathtaking set of academic credentials, Drewe was a skilled and amusing raconteur with none of the haughtiness Myatt had expected from such an upmarket city gent. Drewe joked about the

government ministers he met in the course of his job and spoke breez-
ily about his work as a scientist and inventor. Myatt's life had been
reduced to a run-down farmhouse and two young children, so chatting
with Drewe was like a shot of adrenaline. Myatt found him hypnotic,
a combination of charm and challenge, able to process and expand
upon any topic of conversation. The professor spoke so quickly and
with such authority on such a wide variety of subjects that Myatt
could hardly keep up. "It was like going to the pictures," he later re-
called. "He just took me out of my world."

Drewe ordered a second round and asked Myatt whether he would
paint him another early-twentieth-century work, this one in the style
of the Swiss-German artist Paul Klee. Myatt agreed, and they shook
on it.

On his way home on the train, Myatt reflected on what had been a
very good first meeting. It dawned on him that he had been suffering
from an insidious form of low-level isolation and loneliness, and that
in some profound sense he'd taken leave of the real world. The work he
was doing for Drewe might be a way back.

CANVAS GREED

Over the next several months, Drewe became Myatt's most valuable client. After Myatt had delivered the Matisse, he went to work on the Klee, and then on two seventeenth-century-style Dutch portraits and a seascape for Drewe's wife.

Their phone conversations were always a pleasure. Drewe brimmed with good stories and a palpable optimism, and each time Myatt brought him a fresh painting, the professor had an envelope full of cash for him.

A few months after their first meeting, Drewe invited him to the city for dinner. Myatt took the Underground to Golders Green, a wealthy, predominantly Jewish neighborhood in Greater London, where Drewe lived with his common-law wife, Batsheva Goudsmid, and their two children, Nadav and Atarah, who were a few years older than Myatt's children.

Drewe was waiting outside the station when Myatt arrived. Together

they walked to the house at 30 Rotherwick Road, a dark-red Teutonic brick building with heavy timber lintels and bay windows on a street that was one of the tidiest in the neighborhood, a model of quiet taste. The houses were all stately and anonymous, with identical iron gratings along the front and little gardens in the back.

Drewe seemed even more upbeat than usual when he told Myatt that he'd given Goudsmid the two "Dutch portraits" as a birthday present. However, he had a small confession to make: He'd lied and said that he'd bought the pieces at auction. He'd also neglected to mention Myatt's contribution, telling Goudsmid only that Myatt was his art consultant and adviser on his collection.

"For God's sake, John, don't tell her you painted them," Drewe said.

Myatt hesitated for a moment. He'd told the occasional white lie in the past, but this was a little more elaborate. Still, he felt indebted to Drewe, who had paid him hundreds of pounds and was probably good for hundreds more. It was the least he could do.

Inside, Drewe showed Myatt how he had set the two Dutch portraits—one of a boy in a heavy brown cloak with his hand stuck in his vest, the other of a girl holding an ostrich feather—on a plum-colored velvet background surrounded by a gilt frame. When Goudsmid came downstairs, Drewe introduced her to Myatt, and the two shook hands and admired the paintings.

"Lovely pieces," Myatt said in the most professorial tone he could muster. "Excellent examples of late-seventeenth-century works. Probably painted around 1680."

He felt uncomfortable masquerading as an expert, but he had done a good job on the paintings, and they were thoughtful gifts from Drewe to his wife. Why should he spoil things?

Goudsmid, a petite, good-looking woman, was clad in a business suit and wore her hair pulled straight back. An Israeli army veteran, she now worked as a pediatric eye specialist at a London hospital.

When she wasn't at her job, she was taking care of the children or hunting for antique furniture and remodeling: a new bathroom, a sunroom, a gourmet kitchen. She gave Myatt a brief tour of the house, which was filled with ladders and paint buckets and hammers, in a state of "hyperactive refurbishment," as one of the neighbors described it.

After dinner, Drewe slipped Myatt an envelope, walked him back to the train station, and announced that he was commissioning another piece. Until now, he had been particular about which artist Myatt should copy, but today he wanted to hear Myatt's recommendations for his growing "collection."

"Surprise me!" he said, grinning. "After all, you're my personal art consultant."

As Myatt waited for the train, he felt that something significant had taken place, something that was about to change his life. He turned and watched Drewe strutting away in his perfect suit with his long arms swinging. Myatt had always done his best work in the solitude of his studio, but someone was at his side now. Drewe was offering a partnership, a creative conspiracy of sorts.

Stepping into the train compartment, Myatt saw an old man reading the *Times* next to the scattered remains of a bag of crisps. He sat down and discreetly checked the contents of Drewe's envelope. It was a nice haul.

Most of Myatt's early clients had been partial to Gainsborough, Constable, or Reynolds, eighteenth- and nineteenth-century traditionalists from the Royal Academy, but Myatt had always been more interested in the work of twentieth-century Frenchmen. Given the opportunity to expand his repertoire, he decided to experiment. Drewe did not want direct copies, but "pastiches," works that could pass as paintings a particular artist might have done. Myatt went combing through his art history books.

Over the next several months, he produced works in the style of the Cubist Georges Braque, of Roger Bissière, whose tapestrylike compositions were prized in the 1950s, and of Nicolas de Staël, a Frenchman of Russian origin who painted abstract landscapes in blocklike slabs of color. Whenever he could afford a babysitter to watch Amy and Sam, he would set up his easel in the living room and go to work. Painting in the style of another artist required a certain amount of historical research and psychological insight, as well as a flawless ability to reproduce the brushwork and compositional preferences of the original in a loose and interpretative way. This was far more interesting to Myatt than knocking off straight copies.

Every month or so, he would take the train to London with a new canvas and meet Drewe at the Euston station bar or at Lindy's restaurant across from the Golders Green tube station. Drewe would hand over the money, and they would have a beer or a cup of tea.

Once, Drewe drove up to Myatt's farmhouse in his blue Bristol—a handmade, limited-edition jewel of a car—and Myatt took him to the Sugnall pub. It felt like a royal visit. Drewe waxed on about extrasensory perception, quantum physics, mathematics and its relationship to the artistic process. It all sounded a little high-flown to Myatt's ears, but Drewe seemed as interested in learning from Myatt as he was in pontificating. Myatt felt appreciated when Drewe asked him about the ins and outs of the art establishment, about the technical differences between the moderns and the old masters, about how to tell the talented from the poseurs of the art world. The five years Myatt had spent in art school in the 1960s, and the fact that he had paid his dues on the local exhibition circuit, qualified him to be Drewe's teacher, and when he offered Drewe a crash course, the professor proved himself a quick study.

If Myatt secretly wondered whether Drewe was mining him for information in order to sell fakes, he buried the thought. Whenever he spent time with Drewe, he came away reinvigorated, as if the man's

charm had rubbed off on him. It was encouraging to know that some-
one of such importance valued his friendship. Besides, Drewe's curios-
ity about the art market wasn't unusual, given the fact that everyone
was talking about the unprecedented boom and the spiraling prices.
Traditional collectors who had once been guided by aesthetics alone
had begun to compete against a new breed of wealthy international
collectors and young moneyed professionals who were driving up
prices. These newcomers were excited by the prospect of substantial
returns and saw art as another investment, if one with an added ben-
efit: An art portfolio bestowed an aura of sophistication and culture
that no stock holding could provide.

Andy Warhol had seen through the eager new collector's real
purpose in acquiring well-branded art, suggesting in 1977 that instead
of spending $200,000 on a painting, a smart collector would be well-
advised to take the money, "tie it up and hang it on the wall. . . . Then,
when someone visits you, the first thing they see is the money on
the wall."*

In the new marketplace, money managers nudged their clients to
invest in art. British Rail's pension fund, for example, committed about
£40 million to buying fine art. Its portfolio included impressionist and
modern works as well as pieces by El Greco and Canaletto. Art, in the
words of the dealer Eugene Thaw, was at risk of becoming "a commod-
ity like pork bellies or wheat."†

*Andy Warhol, *The Philosophy of Andy Warhol.* In 1986, when an artist named J. S. G. Boggs
exhibited several of his drawings of £10, £5, and £1 notes, the police seized them and arrested
him on charges of counterfeiting. Two decades later, when Norwegian artist Jan Christensen
made a painting consisting of Norwegian banknotes stuck on canvas, it was snapped up by a
collector for $16,300, its exact face value. When the piece was shown at an Oslo gallery, thieves
broke in and stole the banknotes, leaving the frame behind.

Christensen was not surprised: "I wanted to make a blunt work with the intention of
creating a discussion about the value of art, and about capitalism, and how the art world
works," he told the BBC. "It proves my theory that I have made an artwork that has a value
outside the gallery space."

†Christopher Mason. *The Art of the Steal: Inside the Sotheby's-Christie's Auction House
Scandal.* New York: Berkley Books, 2005, p. 51.

Alfred Taubman, the American shopping mall mogul whose assets included the A&W chain, equated fine art with one of his products. "There is more similarity . . . in a precious painting by Degas and a frosted mug of root beer than you ever thought possible," he told a business audience about the marketing challenges he faced after buying Sotheby's auction house in 1983.*

Taubman's $139 million purchase of the 241-year-old company was a sign that the once insular market was open to newcomers. Under Taubman, Sotheby's began offering financing terms, insurance, restoration services, and storage as inducements to its new and relatively inexperienced collectors. It encouraged Wall Street to move into art investment and assigned staffers to reach out to corporations that wanted to set up on-site galleries. Taubman also sent works scheduled for sale on preauction tours across the United States and abroad, backing the tours with aggressive advertising campaigns. A different language sprang up at the auction houses: The new catchphrases were "threshold resistance," "value," and "liquidity."

Christie's, Sotheby's rival, followed suit.

In this climate it was hardly surprising that the price of an artwork could increase as much as fivefold in a single year. In the past the media had seldom paid much attention to art auctions and sales, except for the occasional story about a rare find or a well-known collection that was headed for the block. Now auction prices routinely made headlines, and the investment returns were phenomenal. A Kentucky nursing home magnate who bought Pablo Picasso's self-portrait *Yo Picasso* for $5.8 million in 1981 sold it seven years later for nearly $48 million, a net rate of return of 19.6 percent a year. Jackson Pollock's *Search*, purchased in 1971 for $200,000, would sell for $4.8 million in May 1988, a 2,400 percent increase. Pollock, who had sold only a handful of

*Mason, *Art of the Steal*, p. 50.

works during his lifetime, would have been amazed. The 1980s sale history of works by Vincent van Gogh was like a helium balloon soaring into the sky. The artist's 1890 glowing blue *Portrait of Adeline Ravoux* had sold for $441,000 in 1966 and five times that when it changed hands again in 1980. By 1988, the price had risen sixfold, to $13.75 million, a more than 3,000 percent increase over the original sale price.

Although art investors were constantly being reminded that the bubble would inevitably burst, even the stock market crash of October 1987 failed to punch a hole in the balloon. A month later, van Gogh's *Irises,* bought in 1947 for $84,000, sold for $53.9 million at Sotheby's. Those who recalled art's historical role in civilizing society, a larger and nobler role than enriching speculators, warned of the dangers of "canvas greed."

"Art is no longer priceless, it is priceful," said *Time* magazine art critic Robert Hughes.

Arguably, in many cases, style was winning out over substance. Young painters who wanted their work to attract a share of the free-flowing money quickly figured out that the key to success lay not only in the quality of the work itself but in the practice of "branding," the establishment of a strong public association of the product with positive values. In the past, an aspiring artist struggled to build an alliance with a respected and powerful dealer, hoping that over time the dealer would persuade the world of art patrons and collectors that the young artist's maturing talent deserved to be recognized and supported. Now, in the commodities-driven eighties, artists like Keith Haring, Jeff Koons, and Julian Schnabel followed Warhol's example and became businessmen as much as artists. Art schools began offering business classes to their more enterprising students.

Some artists developed product lines, opened trademark stores, and pushed for their works to appear on billboards or in commercials in

bald-faced campaigns to increase the market value of whatever they put their names to. At a time when the world seemed more interested in the art of the deal than in the art, the worth of a piece was often determined by the auctioneer's gavel rather than by critical evaluation.

When Picasso's *Au Lapin Agile* sold at Sotheby's in 1989 for $40 million and change, it became the third most expensive work of art ever sold at auction, but the market was so jaded that only a handful of people on the floor applauded, and the night's total of nearly $300 million was considered relatively flat. In this atmosphere, demand quickly exceeded supply. Handshake deals were being struck for works that had not even been painted yet.

Plugging away at his works "in the style of," Myatt couldn't help being aware of these trends. Sometimes his clients, mesmerized by the market boom, asked what their paintings might be worth if they were real. Myatt would humor them and invent an exorbitant sum. Whenever he dropped off a Braque or a Bissière for Drewe, the professor would speculate on what price it might fetch at auction. Over drinks one night, he explained to Myatt that he worked in a world of precise scientific calculations and that the art market's way of determining value was still a mystery to him. He wanted hard information on the dynamics that drove the business.

How was the authenticity of a painting determined?

Was the decision entirely subjective? If so, who was authorized to say whether a work of art was genuine?

If something was satisfying to the eye, wasn't that enough?

Who actually determined the price placed on a particular work of art?

"I'm just curious to know what you think, John," said Drewe.

Again Myatt felt a touch of pride at being treated as an equal by such a distinguished man. He had considered these issues for years, and he answered Drewe's questions thoughtfully.

Unlike scientists, he said, art collectors did not rely on a peer-review

system. Works of art were not evaluated by juries of artists and historians, nor were dealers bound by specific guidelines, let alone hard and fast rules. Myatt respected the art establishment for supporting the careers of artists, but lately he had begun to question the whole enterprise of evaluating art. He thought great art should be kept out of the hands of the wealthy few, who could drive prices up by trading in masterpieces as though they were stock options or locking them away in vaults.*

"The world's gone mad," Myatt told the professor. "Art was never meant to be just a question of money."

By the middle of 1988 Drewe's and Myatt's relationship was flourishing. Drewe often invited Myatt and his children over for dinner, and Myatt took a liking to Goudsmid. During one meal, when he mentioned that his daughter had an eye problem, Goudsmid took Amy to her private office upstairs, examined her carefully, and made sure Myatt found the right specialist for her. She was the disciplinarian in the family, the bookkeeper, the educator. It was Goudsmid who made sure Nadav and Atarah did their homework, watched them brush their teeth, and hustled them to bed. Drewe, on the other hand, seemed lackadaisical, and let them do whatever they pleased.

The two families enjoyed their evening get-togethers, and on one occasion Drewe took them all out to the West End to see a pantomime. It was an unusual theater season: Three productions of traditional children's pantomime starred former television anchormen, while another featured a well-known stuntman who had once jumped his motorbike over dozens of London double-deckers.

*Just a few years later, in 1990, Vincent van Gogh's *Portrait of Dr. Gachet* would be auctioned off for $82.5 million to Ryoei Saito, a Japanese industrialist who spent a few hours with his purchase, then put it in a crate and locked it in a climate-controled vault in a top-secret storeroom in Tokyo.

After the performance, as they strolled outside the theater, Drewe took Myatt aside, pulled out a cigar, and announced that there had been an interesting development. A friend of his at Christie's had been over for dinner, examined the two Dutch portraits on the wall, and pronounced them "very competent" eighteenth-century copies of seventeenth-century Bakkers. Then Drewe said something that truly astonished Myatt. The two works, the Christie's friend had said, could easily fetch £15,000 to £20,000 at auction.

Myatt laughed at the irony. With just a little more scrutiny, Drewe's friend would have known that the paintings were very competent *twentieth*-century copies.

Only when Myatt thought back on his relationship with Drewe years afterward did he realize that the professor had been testing him that night to see if he was ready for the next step.

A few weeks later Myatt was at Drewe's for supper and noticed that the two portraits had vanished, along with several other works, including a Bissière, a de Staël, and a work on a coarse jute fabric after Braque.

Something wasn't right. Drewe had already placed orders for more works than could possibly fit on the walls of his house. It didn't elude Myatt that Drewe might be passing them off as originals and selling them, but he quickly developed a rationale: Most likely the paintings had been given away and were hanging in someone's vacation home. Drewe was a generous fellow, after all, a man of character. He was at the height of his career, and married to a woman who was also earning a good salary.

Myatt struggled with his suspicions. He feared losing Drewe as a steady client, and this was no time for a confrontation. It was really none of his business.

ART FOR SALE

On a busy thoroughfare in Golders Green, in the converted garage of a mews house that had served as a stable a century earlier, Danny Berger set up a small office and a temporary home for himself and his girlfriend. A middle-aged Israeli salesman with a heavy accent, Berger had been trolling the neighborhood for the past two decades with varying degrees of success. He dealt in whatever came through the marketplace: luggage, fixtures, appliances, "a full product line," as he put it, anything that could be imported or exported and marked up. Most often he did business through handshake deals with friends of friends.

The garage faced Finchley Road, which ran straight to the bustling center of Golders Green, a thriving Jewish community since the early 1900s, filled with synagogues, bakeries, delicatessens, and coffeehouses. Berger had installed cheap wall-to-wall carpeting and a battered desk with a phone that was nearly buried by the car parts strewn around.

Behind the main room was a bed he could use while he finished renovating a house he'd bought in Greenwich, on the south bank of the Thames.

Quite by accident, he had recently found himself in a whole new line of business. He'd become a "runner," a mobile art dealer without a gallery or a private collection. Traditionally, runners were part of a small squadron of professional go-betweens who worked to match buyers with sellers. Runners tended to be energetic, refined, and well connected. Part of their job was to scour homes, attics, antique shops, and auction houses in search of pristine and unique works that would appeal to collectors. At any given moment there might be several dozen runners crisscrossing the globe with their little jewels: a small Magritte to Paris, a Hockney to Rome, a Duchamp to Dallas.

Berger didn't exactly fit the profile. His new sideline had begun unexpectedly one day at the Costa Café, a Golders Green hangout popular with émigrés, where he liked to sit nursing a double espresso, watching the street, and chain-smoking his Time cigarettes, an Israeli brand. Here at the Costa, Berger could chat comfortably with fellow Israelis and read his *Haaretz* newspaper. The other Britain—characterized by Benny Hill, cricket, and marmalade—sometimes felt like a neighboring republic. The Costa, a chummy and informal place, felt like Tel Aviv. It was filled with a nice mix of entrepreneurs, chatterboxes, and the occasional philosopher, and had served for years as Berger's de facto office and a place to catch up on local gossip. It was close enough to his garage that he could walk home to follow up on a business lead or take a nap and get back to the café before it closed.

Late one morning in mid-1988, Berger was sitting in the Costa going through some papers when a man wearing a nice brown suit and carrying a leather briefcase introduced himself and asked whether Berger would mind sharing the table. The café was crowded, so Berger moved his stack of papers over and gestured for him to sit.

"Are you Israeli?" asked Drewe, noticing Berger's accent. "So is my wife."

Drewe bought espressos for them and started up a conversation about Tel Aviv. Berger told him he had an Israeli girlfriend, and they talked briefly about their work. Drewe said he taught nuclear physics and spent most of his time consulting for the Ministry of Defence. He was developing propulsion systems for nuclear submarines and had an office on Gower Street, near MI6 headquarters.

To an outside observer, the two men would have made a strange pair. Drewe, with his natty suit, starched collar, and trim mustache, looked as if he had just come from a business meeting. Berger, with his stack of newspapers and invoices, untucked shirt, and unkempt hair, looked as if he'd just slept through the matinee and woken up in the back row of the cinema.

But such details did not trouble Drewe. A good judge of character, he was less concerned with appearance than with a person's vulnerability. Drewe could size up a person quickly, and although his meeting with Berger seemed random, Berger had one obvious weakness—he was too eager for business. Drewe had paintings coming in at a good clip now, and he needed to put together a small sales team. He was sure he could straighten Berger up. Perhaps a believer in reverse psychology, Drewe may have thought that dealers would be disarmed by someone who seemed as far removed from the refinements of the art world as Berger.

Drewe rose from the table and suggested that they meet again. He said Goudsmid could use some new friends. She was working much too hard and would love to meet other expat Israelis.

Soon enough, the two couples were meeting regularly for bridge at Drewe's home and going out to dinner. The women had both served in the Israeli Defense Force and had plenty to talk about. Drewe always picked up the tab. It was clear to Berger that the professor was doing well for himself. He drove two cars, a blue Bentley and a blue Bristol,

and the walls of his home were covered with paintings by Chagall, Le Corbusier, and Braque. Berger knew little about art, but he recognized the signatures.

After dinner one evening, Drewe made Berger a business proposition. He said he had been entrusted with some five hundred works of art by an old fellow named John Catch, whom he held in high regard. Catch had been his boss and mentor when Drewe was a young scientist at the Atomic Energy Authority, and had become like a father to him. Drewe took off his Rolex and showed Berger the inscription on the back: "From John to John." The watch was a gift from Catch.

"He's ex–Foreign Office, lives in America now," Drewe said, adding that Catch had made him a beneficiary in his will, and that he was to inherit the five hundred works, worth about £2 million. "He wants me to start selling them and keep the proceeds," Drewe told Berger. "Will you help me?"

If Goudsmid had been listening to the conversation, she might have informed Berger then and there that John Catch was a mythical figure as far as she was concerned. Whenever Drewe mentioned his name, Goudsmid bristled. Drewe had told her that Catch held the hereditary title Lord Chelmwood, and that the old man had helped him along over the years. He had given Drewe money, financed his studies, and named him his heir. The inheritance had become a sore point. It was Goudsmid, not Drewe, who had bought the house on Rotherwick Road in early 1986. When the couple moved in, Drewe convinced her to take out a larger mortgage than she had envisioned. Moreover, she had taken it out in both their names. He promised to pay it off as soon as the Catch windfall came in, but the money had never materialized. Goudsmid badgered Drewe about the inheritance, and around the time that she met Myatt, Drewe began to tell Goudsmid that the money would come in the form of earnings from the sale of artworks that Catch owned.

Blissfully unaware of the financial intricacies of the Drewe/Goudsmid household, Berger accepted Drewe's proposition that he become his agent in selling some of the paintings. In return, he would receive a 10 to 20 percent commission, depending on the sale price of the work.

The first painting Drewe brought to Danny Berger's garage was a canvas by the British artist Ben Nicholson. Berger put on his best suit and took the tube down to Cork Street, a stretch of London that was home to some two dozen galleries and private dealers. He walked the picture from one shop to the next but found no takers. Dejected, he tucked the canvas under his arm, went home, and called Drewe to give him the bad news and ask for an explanation. Was there something wrong with the painting? Something lacking in his salesmanship?

No, Drewe said. The piece was solid. Berger needn't worry. There would be other works to sell very soon.

A week later, Drewe called to say that he had sold the piece to the dealer Leslie Waddington for £135,000. Waddington was one of the most prestigious dealers in London, an irrepressible man with a large staff and three blue-chip galleries on Cork Street. He was also a Nicholson expert who had once worked closely with the painter. The news of the sale renewed Berger's confidence in Drewe. He knew enough of the market by now to know the dealer's reputation. If it was good enough for Waddington, it was good enough for Danny Berger.

Within days, Drewe was back at the garage with two abstract works by Roger Bissière. This time Berger was determined to make a sale. He called on every business acquaintance and distant relative, every former partner and friend. A private dealer he knew agreed to show photographs of the paintings to Adrian Mibus, an Australian gallerist on Duke Street, and Mibus agreed to come by and see the works.

At the garage, Drewe let Berger do most of the talking. Mibus did

not seem put off by the grubby surroundings. "It's not all that common to meet in a place like that, but not unusual if the buyer or seller wants to be private," Mibus later recalled.*

Mibus looked closely at the two Bissières. Though they were hardly extraordinary, the price was right. Berger and Drewe wanted to make a quick sale and were prepared to accept a price well below market value. If Mibus paid cash, they would take £15,000 for the pair.

Cash deals were common, and were a good way to lighten the tax burden. Mibus agreed to the terms and almost immediately sold one of the paintings to a French dealer for a good profit. He decided to hold on to the second and show it at an upcoming art fair.

Several weeks later he returned to Berger's garage to see another Bissière, as well as a work by Nicolas de Staël. The Bissière, titled *Composition 1958,* was a colorful oil with a red border and several red, yellow, blue, and white squares. The de Staël was equally vibrant, with the artist's characteristic use of thick layers of paint laid down with a knife. On its reverse was a brief dedication to a Mrs. Richardson: "To the memory of our walk in the park this afternoon."

A nice detail, Mibus thought, wondering who the handsome artist's companion had been.

He struck another cash deal with Berger: £32,500 for the de Staël and £7,500 for the Bissière. Then he took the de Staël to Christie's for a "flyby," an informal estimate of what the work might bring at auction. One of the Christie's experts quoted a figure much higher than the sum Mibus had paid and encouraged him to put it on the block. He said he would think about it.

*Mibus no doubt knew that similar caches of artworks could be found all over the world. London, Paris, New York, and Tokyo were dotted with anonymous storage depots where dealers routinely stashed their best works until the market was ready to pay the right price. These gloomy treasure troves, which often called to mind the interior of a state prison, ranged from modest warehouses to much larger operations manned by discreet uniformed attendants riding prewar elevators. One such facility in New York was said to be filled quite literally to the rafters with thousands of priceless works, some of which had not seen the light of day in decades. The occasional thefts, almost always inside jobs, were kept quiet and in the family.

Mibus's was a labor-intensive business. For all the glamour and spark it provided, and for all that he could be physically close to paintings he loved, art was a very tough market, one that operated in a narrow universe whose inhabitants could be as petty and vicious one day as they were generous the next. Competition was fierce: Of the several hundred active art dealers in London, New York, and Paris—three of the major art markets—only a handful were successful on a grand scale. Galleries went out of business every year. Mibus had held on through the bad times and remained a respected midlevel dealer.

Most gallerists earned the lion's share of their income from commissions, taking a third to two thirds of the selling price of works by the artists they represented. These were high fees indeed, but the risks were high too. The art market was stormy at best, and an artist on whom a dealer had bet heavily might fail to generate the buzz necessary to command top dollar. And the overhead for a gallery was huge. A successful gallery needed a respectable address, as well as a staff that included secretaries, accountants, and stock handlers. A top-notch gallery had to install a new show once every few months to maintain credibility, and to try to make a profit on pieces in inventory. The shows were not cheap: There were costs for promotion, advertising, crating, trucking, insurance, installation. After a splashy opening night, the whole thing could run to as much as fifty thousand dollars. It was not unusual for a dealer to break even or report a loss, even if the show sold out.

In a good year, a midlevel dealer might move a dozen works by a handful of new artists at $5,000 to $20,000 apiece, but that was hardly enough to keep a business going. The dealer also had to make a few top-drawer sales of $200,000 and up, and sell a few paintings from other dealers or collectors on consignment, which could net 10 percent of the selling price.

Dealers had to keep an eye on rival gallerists as well, and maintain a solid list of contacts and a full social calendar. Gossip was an impor-

tant element of the art business. Deals were often struck in back rooms, with only the dealer and the buyer knowing exactly how much money had changed hands. Even at auction, and even for experienced paddle raisers, it wasn't always clear when a work had been sold and at what price, leaving dealers to rely on their best guess to price their own holdings accordingly.

They also had to worry about antagonizing their clients, who were often among the richest people in the world: industrialists and financiers and attorneys who could easily put a gallery out of business with a single lawsuit. Not only that, but selling to a wealthy collector did not necessarily guarantee payment. Stories abounded of collectors buying a work on credit, enjoying it for a year, then returning it without having paid a penny. Others had been known to buy a picture on credit and then sell it at auction before paying the debt. Police in London and New York knew of collectors who had skipped town with "borrowed" paintings. In a world where transactions were often sealed over a nice meal or by oral agreement, there wasn't much a stiffed dealer could do but weep.

Mibus took the de Staël home and hung it in his living room. It was filled with color, an abstract landscape of optimism created by a man who had suffered from insomnia and severe depression, and had eventually flung himself from his eleventh-story studio. It had been a while since Mibus enjoyed the luxury of an acquisition like the de Staël, but circumstances were such that he could now afford to keep it for a while. Instead of consigning it to Christie's, he would allow himself to savor the painting.

CROSSING THE LINE

Over the previous few weeks Myatt had been getting calls from his ex-wife. She said her boyfriend was becoming abusive and had hit her on several occasions. The calls grew increasingly frantic, and late one night, after Myatt was in bed, he picked up the phone to hear her frightened voice begging him to come over. He jumped into his car and raced to her house. When he arrived, he found her bruised and bloodied. She told him that she feared her boyfriend would return and hurt her more seriously.

Myatt packed her into the car and drove her home to Sugnall. He said she could stay with him as long as she needed to. She would be safe with him.

She stayed for a week, and Myatt was glad to have her around. She was a real and familiar comfort. Soon, however, she was talking about going back to her lover. Myatt argued against it. He was worried about the children's safety. He had custody of them, but he'd promised

her he wouldn't stand in the way of their visiting her. Having her there in the farmhouse felt tantalizingly like old times, as if the family were whole again, and yet he realized that he no longer loved her, and that he was feeling more and more confident as a father, even though his life hadn't been easy since she left. He was torn.

Myatt turned to Drewe for advice. The professor always seemed happy to listen to him when he had a problem at home.

"Don't be a fool!" Drewe said firmly when he heard about the latest round of fireworks. "You're not responsible for her well-being. You're divorced. Except for the children's safety, what matters most now is your work. You have to paint. You must provide for the children."

Myatt agreed to put an end to his ex-wife's extended stay, and placed a call to his former in-laws to tell them that their daughter needed help. Before long, his ex-father-in-law had moved her out of her boyfriend's house and into a new one near Myatt, and the boyfriend began to come around less and less.

Within a few weeks the storm had passed, and Myatt felt comfortable enough to let her take the children when she wanted to. He returned to his painting full force. Several weeks later, however, he received an unpleasant surprise visit from Social Services. It was billed as a routine checkup to make sure he was providing a healthy environment for the kids, but the experience left him shaken. It was clear that he was barely making ends meet. The house was a single-father nightmare: frames and canvases, toys and finger paints, food and diapers were everywhere. In addition, the sleeping arrangements were far from ideal. Amy slept in the attic, up a steep, narrow flight of stairs, in a room with a ceiling that sloped so badly Myatt could hardly stand up straight. Sam, a fretful child, had the room next to his, so Myatt rarely got a good night's sleep.

The visit from Social Services ended without incident, but Myatt was rattled by the notion that the government could simply march into his house, declare him an unfit father, and take off with the kids. A few

days after the visit, when he took the train to Euston station to drop off another piece for Drewe, he was still in a deep funk.

"Calm down," said Drewe, who was waiting for him at the bar. "You don't have to be a perfect housekeeper or live in a palace to prove you're a good father and a good man. This will pass."

Again Drewe encouraged him to focus on his painting and not to let anxiety get in the way of his life with the kids. Family and loved ones came first, he said. Something would turn up. Myatt's finances would improve. All he needed was patience.

Drewe was no stranger to family upheavals. When he was a boy, he told Myatt, his father, a scientist, had beaten up Drewe's mother after learning that she was having an affair with one of his colleagues. The scandal ended in divorce, and his father spent a year in prison for assault. Drewe hadn't seen him since. To dissociate himself from his family's unsavory past, he had changed the surname he was born with, Cockett, and become John Drewe, adopting a variation on his mother's maiden name.

While Myatt was digesting this news, Drewe went on to say that he had married a Cambridge mathematician, the love of his life, but she had left him and broken his heart. Her work took precedence over their relationship, she'd calmly explained. He was devastated, but he'd gotten over it.

"Look at me," he said. "I've suffered a great deal, but I've put my life in order. It takes time. Things work out in the end."

Myatt nodded. Drewe was apparently living happily with Goudsmid now, well off, successful in every respect.

"You're spending too much time teaching other people's children and not enough time teaching your own. Your job is a drain on your talents." The most important thing in the world, he reiterated, was for Myatt to provide for his children, preferably without having to suffer the daily drudgery of working for a pittance.

Myatt had always wanted to work from home and manage his

schedule around the children's, so he listened carefully. By now, even though Myatt was nearly three years older than Drewe, the professor was a father figure to him, someone with authority and compassion who could guide him through the difficult moments. What Myatt didn't know was that Drewe had invented most of his tragic narrative, conjuring it from air to tug at Myatt's heartstrings and tighten their emotional knot. Drewe's father wasn't a scientist but an engineer for the telephone division of the British Post Office,* and the failed marriage to the Cambridge mathematician was pure fiction. If Myatt had been aware of any of this, he might have walked away, but he was already in Drewe's pocket.

"Remember that Gleizes you painted a few weeks ago?" Drewe asked him suddenly.

Myatt had been captivated by a reproduction he'd seen of a small elliptical pencil drawing, a 1916 sketch titled *Portrait of an Army Doctor,* by the cubist Albert Gleizes. The sketch had prompted him to make a painting of the doctor in the artist's style, as what he called "a small homage" to Gleizes. He couldn't afford real oils, so he'd bought house paint from the hardware store. Once it was dry, he'd applied a thick coat of varnish until it looked very much like the real thing. Drewe had framed it nicely and hung it on his stairway wall. Myatt thought it looked glorious and was quite proud of himself.

Drewe said he had shown the piece to an acquaintance at Christie's, who believed it was genuine and could fetch at least £25,000 at auction.

"You know, you don't have to sell these paintings to me exclusively," said Drewe, "though of course I'm happy to handle them for you. For the Gleizes I can get you £12,500."

That was more money than Myatt had seen in years. He could buy shoes for the kids, stop worrying about the rent, and have more than enough coal for the stove. It would solve all his problems.

*Neither the alleged affair, assault charge, nor prison sentence could be verified.

"We don't have to stop there," said Drewe. "You can make a decent living at this." He held out a fat brown envelope full of bills. "It's yours if you want it."

It hit Myatt that Drewe had already sold the piece. He could no longer deny what he had suspected, that Drewe was passing off his works as genuine. He had already painted fifteen or twenty pieces for the good professor, and Drewe wanted more.

Myatt took the cash and realized that with that one small gesture he had crossed the line.

"What would you like to paint next?" asked Drewe.

Myatt thought for a moment.

"Giacometti," he said.

MIBUS WANTS HIS MONEY BACK

Frequently there is a tender complicity between faker and victim: I want you to believe that such and such is the case, says the faker; if you want to believe it, too, and in order to cement that belief, you, for your part, will give me a great deal of money, and I, for my part, will laugh behind your back. The deal is done.
— JULIAN BARNES,
Letter from London, June 11, 1990

Adrian Mibus was becoming increasingly unhappy with the de Staël he had bought from Danny Berger. The longer he stared at it, the more he realized something was off—the brushstrokes seemed a little too stiff, and the painter's casual elegance was absent. It had been nearly a year since he'd bought the piece and put it up in his home. Now, in the summer of 1989, he decided to get a second opinion. He took it down, wrapped it carefully, and brought it across the Channel to Paris to show to the artist's widow.

As heiress to the estate, Madame de Staël retained what in France is known as the *droit moral,* an absolute right to judge an artist's oeuvre and declare whether or not a work is authentic. The *droit moral* is legally binding in France, where it often serves as the ultimate arbiter in disputed cases of forgery.

As soon as she saw the canvas, the widow de Staël expressed her doubts. What disturbed her even more than the painting itself was the inscription on the back—the scrawled reference to a walk in the park—and the signature, "Nicholas de Staël."

"That's quite wrong," she said.

Her husband, a Russian émigré who had settled in France, always spelled his name "Nicolas." As for the alleged promenade through the park with "Mrs. Richardson," Madame de Staël knew nothing about it.

When Mibus returned to London with the painting, he tracked Professor Drewe down through Danny Berger and told him he suspected the de Staël was "wrong." The artist's widow was not convinced that the work was her husband's, and a Parisian dealer named Jean-François Jaeger, one of the foremost experts on de Staël, believed it was a fake.

Mibus asked for his £32,500 back, fully expecting Drewe to uphold the standard of any legitimate dealer—to refund a client when a work is considered suspect.

Drewe suggested that they discuss the matter over lunch at White's, a private members' club near Mibus's gallery. Mibus assumed they would have a quick, conciliatory meal and wrap up the whole unfortunate affair, but Drewe avoided the subject of the de Staël. He motioned for the waitress and ordered a three-course meal. He spoke quickly, as if he'd downed half a dozen espressos, and when the food came, he made a pass at the waitress, a thin young woman with a boyish haircut. She ignored him. Drewe was unfazed and continued chatting.

Mibus interrupted him. What about the painting?

Not to worry, said Drewe. The work was genuine. Opening his

briefcase, he removed two large photographs of another de Staël that had also been signed "Nicholas" and slid them across the table. He explained to Mibus that de Staël was known to have used the English spelling of his name occasionally.

Mibus heard him out. Like any other European or American dealer, he understood that while the *droit moral* added weight in disputes over authenticity, it was by no means the deciding factor outside France. Why should the opinion of a family member count for more than that of an expert or scholar? True, Jaeger thought the piece was a fake, but hadn't Christie's approved it the previous year?

Drewe perhaps noticed the doubt flickering across Mibus's face and hinted that de Staël had had an affair with the woman in the park, and that the widow was letting jealousy get in the way of good judgment. He told Mibus that the piece had previously belonged to John Catch, a key member of a consortium of military defense contractors that owned a large collection of artworks. Drewe himself was a member of the consortium as well as its official representative delegated to sell the group's artworks.

He ordered another bottle of wine and began to talk about his own career. Mibus listened politely. Drewe said that his research firm, AceTech Systems Ltd., was developing a machine gun that could fire a thousand rounds per minute. In addition, the company was working on a chemical warfare suit that could be folded up and reduced to the size of a golf ball. Drewe suggested that he was in a position to broker the sale of tanks and F-16s, and jokingly asked whether Mibus knew anyone who wanted to buy a fighter jet. When the dealer tried to steer the conversation back to the business at hand, Drewe dug another channel.

"He was good at making one lose one's train of thought," Mibus recalled.

As lunch drew to a close, Drewe pulled from his briefcase a high-resolution transparency of a Picasso titled *Trois Femmes à la Fontaine*,

a $2.7 million oil on canvas that a private collector in New York was willing to sell for just $1.8 million, according to Drewe. The work was represented exclusively through his consortium, and Mibus could get a jump on the competition. Given three days' notice, Drewe could arrange for a private viewing in New York.

The transparency had the intended effect: The work looked good to Mibus. It was in fact the genuine article, most likely in the hands of a real collector. Mibus told Drewe he was interested, and for now the de Staël was forgotten. Drewe had bought himself some time.

Meanwhile, he was having similar problems on another front: His runner, Danny Berger, was running into trouble selling Myatt's work in London.

Things had been going well until recently. Through a business contact, Berger had unloaded two Le Corbusiers and a pair of Bissières to an expatriate Fijian financial consultant and property developer who had made a tidy profit by flipping one of the Le Corbusiers at auction. Since then, however, Berger's luck seemed to have dried up. Gallery owners were beginning to ask for more detailed provenances, documents proving the works' authenticity beyond any doubt. Berger's resources were limited to titles of ownership from John Catch of Norseland Industries, from John Drewe, and from Drewe's mother, and these no longer satisfied the dealers.

While the source of Drewe's inventory must have seemed vague even to Berger, he had not thought to ask more probing questions about provenance. He knew little about the traditions of the art world. For him, a painting was just another commodity. The art market was a realm outside his own, and he considered himself a salesman, not a historian. Although there were always gaps in the history of the works he was handling, Drewe had explained that collectors often preferred to remain anonymous and liked to keep their names out of the auction catalogs, which were notorious hunting grounds for burglars looking for a good haul.

But now Berger was telling Drewe that he needed a comprehensive history for each of the pieces he was trying to move. Could Drewe get him the names of previous owners? Were there sales receipts or exhibition catalogs detailing where the works had been shown?

Drewe promised to check with his art historian.

With Myatt at his side, Drewe stepped into one of the more prestigious galleries that dominate London's fashionable Cork Street. He had made an appointment to see a Bissière and wanted his art consultant to look over the piece and its provenance. When the dealer showed them the work, Myatt and Drewe agreed that it would fit nicely with the professor's growing collection of twentieth-century modern masters. When the dealer's back was turned, Drewe examined the painting for gallery labels or dedications that might provide clues to its history. Myatt and Drewe had been to several galleries earlier and discovered that dealers tended to be discreet about where a painting came from. It was good business, a way of keeping their clients from cutting them out of the deal by going directly to the source.

It hadn't taken Drewe long to realize that Myatt's fakes were sorely lacking in provenance. To overcome that handicap, he would have to learn how to create paperwork so impressive that any doubts about Myatt's work would evaporate. He would need to produce a chain of documents that signaled a painting's clear trajectory from artist's studio to museum, from auction house to collector—receipts, invoices, letters, exhibition catalogs. If he could chronicle the involvement of a well-known collector or gallery along the way, all the better. A painting's cachet was not based solely on the quality of the canvas but also on its lineage. The more prestigious or infamous the previous owner, the better. A piece of art with a juicy history was always worth an extra ten grand.

"Buying a painting that was once owned by a well-known person

means, in a way, standing in their shoes, walking in their footsteps, possessing a small part of their myth," Werner Muensterberger wrote in his book *Collecting: An Unruly Passion*. "The idea is that the value of the objects they buy will rub off on them. The objective is to convince themselves that they are 'someone' or alternatively they cultivate a secret garden which may bring to light a different self." Muensterberger could just as easily have been writing about Drewe, a classic con man who presented himself as an empty slate upon which his mark could etch out a fantasy or wish.

Drewe walked out of the gallery, trailed by Myatt. He had seen enough. There were dozens of counterfeit histories he could attach to each of Myatt's works. The possibilities were endless.

For the past several weeks, Mibus's conversations with Drewe had revolved around two subjects. One was the promised viewing of the Picasso in New York; the other was the de Staël, whose authenticity Drewe was now certain he could prove through newly acquired documents.

At their next meeting, again at White's, Drewe ordered an expensive bottle of wine and lunch for both of them, then proceeded to spend a good half hour criticizing the French expert Jaeger's artistic eye. He said that Jaeger was a stubborn man, but that even he would be persuaded by this new evidence. He showed Mibus several letters from other well-known experts in France, all of whom appeared willing to authenticate the de Staël—which was only natural, since Drewe had written the letters himself.

As usual, he hogged the conversation. Mibus listened quietly as the professor bragged about his access to classified information about a secret city beneath London, a six-level subterranean fortress built by the government for wartime use as an emergency control center in case of a nuclear attack or a major disaster. He described a "ghost station"

near Tottenham Court Road that had not been used since the 1930s but had recently been refitted as a government laboratory. He said he knew of a secret tunnel that had been built behind the Institute of Contemporary Arts for the express purpose of providing an exit route for the royal family in the event that they needed to flee Buckingham Palace and the city.

Mibus ran out of patience, excused himself, and took a taxi back to the gallery. There he learned about yet another problem with one of Drewe's paintings, a Bissière he had bought from Catch's consortium and then sold to a French client. The Frenchman had returned the piece after he tried unsuccessfully to sell it through an auction house. Bissière's son had seen it at a preshow viewing and denounced it as a fake. The younger Bissière had the *droit moral* and had stripped the work of its signature.

Mibus promptly refunded the client and called Drewe, who eventually agreed to refund the £7,500 Mibus had paid him.

Still unresolved was the dispute over the de Staël painting. Mibus asked for and received a formal letter from the artist's widow officially nullifying the work. He sent this to Drewe and demanded his money back.

Drewe offered him an alternative: He would supply Mibus with a "generous" consignment of pieces by Giacometti, Tàpies, Oskar Schlemmer, Mark Gertler, and Dubuffet, and Mibus could keep 50 percent of the proceeds from whatever he sold.

Mibus wasn't interested. He wanted a full refund for the de Staël, and then he wanted nothing more to do with Drewe.

Drewe wouldn't budge. He refused to give Mibus his refund. He was polite but firm. He didn't need to keep Mibus happy, because by now he had begun the process of forging documents for each of Myatt's works.

SELF-MADE MAN

The idea of concocting the intricate history of a work of art from whole cloth was no great leap for Drewe, who had been inventing and reinventing himself since he was a child. By the time he was a nervous thirteen-year-old thread of a boy in short trousers and cap, he had mastered the art of dissembling. He boasted that he was a descendant of the earl of York though he had in fact grown up in a lower-middle-class home in southeast England, the stepson of a coal merchant. He was quiet and circumspect, with anxious eyes behind thin spectacles. He had a scar running from his chin to his neck, and this was a sore point: He told the other boys that he'd been accidentally scalded by boiling water. (Later, he would claim that he had been wounded in battle.) He was clearly an intellectual, above the norm. He had few friends, and it seemed he liked it that way. He was never bullied. Even in those tender years, from thirteen to fifteen, he was with-

drawn. There was a controlled grief about him that made the other children keep their distance.

In the summer, he and his only real friend, Hugh Roderick Stoakes, would play long games of whist, an early version of bridge. Drewe (still John Cockett at the time) would deliver speeches to an imaginary audience and tell Stoakes that the two of them were fated to be "heroes for the future." They rarely talked about girls or football or pop music. They preferred to listen to the funeral march from the second movement of Beethoven's *Eroica,* imagining the mourners' silhouettes against a darkening sky. They traded horror paperbacks, and Drewe kept his collection next to his advanced chemistry and physics tomes and his copies of Conrad, Kafka, and Joyce. His room was clean and neat, with reams of paper stacked next to a typewriter on which he composed complex mathematical equations and theories.

Even as a boy, Drewe was drawn to the rigors of science. He loved the precision and control and discipline of scientific endeavor. His math skills were sophisticated, and he could assimilate information quickly and accurately. By his early teens he was reading up on quantum mechanics and cold fusion. He plumbed the philosophy of science and pored over *Vogel's Textbook of Practical Organic Chemistry,* a university-level text. Stoakes suspected that his friend was uncomfortable with purely conceptual matters, but he could see that Drewe was able to devour buckets of hard facts, and was quick to pick up the gist of an argument. He had a pigeonhole mind, an uncanny ability to locate and isolate relevant data from massive amounts of information.

In their late teens Drewe would pour tea for his friend from a Georgian pot when he visited, and they would chat for hours about physics, ballistics, and weaponry. He showed Stoakes a yellowing document that illustrated how to build a homemade nuclear bomb, and they discussed Einstein's unified field theory. He was quiet and reticent until they talked science, and then he would go on for hours. Hard science pro-

vided a necessary jolt, he said, a rush of sheer intellectual joy. It was his calling. He was determined to be a pioneer, to crash through boundaries. He gave Stoakes a paper he had written that appeared to break clear of the fundamental laws of physics. Stoakes thought it read like science fiction.

The boys enjoyed an extended adolescence. Sometimes Drewe pretended to listen, but Stoakes could tell he was somewhere else. Occasionally he would short-circuit. Stoakes remembered these moments with absolute clarity, because Drewe's temper tantrums could be terrifying, like thunderclaps. The softness would vanish as though it had never been there, his face would contort, and he would speak in staccato bursts through gritted teeth.

Drewe did reasonably well at school and got through his ordinary level exams, the earlier and less rigorous of two standardized tests in secondary school subjects, but he seemed to have little patience for his teachers, who seemed increasingly resistant to his obvious talent. His family expected him to become a lawyer or a professor, but he was determined to make his own way in the world. He'd had his fill of academia and wanted to run his own ship without middlemen or explanations. When he turned seventeen, he took an internship at the Atomic Energy Authority, a clerical position that he must have felt was beneath him. His boss was one John Catch, and he had an enormous impact on Drewe. Catch would remember him as a "very clever" young man who had an impressive knowledge of advanced physics, even though tests showed he hardly understood the basics. Catch encouraged him to take college-prep classes through the AEA's part-time study program, but Drewe dropped out, claiming that he already knew the material.

Finally, at the age of nineteen, he resigned from the AEA, changed his name, and disappeared without a trace. When he resurfaced some fifteen years later, he had mysteriously acquired a PhD and claimed he was a well-paid nuclear physicist who did consulting work on high-level technology. At various times, he also claimed to have been a professor,

a historian specializing in the Nazi era, a consultant for the Ministry of Defence, an army lieutenant, a weapons expert, and in his off-hours, an expert hang glider.

Drewe's life during those fifteen years remains a mystery. Although Stoakes did see Drewe a few times during that period, he had for the most part fallen out of touch with his friend—which didn't seem to affect Drewe much. Drewe would make use of Stoakes's name regularly in his con.

There is no official record of Drewe until shortly before he and Goudsmid set up house in Golders Green, where he soon found a ready audience for his tales at one of his favorite pubs, the Catch-22. Located across the street from the Golders Green police precinct headquarters, the pub was named after the quintessential antiwar novel, but it had become a second home to an assortment of military types, a watering hole for army buffs, uniform aficionados, private bodyguards, veterans of the Special Forces, and off-duty detectives. The Catch was run by an easygoing ex-paramilitary man. Regimental ties hung from the wall behind the bar, along with various battle emblems and group photos of soldiers. In the muddy Guinness light, with Queen and Elvis on the jukebox, the regulars traded war stories and argued about rugby, cars, and politics.

One spring evening not long after his visit to the gallery with Myatt to inspect the Bissière, Drewe stepped out of his house in his blue overcoat, briefcase in hand, and turned onto Finchley Road, past Danny Berger's garage, on his way to the Catch. He looked like any other well-dressed businessman heading for a pint after work. In fact, he was still *at* work. He was always at work, always on the lookout for a new "legend," a cover he could use for his game, a thread he could weave into one of his stories. It was part of the con man's job, and Drewe was a patient sort. If tonight he came across someone whose name or story he could sew into the quilt, all the better.

At the pub, Drewe was greeted by several of his mates. When he'd first arrived a few years earlier, he stood out as something of a loner, but he had since become a familiar face, a little odd perhaps, but an interesting fellow nonetheless, with a background in nuclear physics and an uncle or cousin or some sort of relative who had invented the hovercraft.

Terry Carroll, a Catch regular who lectured in computer technology and digital systems at the University of Westminster, remembered Drewe striding into the bar for the first time. "Instantly you knew someone was in, that the lights were *on*," he said. Drewe was six feet tall, intense, and clearly intelligent. He was accompanied by a friend of Carroll's, Peter Harris, a veteran of the armed forces with wild red hair and an improbable stew of wartime tales. Harris introduced him to Carroll and suggested that the two probably had a lot in common.

Carroll had studied physics and gone on to work in the field of artificial intelligence. Drewe said he had studied abroad, at Kiel University in Germany, and then in Paris, where he had taken to the streets during the May '68 demonstrations. Subsequently, he had worked at the city-sized atomic energy research complex in Harwell, near Oxford, where he'd made substantial and lasting contacts with the police and with MI5. Those contacts were useful in his current line of work, which included consulting for the Defence Ministry.

Carroll said that he too had worked at Harwell, back when he was a young physicist analyzing various materials with the use of neutron beams. Harwell was so enormous that most employees knew only a small fraction of the layout, but Drewe recalled the place as vividly as if he'd been there the day before.

Whenever Drewe spotted Carroll at the pub after that first night, he greeted him warmly and bought him a beer. Usually he dominated the conversation. He liked to talk about defense technology, and said

he was developing a handgun that could fire a thousand rounds a minute. On a good night, he sounded like Ian Fleming on Dexedrine. He told Carroll that once, after a meeting at the Defence Ministry had gone late into the night, he was accidentally locked in the parking garage. Fortunately, he had recently been demonstrating the effects of a powerful explosive called pentrite, and he had a small supply on hand. With it, he had blown the garage door off its hinges.

Carroll found the story amusing and a little strange, but he didn't ask for details. He knew quite a bit about pentrite from his own army training, and it was obvious that Drewe was well versed in detonators, boosters, and initiators. The man was an all-rounder, he thought.

Drewe never forgot a name or a face, and seemed able to retain every last stray piece of data. He could recite Newton's laws of motion, Maxwell's equations, and the principles of quantum mechanics. Carroll envied his ability to remember it all. Drewe explained that he compartmentalized information so he could call it up for use whenever he needed it. It was effortless, he said, like pulling documents out of a filing cabinet. He could remember every room he'd been in, every nuance of every story he'd been told, every twist and turn. No bit of information was trivial to him. He was a data sponge, a Hoover of books, journals, and news.

"John was able, almost at will, to drop in important parts of the history of physics from memory," Carroll recalled, "and in doing so to convey the impression of a much greater understanding of the subject area in which he purported to be expert."

Drewe created an entire informational universe from other people's lives, storing potentially useful morsels and retaining details of the quirks and professional habits of each of his acquaintances. He would look them straight in the eye with his flat, unwavering stare, listen intently, and come away with flakes of character and personality, pieces so small his marks hardly knew anything was gone.

"He was like a shark that doesn't bite but rubs up against you and takes away little bits of your skin," said one such acquaintance.

Drewe often boasted to Terry Carroll that he had a pilot's license, that he loved flying helicopters, and that he was an accomplished hang glider. Carroll thought it would be nice to surprise his friend with a private visit to the Concorde, and on a clear day the two men drove out to Heathrow in Drewe's Bentley. On the giant airliner, at the pilot's invitation, Drewe took the controls in his hands. He looked as excited as a four-year-old with a lollipop, and asked a variety of technical questions. (Interestingly, Goudsmid would later tell police that Drewe had a mortal fear of flying.) On the way home he expounded on various theories of unmanned flight and drone weaponry, and Carroll noted again that he had a sophisticated understanding of physics. Years later Carroll realized that Drewe had simply memorized basic concepts from physics textbooks.

Drewe quickly added Terry Carroll to his collection of unwitting accomplices. The soft-spoken lecturer was developing powerful intelligence-gathering software that could be applied to various disciplines. Drewe told Carroll he was sure the Home Office would be interested in the software for a newly proposed national computerized fingerprint identification system, as would the auction houses for an international database for art. Drewe said that he could broker both potential deals. Soon he was bringing an assortment of interesting characters to Carroll's office: a group of MI6 and Scotland Yard acquisition officers; a handful of Russian and South African officials; a Chinese military attaché and his computer specialist. Carroll couldn't help but be impressed.

Another candidate for Drewe's crew was Peter Harris, the larger-than-life armed forces veteran who had introduced him to Carroll. Harris was well into his fifties, a hard drinker and smoker who had already lost a lung, and whose appointment with oblivion was neatly

stamped on his forehead. A retired commercial artist, Harris supple-
mented his income by working an early morning paper route and sub-
letting his flat, most recently to Carroll.

Harris's friends would probably have pitied him if he hadn't been
such a great raconteur. He claimed that in the late 1960s, while fighting
in Aden in the British Army's last colonial counterinsurgency cam-
paign, he had stood his ground after a sniper shot one of his mates
dead. Wearing the Tartan kilt of the Argyle Highlanders, he had picked
up his bagpipes and marched down a bullet-pocked street playing
"Scotland the Brave" and daring the bastards to finish him off. Or so
the story went.

It was questionable whether Harris had ever seen combat, but the
Catch-22 was a perfect venue for such yarns, with its collection of arm-
chair warriors and tin soldiers who enjoyed the camaraderie of real
fighters. Britain was filled with barflies who lied about their war ser-
vice. Many of the kingdom's khaki fantasists claimed to have served in
the elite Special Air Service (SAS), or as commandos during the Falk-
lands War, or in the bomb-disposal squads in Northern Ireland. Drewe
also claimed to have belonged to an elite military unit, one of several
in the British Army that operated covertly against the IRA in Northern
Ireland in the 1980s, relying on spies, "dirty ops" informers, and army
and loyalist death squads. Terry Carroll realized much later that Drewe,
who could reel off military commands, ranks, and lists of weapons,
probably got most of his information from spy novels and military
manuals.

Psychiatrists who treat serial war fibbers and compulsive liars use
the term "pseudologia phantastica" to describe this pattern of habitual
deceit. The lies often contain some element of truth: A onetime army
clerk, for example, might claim to have seen hazardous duty during
wartime. Fabricators most often tend to be in search of some internal
psychological gain rather than a tangible or monetary reward. They
want to be seen as extraordinarily brave, important, or above average,

somehow superior to the ordinary citizen. The typical fantasist is not delusional.*

Peter Harris and John Drewe both fit the pattern. They were habitual exaggerators. At the Catch, they loved to talk about their shared passion for all things military, about calibration and cannons, missile velocities and the merits of the old Lee-Enfield rifle. Harris wasn't making everything up. His service career was as an airman between 1947–1949. He knew about guns, having worked for three years as a security officer for the South African High Commission, and he was still a registered firearms dealer, although the only guns his friends could remember were replicas imported from Spain.

For his part, Drewe never let the facts get in the way of a good story, particularly one that could help him sell more fakes. He needed real names to attach to Myatt's paintings, and Harris was a fine addition to his roster. The self-described "oldest newspaper delivery boy in Hampstead," whose only artwork was a framed certificate proclaiming, "I've visited every Young's Pub in London," was about to morph into a wealthy arms dealer with a large art collection. This new, improved Peter Harris would be based in Israel and would have close ties to an ammunition manufacturer in Serbia.

*War fibbers are not confined to Britain. According to a 2001 *Guardian* article by Duncan Campbell, thousands of American fabricators claimed to have taken part in the Vietnam War. In a notable example, Los Angeles Superior Court judge Patrick Couwenberg was removed from the bench in 2001 after it was determined that he had lied to get his job, claiming he was a decorated Vietnam War veteran who had received the Purple Heart for a groin injury sustained in battle. He had also claimed that he had worked undercover for the CIA in Laos in the 1960s, that he had studied law at Loyola, and that he had a master's degree in psychology. These were all lies. At hearings to determine whether he should remain on the bench, Couwenberg's defense lawyers argued that he was suffering from pseudologia phantastica. Other well-known war fibbers include the historian and Pulitzer Prize winner Joseph Ellis, who was suspended from his university job after inventing a Vietnam War past for himself. (He said he had been a platoon commander near My Lai, the site of the notorious mass killing by U.S. soldiers.) Chicago District judge Michael O'Brien falsely claimed to be a medal of honor winner and was forced to step down in 1995, after fourteen years on the bench. Toronto Blue Jays manager Tim Johnson was fired after his claims about Vietnam War combat turned out to be bogus. War liars are often caught because of the grandiosity of their boasts—for example, that they belonged to elite units such as the Special Forces, Britain's SAS, the U.S. Navy SEALs, or the CIA, claims that for the most part can be verified.

Piece by piece, document by document, Drewe reinvented Harris. Years after his con had come apart, the police were never certain whether Harris had wittingly posed as an owner of Drewe's fakes or whether he had been another of his marks. In either case, his name figured large in Drewe's provenance documents, even after Harris died of cancer. Police suspected that as he lay on his deathbed, barely able to talk, Drewe was feeding him blank documents to sign.

WRECKERS OF
CIVILIZATION

One night in the late fall of 1989, as Drewe sat at home with his KGB paperbacks and Mossad memoirs, he got a call from one of the auction houses. He had recently gone to the auctioneer with one of Myatt's Le Corbusier works, a collage pieced together from bits of newspaper from the 1950s. Drewe said it had come from his family's collection, but the auctioneer had bad news for him: The provenance was insufficient, and the piece had been turned down.

"Are you related to Jane Drew?" the auctioneer asked in passing.

A renowned British architect with close ties to the Swiss-born architect and artist Le Corbusier, Jane Drew had helped design the original premises of London's Institute of Contemporary Arts, which was founded in the late 1940s as a cutting-edge art gallery and cultural center. Drewe knew about her design work for the modernist Indian city of Chandigarh and her influence on the Modern Movement, a group of avant-garde architects and painters of the 1940s.

The professor was not one to let an opportunity slip by. He told the auctioneer that Jane Drew was indeed a distant relative. Drewe carried on the conversation long enough to learn that the legendary woman was still alive, living just a few hours away, in the northeast.

Perhaps, Drewe thought, it was time to pay her a visit.

Drewe and Myatt drove north in the blue Bristol for three hours, until they reached the tiny two-pub village of Durham. Drewe had called beforehand and introduced himself as a patron of the arts who was writing a book on the history of the ICA. Jane Drew had immediately invited him up.

As soon as they walked into the house, Myatt was in awe, for he considered the seventy-eight-year-old woman a living, breathing part of Britain's culture. Before long they were chatting about her work with "Corbu," her role in the Modern Movement, and her friendships with Frank Lloyd Wright and Buckminster Fuller, who had invented the geodesic dome and coined the phrase "Spaceship Earth." At Drewe's prompting, she reminisced about her involvement in the postwar celebration dubbed the Festival of Britain and her work as a pioneer in tropical architecture and public housing.

She spoke with affection about some of the artists she had met through the ICA, particularly Ben Nicholson, a jaunty character who wore a beret and talked in a high-pitched voice. She remembered his uncanny penchant for design and his beautifully composed vegetarian dishes, with a red radish placed slightly off center, a fistful of asparagus laid out in a curve on the edge of the plate.

Drewe was in top form, and Myatt noted his effect on the aging woman. When the professor suggested that it was high time she wrote her autobiography, she seemed flattered. Then he offered to finance the project himself. He was certain her memoirs would reach a wide audience.

Within weeks of the meeting, Jane Drew had prepared a detailed outline of her life, and when Drewe returned north to pick it up, she

asked him for a favor. Would he use his contacts in London to act as her representative in the sale of a small Eduardo Paolozzi sculpture she owned? Drewe had seen the piece and knew a dealer who might be interested. He said he would be delighted to handle the sale.

After several more visits to Jane Drew's country home, Drewe began systematically widening his circle of art world acquaintances by dropping her name and inviting members of the establishment to lunch with them. He reserved tables at Claridge's or at L'Escargot in Soho for such eminent Londoners as the former head of the Tate Gallery, Alan Bowness—Ben Nicholson's son-in-law—and the art critic David Sylvester, who had once had his portrait painted by Giacometti.

Through Jane Drew he also met Dorothy Morland, the former director of the ICA. Until a few years earlier, he learned, the bulk of the ICA's archives had been stored in Morland's garage for safekeeping. She had eventually returned them, and they were now in box files in a small room on the ground floor. The cache consisted of forty-five years' worth of memorabilia and personal papers, stacks of letters, sketches, and programs in no particular order, with huge chronological gaps. There were letters from Picasso, the art critic Herbert Read, and the surrealist painter and poet Roland Penrose, along with dozens of catalog and texts of forgotten lectures by W. H. Auden and Buckminster Fuller. By and large the archives had been ignored for decades. Dorothy Morland felt that she had saved them from destruction. She told Drewe that Bill McAlister, the current ICA director, wanted very much to put the material in order but that the institute was always short on funds.

She suggested that Drewe give the director a call.

Bill McAlister was a busy man. Normally his secretary screened his calls thoroughly, but this one was from a gentleman who was so persistent and seemed to know so many of the institute's longtime supporters that McAlister took it.

Dr. Drewe got straight to the point. He said he was a scientist and a businessman, and that in his capacity as chairman of Norseland Industries, which had a large collection of modern art, he was considering a substantial donation to the ICA. He spoke knowledgeably about the institute's inner workings and his wish to help overhaul its legendary archives.

McAlister immediately agreed to meet him for lunch.

The business of donor fishing was at best frustrating for McAlister, like rowing upriver for a week and coming back with minnows. On the rare occasion when he managed to land a contributor, one or another of his department heads would be at the door, cap in hand, with plans for a new play by a Nordic iconoclast, a seminar on chastity in Pop, or a Bavarian film festival. There was never enough money to go around, certainly never enough for what McAlister hoped would be his final project: refurbishing the archives, which had never been properly cared for. Over the years former senior staffers had felt it necessary to remove archival material in the belief that it needed protection or was part of their own private papers. One had even removed a visitors' book containing sketches and signatures by Picasso and Hockney. This valuable volume later found its way to the British Museum's library.

McAlister was aware of other such potential improprieties— nothing that verged on the criminal, but there was simply no excuse for the lack of a system to identify and maintain the archives. Thus, he was especially pleased to find someone who shared his concern. "I felt very lonely in that regard," he recalled.

He and Drewe met at a fashionable Soho restaurant. Drewe was punctual and impeccably dressed. McAlister was a gourmet and mushroom hunter, and they both took their time with the menu and the wine list. Right away, McAlister felt that they had much in common. Drewe was a man of the Left, a former official with the Atomic Energy Authority who had quit after Margaret Thatcher began to privatize gov-

ernment programs. He accused her of wreaking devastation on the arts and sciences with her denationalization campaigns.

McAlister was no Thatcherite either, and complained to Drewe that while bastions of the art establishment such as the Tate and the Victoria and Albert Museum still enjoyed government beneficence, the ICA got chicken feed.

Cultural historians well understood official Britain's arm's-length relationship to the ICA. Ever since its founding in a small L-shaped room on Dover Street in 1947, it had been a constant irritant to the arbiters of art. When cofounder Herbert Read called for public funding, the prickly George Bernard Shaw declared that such funds "would be better spent on hygiene, since hygiene [and] not the arts was responsible for the improvement in the nation's health over the preceding hundred years."* But the ICA's early members, who included Henry Moore, T. S. Eliot, W. H. Auden, Peggy Guggenheim, and Dylan Thomas, believed that the institute stood as a beacon to those who wanted to create and debate new art forms. The ICA organized poetry readings and "conversation nights" with Le Corbusier and "Bucky" Fuller, and opened a bar where patrons could buy a snack and a drink and discourse until dawn on the new postwar aesthetics.

"It felt like a railway stop," Dorothy Morland told an ICA historian.† "People passed one another without realizing that some would one day be famous and some would change the face of art beyond all recognition. But as with every station, everyone was in a hurry."

Over the years the ICA became a relatively safe haven for avant-garde artists from all over the world. In 1959, during a "Cyclo-Matic" demonstration of the mechanical nature of art, the Swiss Dadaist Jean

*Lyn Cole. *Contemporary Legacies: An Incomplete History of the ICA 1947–1990*, unpublished.
†David Mellor, ed. *Fifty Years of the Future: A Chronicle of the Institute of Contemporary Arts*. London: Institute of Contemporary Arts, 1998.

Tinguely set up a machine operated by cyclists that dumped fifty pounds of drawings on paper onto the street. In the sixties, during an era of sit-ins and protests and the first stirrings of conceptual art, a young Australian artist taking part in a Destruction in Art symposium stood by the roadside waving an animal corpse and spattering the pavement with blood.

That same decade, the ICA moved to one of the more incongruous locations it could have found anywhere in Britain: a Georgian mansion on the Mall, a few hundred yards from Buckingham Palace. There, it held symposiums on horror comics, television culture, and rubber fashion, during which someone set off a fire alarm, and when the fire brigade arrived in their bright yellow plastic macs they became a ready-made instant hit.

In the late 1970s, the ICA held a string of "shock shows." The "Prostitution" show had transvestite guards posted at the door and featured strippers and snake-oil wrestlers. During a subsequent show, in a paean to motherhood, an artist hung tampons and soiled diapers in the gallery.

Predictably, the drumbeat of criticism against the ICA was relentless. The *Daily Telegraph* fumed that its shows were "publicly-funded porn." The "Prostitution" show in particular was "an excuse for exhibitionism by every crank, queer, squint and ass in the business." The *Daily Mirror* blasted the ICA as the home of "extremist art," and one member of Parliament denounced the show's founders as "wreckers of civilization."*

The ICA's government subsidies were supplemented by various foundations and philanthropists, but by the late 1970s many of them had ceased to be amused. The mansion on the mall was expensive to maintain and the ICA was in constant financial crisis. The building

*See www.genesisp-orridge.com. Web site of Genesis P-Orridge, a founding artist of COUM Transmissions, a performance art group that created the ICA show.

was an eyesore, often dirty and in dire need of repair. One member quit after complaining that he kept "tripping over hippies in the corridor," according to ICA historian Lyn Cole. In 1977, Bill McAlister was hired to bring order to the chaos. He spruced the space up, installed a decent bar in the mezzanine, improved the food, and introduced a cheaper membership fee that attracted younger crowds. Over time he reaffirmed the ICA's trendiness and reached out to new artists. As one reporter for the *Guardian* noted, patrons could now "read Baudrillard in the bookshop, munch a healthy lentil-carrot cake in the restaurant, and guzzle a Grolsch in the bar" before the show.

During McAlister's dozen years at the helm, the ICA had seen a sharp increase in ticket sales and membership, but funding remained a constant headache, and his tenure was coming to an end. Before his departure, he wanted to get the archives in good shape, but in case he couldn't find the money to do it, he opened negotiations with the Tate, which was interested in acquiring the ICA records. However, he felt the Tate was overly fussy in restricting access to its archives to scholars and serious researchers, and it was only interested in the visual arts, not the ICA's records on film, performance, and literature. He thought the ICA's complete history should be open to students and youngsters as well as to academics. The negotiations had dragged on painfully and had eventually broken down over the issue of access.

Now McAlister found himself sitting across the table from a wealthy scientist with a strong interest in the arts, someone who wasn't part of the intellectual mafia and who recognized the ICA's worth. Dr. Drewe also seemed to have a solution to the archives problem. He told McAlister that he had a team of university researchers, led by his colleague Terrence Carroll at the University of Westminster, who could update the archives and make them universally accessible by using computer technology and digital photography to collate, cross-reference, and store them. The system would change the way art historians worked.

Drewe spoke of heading up an ICA foundation of like-minded wealthy individuals who would promote the institute through a series of gala dinners and celebrity auctions. He mentioned the names of Jane Drew, Dorothy Morland, and Anne Massey, a young researcher who had worked on a history of the ICA.

McAlister was delighted. Drewe reminded him of another left-wing scientist with a penchant for the arts. The molecular physicist J. D. Bernal, a peace activist during the cold war era, had insisted that his fellow scientists were duty-bound to use their knowledge to benefit humanity. Bernal kept an apartment above his lab, where he entertained intellectuals and artists, including Picasso, who during one party in 1950 painted a large mural of a man and woman with wings and wearing laurel wreaths on their heads. When Bernal's apartment was set to be demolished in 1969, the mural was chiseled out of the wall and given to the ICA. It had been gathering dust for two decades, and one of McAlister's first tasks at the ICA had been to restore it and install it in the new foyer.

History was about to repeat itself, McAlister thought. Drewe was a latter-day Bernal.

At their next lunch meeting McAlister told Drewe that before he left the ICA he was organizing a benefit auction for the institute. Would Drewe's company consider donating a work of art, the proceeds of which would be set aside to refurbish the ICA archives? Drewe immediately offered two pieces, and several days later he brought McAlister a Le Corbusier collage and a simple and transcendent Giacometti drawing. McAlister was charmed by the collage and joked that he would love to have one for himself.

"I can get you another one, a very similar one," Drewe said.

The comment puzzled McAlister, but he let it pass.

A month later the ICA auction at Sotheby's was a big success, raising about £1 million for the institute. Drewe's contributions brought in

nearly £50,000. When McAlister called to thank him, Drewe brought up the archives project. He said he wanted to familiarize himself with the scope and condition of the archives to prepare for a meeting with his computer software engineer, Terrence Carroll.

The archives had been moved to a small, seldom-used room with a separate entrance. McAlister asked his secretary to find the keys and have them ready for Professor Drewe.

"He's free to come and go as he pleases," McAlister told her. "Make him feel at home."

AT THE EASEL

Myatt put Amy and Sam in their pajamas, tucked them in, and read them their bedtime stories. When they had drifted off to sleep, he went down to the living room and cleared off the table. Closing the curtains, he turned on the lamp and returned to the Giacometti he'd been working on for the past few days.

He had become extremely cautious, even paranoid, about being seen at work. He painted only at night. After he'd pocketed Drewe's money for the Gleizes he could no longer deny that what he was doing was illegal. In the back of his mind, he was always afraid of being caught. A neighbor might drop in unannounced, put two and two together, and turn him in. Or the children might innocently tell the babysitter that Dad was painting all the time, and then she'd go to the police and inform them that she suspected her employer was engaged in forgery.

It was all quite irrational, of course, but Myatt's livelihood now

depended entirely on Drewe, and he couldn't take any chances. With a little luck Drewe would sell one or two more pieces, and then Myatt would get out of the game. He'd be able to cover the rent for a few more months while he looked for a legitimate source of income.

He returned to the canvas, dabbed the brush into a pot of gray, and made several bold strokes around the figure in the center.

It had occurred to him, once he consciously acknowledged that he was in the business of making fakes, that a good forger had to go beyond technique to avoid detection, so he'd been around to the galleries and museums to stand as close to Giacometti's paintings as he could without attracting the attention of the security guards. The Swiss artist was famous for his elongated, ethereal bronze sculptures, but his paintings were equally masterful, with a distinctive palette of blacks, whites, and grays, and a few strokes of primary color. To paint a decent Giacometti, Myatt would have to adopt the artistic vision of the man whose creative expression he had chosen to appropriate. He would have to set aside his own preconceptions about what could be achieved in a work of art and see the work through its "creator's" eyes. He would have to become Giacometti.

Myatt had found some good biographical material on Giacometti and had read up on his techniques, looking for telltale quirks that would convince the experts that what they were seeing was the master's handiwork. He'd read about Giacometti's marriage and his numerous affairs. He'd discovered that the artist was injured in a car accident that left him limping around the studio with a cane, and that he smoked four packs of cigarettes a day, drank countless cups of coffee, worked until dawn, and rarely slept.

Every detail of Alberto's work habits would come in handy.

Was he right- or left-handed?

How did he hold the brush?

What kind of light did he favor?

Was he prone to reworking a painting ad infinitum?

Was there ever a sense of closure, of satisfaction with the outcome?

For Giacometti, there was not. He considered many of his masterpieces failures and could never manage to leave a work alone.

"The more one works on a picture, the more impossible it becomes to finish it," he once said. One artist and writer called his artistic process an "obsessive paring down." When Giacometti was sculpting, his hands "would flutter up and down a piece, pinching and gouging and incising the clay, in a seemingly hopeless, even heartbreaking, struggle for verisimilitude."[*]

Giacometti began to resemble his own creations. His frame

became thinner, his face more haggard, his hair ever paler with plaster dust. It was as though he'd been boiled down to his essence. In the end he resembled an armature of a man, a bonhomme of gnarled steel and chicken wire, smoking in the corner café. Once, when he was already rich, a lady saw him sitting forlorn, took pity on him and offered to buy him a cup of coffee. He accepted at once, his eyes brimming with gratitude and joy.[†]

Myatt could definitely relate, but that didn't seem to help much. His canvas was a plain composition of a nude woman emerging from blue-gray shadows, a copy of one of three basic figures Giacometti had painted again and again: the standing nude, the seated figure, and the walking man. Ever since he was an art student, Myatt had admired them. He thought they were simple constructions that would be easy enough to imitate. He was wrong.

The Swiss artist had his own unique energy, painting in a tangle of lines that seemed both calculated and frenzied. His nudes were full-figured and so evocative that Myatt could almost feel the bones beneath

[*]Dan Hofstadter, "A Life Unlike His Art," *New York Times Book Review*, Sept. 22, 1985, a review of James Lord's biography *Giacometti*.
[†]Ibid.

the flesh. His mysterious images seemed to emerge from the canvas as if they were about to step out into the room.

How had Giacometti managed it?

Myatt lashed at the canvas, then stood back. The nude looked emaciated. He moved in again and worked on the torso, dabbing at the rib cage to put meat on the bones. This improved things a little, but the arms looked wrong.

The more he tried to copy Giacometti's style, the more elusive it seemed. He'd already scrapped one attempt at the standing nude because it was utterly lifeless, like a puppet on a string. He'd tried hard to correct it, to harness Giacometti, but it was no use. He'd lost his focus. Now he was failing at his second attempt. He began to question his own talent and consider the potentially disastrous consequences of his new endeavor. What would happen if he got caught? He would never survive the loss of his children and his farmhouse.

In a fit of anger and frustration, he took a bucket of white paint and splashed it onto the canvas. The nude disappeared. When he finally calmed down, he smoothed the surface over with a brush and set the canvas aside to dry. He would use it again to give the nude one more shot.

Myatt's third attempt began promisingly enough, but again the figure he envisioned vanished with each brushstroke the more he worked on it. It would have been easier if he'd been able to use a live model, as Giacometti had. The artist had always painted from life (his wife was one of his favorite models), demanding absolute stillness and concentration from his subject. He would spend months on a single painting, sometimes sitting a few feet from the model while he worked. He would ask her to look straight at him until she was within his gravitational arc, and then he would reel her into the canvas.

Myatt feared it would be too risky to bring in a model, so each

night, after he pulled out his old Winsor & Newton easel and put his cans of paint on the table and began to mix black and white and all the shades in between he could find, he would imagine the nude in his living room. He had been trying to keep this image fresh in his mind for several days now, struggling to re-create the precise tilt of the head and the right proportion of limb to torso, but he just couldn't transpose his mental image onto the canvas. He dabbed again at the nude's arms, then lengthened the legs and stepped back. It was better, but he still didn't have it. The feet looked wrong, as if they were anchored to the canvas.

Sometimes he could tell right away whether a piece was ready. If not, he would wait until early the next morning, when he could look at it with a fresh eye. Tonight he worked on the nude until he was too tired to think and his vision faded. Then he leaned the canvas against the wall, covered it, and put the paints away.

In bed, Myatt tossed and turned. When it was hard to sleep, as it often was these days, he would lie there and try to drift back to his childhood. He'd been four years old when his father moved the family out of the city to Sugnall. There was always music in the farmhouse. Mom and Dad would stand at the piano, and Dad would make like an Italian tenor while his boy sang along with perfect pitch. John had taught himself piano, and they'd set him up in the parlor next to a windup gramophone to play along with Anton Karas's zither music and Frankie Laine's honking High Sierra yowls. It was clear to his parents, who sang Mendelssohn in the village choir society, that the boy had a good ear and a degree of artistic talent. They had no television, so when they sat him down on the floor with his crayons and pencils, he would tumble into a world of Beano comics, chocolate Smarties, and Spitfire fighter aircraft, drawing mosaics of color and spark, Gauls at the bonfire and Saxons coming up over the hill. By the age of six he could sketch a credible and expressive human figure, a skill that came as easily to him as repeating a melody after a single

listen. With his colored pencils and sheets of paper, he was as good as gone.

For the teenage Myatt, 1960s Britain was a grand place to be. He left a private cathedral school for a public education, developed a strong physique, and grew a good head of hair. His talent for portraiture was such that whenever he had his sketchbook out the girls would come around to see what he was up to. He played a little guitar and favored bell-bottoms and tie-dyes. His parents put up with his scruffy appearance because he was enthusiastic and persistent about his studies. During holidays he worked construction on the M6, England's north-south highway, and drove an ice-cream truck that played Mozart over its speakers. In his spare time he sketched whenever he could, for the pure joy of it. Then he went to art school, where joy gradually turned to defeat as his work was found wanting, despite his relentless attention to technical detail—or perhaps because of it.

Myatt rolled over for the umpteenth time and punched his pillow. He wondered what his professors would think of him now. Well, at least he was still obsessed with getting it right. He'd been lying awake half the night brooding about the Giacometti he'd promised Drewe.

In the morning, when Amy and Sam were settled in the kitchen with bowls of mashed bananas and yogurt, he walked into the living room and turned the canvas over.

The nude was a bust. He had failed to crack the code. He'd have to start from scratch again. Frustrated, he called Drewe to say he would be late with the delivery.

"I can't get the feet right," he told the professor.

"Don't worry," said Drewe. "Just hide them. Paint in a bowl of fruit or a piece of furniture. No one will know the difference."

Drewe wanted the painting sooner rather than later because he had an interested buyer, but Myatt argued that the piece would never pass muster. As far as he knew, Giacometti had never painted a standing nude with an object in the foreground. Any dealer would know that.

Worse still, the nude, like all his other forgeries, had been painted with ordinary house paint. Suspicious of the composition, a dealer might scrutinize the paint. Myatt had stopped using proper oil paints about a year before meeting Drewe because they were too expensive and took too long to dry. Besides, the smell of the solvents used to mix oils gave him a headache.

Regular house paint, on the other hand, came in large, affordable cans. Within five miles of his home he could find any color he wanted, from Tuscan Gold to Aegean Green. It wasn't the most elegant medium, but after some experimentation he discovered that adding a little lubricant jelly to the paint helped make the brushstrokes "move" across the canvas, just as if they'd been done with oils. The jelly made the paint more viscous, and with the right mix it held to the canvas with greater definition and produced a richer color. A little varnish sprayed on the work added depth and luminosity.

Apart from Myatt's general preference for the modernists, paint was the principal reason for his reluctance to go back too far in time with his forgeries. Any attempt to duplicate sixteenth- or seventeenth-century works would have required more effort than he was prepared to expend. He would have had to scour herbal shops for the base ingredients of the old masters' pigments: beechwood soot to make bister; a certain South American insect to make carmine red. He would have had to grind lapis lazuli for the beautiful pure blue—now replaced by the synthetic French ultramarine blue—for which patrons had once paid extra if the artist would include it in their portraits. It would have been fun to find these ancient sources, but Myatt didn't have the financial or emotional resources to do it. He told Drewe about his choice of materials.

"Don't worry," Drewe assured him. "No one's going to ask for a paint sample." Even if they did, he said, a chip of new paint could be interpreted as a sign of recent restoration rather than proof of forgery. It was well-known that restorers dealing with a badly damaged work

often repainted part of the canvas in an attempt to re-create the artist's intention.

Besides, Drewe said, he had come up with a new approach to age Myatt's works: by impregnating the paint with turpentine and linseed oil, then placing the canvas in a pressurized container to force the oil into the paint's nuclear structure. Under analysis, he told Myatt, the house paint would show up as oil paint.

Myatt had nearly run through the £12,500 from the Gleizes and was in no position to argue with Drewe. If the professor could create a facsimile of fifty-year-old paint in his lab, all the better, but in the end it wasn't about materials. It was about attitude. If he approached a painting with the right energy, he usually came up with something decent.

Myatt hung up. That night, after the children were asleep he returned to the canvas and painted a table in the foreground, cutting the figure off at the knees. The standing nude had become the Footless Woman.

When the paint was dry he took the canvas down to London in his old Land Rover and met Drewe in the parking lot outside the Spaniard's Inn, a four-hundred-year-old pub in Hampstead Garden Suburb. He expected Drewe to take one look at it and turn it down, but the professor seemed pleased enough.

"Great work, John," he said. "We'll sell it, no problem at all."

Myatt thought the nude was crap, truncated and off-kilter, but he was touched by Drewe's kindness. They shook hands, and Myatt drove off into the night.

THE FINE ART OF PROVENANCE

On a cloudy morning late in March 1990, Myatt stood at his easel ironing out the compositional kinks in his latest piece, a pair of abstract Bissière panels that looked like a flock of birds on a vine. With a clean brush, he softened the paintings' odd tonal glow. Before they were fully dry, he placed them carefully in the back-seat of the Rover and set off for Drewe's house.

As he drove south to London he had a feeling of relief and well-being. Over the past few months the enterprise had become a relative breeze. Drewe's confidence was contagious, and Myatt was now convinced that their chances of getting caught were slim. Even though Drewe had not yet sold the disastrous Footless Woman, he had accepted each subsequent painting with enthusiasm and reported it sold.

It was becoming clear to Myatt that dealers routinely bought second-rate works not because of some hidden or mysterious aesthetic quality but simply because of the signature on the canvas.

Every artist could have an occasional bad day, he thought, even masters like Giacometti. Myatt had seen several poorly executed originals during his research, evidence that artists weren't always firing on all cylinders. And yet those works had sold in the tens and sometimes hundreds of thousands of pounds. Myatt felt that many of his own copies were as good as, if not better than, the genuine article. There was something unjust in the fact that bad Giacomettis and Bissières were always infinitely more desirable than his perfectly adequate fakes. Although he had painted a number of Giacomettis, Bissières, Chagalls, and Le Corbusiers that he knew were abysmally bad, Drewe had nevertheless sold them at bargain-basement prices. Whatever respect and trust Myatt had felt toward the art world had evaporated. Even the most prestigious dealers could be swayed by a bargain or a dubious certificate of authenticity. He wondered how many fakes he'd seen in galleries and catalogs and museums over his lifetime. He couldn't trust his own eyes anymore.

In the first year of the scam he'd had qualms about compromising his moral code. After all, he was a practicing Catholic, a charitable man, and a father. Now, after a track record of successful sales, he was fairly comfortable in his role as a criminal forger. What he was doing didn't really constitute a crime. If a collector believed one of his pieces was an authentic Braque, why spoil the thrill? And from a broader perspective, surely what he and Drewe were engaged in was small potatoes in the history of fakery.

When Myatt walked into Drewe's home with the new Bissières, the professor was standing in front of his dining room table, which was covered with piles of documents. Drewe seemed as gleeful as if he had just won the lottery. Sweeping his hand over the table, he told Myatt that his lunches with the ICA director had paid off.

"Take a good look," he said.

Myatt read in bursts. It was an astonishing collection: handwritten letters from Picasso and Giacometti; old invitations to lunch with

Buckminster Fuller; some of Ben Nicholson's lecture notes; a letter to Nicholson from the architect Sir John Summerson, whose books Myatt had studied in art school.

Drewe beamed as Myatt picked up one letter after another, then a group of sketches by the French artist Jean Dubuffet and some exhibition catalogs from the late 1940s and the 1950s. There were stacks of gallery ledger pages listing artists with links to the ICA, along with blank ledger pages and gallery stationery of all kinds. There was a steamy note from Dubuffet to a female assistant at the ICA, which Myatt held delicately in his hand, wondering what effect it had had on its recipient.

Priceless, he thought. An intimate history of London's modern art scene, the kind of stuff you left to your grandchildren. He was amazed by the size of the haul, and he could see more documents poking out of Drewe's briefcase. Clearly, the professor had become a frequent visitor to the ICA archives.

How did someone walk out of a major British institution, five hundred yards from Buckingham Palace, with its entire history in hand?

Myatt wasn't sure whether he was appalled by the lack of care or terrified. The full significance of Drewe's scheme was becoming clear to him. For nearly two years now he had been forging works by the same group of modern artists whose histories Drewe had just extracted from the ICA. With the correspondence between Nicholson's collectors and the ICA, with the letters and receipts from Erica Brausen (Giacometti's daring dealer), and all the rest of it, Drewe would have enough material to sweep any potential buyer off his feet.

"I'm doing the ICA a favor getting all this stuff out of there," he told Myatt, explaining that the documents had been left to rot in boxes in an unventilated room. Now he had saved them.

The weak afternoon light was fading. It was time for Myatt to return to Staffordshire and pick the children up from the babysitter.

First he and Drewe would have to decide which of the artists to focus on next.

Myatt wanted a break from Giacometti and Bissière, and once they had gone through the ICA material again they decided to give Ben Nicholson a shot. Myatt knew his work well, having seen dozens of his still lifes and geometrical landscapes. There was a gallery not far from his home that specialized in Nicholson, and he could study the painter's technique there, at his leisure. He had always thought of Nicholson's work as clear, bright, and not terribly intricate, so the job would require scant emotional involvement, unlike the Giacomettis. He could probably whip out a Nicholson in an afternoon.

As Myatt was leaving, Drewe pulled out one of the original ICA documents, a letter from Picasso to the photographer and journalist Lee Miller, an American beauty who had been on the cover of *Vogue* before becoming a war photographer and chronicler of the surrealists. Drewe put the letter on the table next to a copy of a magazine cover shot of Miller and asked Myatt to draw a quick sketch of her next to Picasso's signature. With a few bold strokes, Myatt captured Miller's dark eyebrows and her slightly mournful gaze. He had just upped the value of the letter by several thousand pounds.

Myatt capped his pen and walked out the door.

D rewe was spending a lot of time at his mother's home in Burgess Hill in Sussex. He had always been close to her, and she in turn apparently regarded him as her golden boy who could do no wrong. For the last few months he'd been using her house as his own private office, a mail drop for his various aliases and front companies.

Today he sat down at an old manual typewriter and began to type out a letter from "John Cockett, director of Cybernetic Systems International Inc.," to the National Art Library at the Victoria and Albert

Museum. In the letter, "Cockett" vouched for John Drewe, who had applied the week before for a reader's ticket to the library's special collections archive, which contained the records of nearly every major British art gallery from the 1940s and 1950s, including correspondence, catalogs, and sales ledgers.

"I have known Dr. Drewe since 1974, when he participated in a series of programs on BBC Television," he wrote. He went on to praise Drewe as a physicist "who has undertaken some outstanding experimental research in electromagnetism."

Cockett claimed to have served as a character reference for Drewe once before, when Drewe asked to examine some private documents relating to Nicolas de Staël. "I understand that the correspondence is of great interest to art historians because it gives an insight into the artist's problems during the years immediately before his suicide." Here Drewe was displaying his expertise in the con man's traditional diversionary tactic of changing the subject and deflecting attention from the original question.

Finally, and most conclusively, Cockett called Drewe "a man of integrity and ability who will show the appropriate consideration when handling your valuable material."

Drewe posted the letter to the V&A and waited for his reader's ticket.

Then he got in touch with the Tate. An idea had begun to take shape, one that would turn his scheme into an art fraud on a much grander scale, and the Tate was key. If at that moment Drewe had thought about the history of the venerable museum, he would have smiled. The irony was not lost on him that the Tate sat on the site of what had once been one of Europe's grimmest prisons, Millbank Penitentiary, a gloomy Dickensian cesspit with a three-mile-long maze of passages. The convicts had been forced to serve their sentences making shoes and mailbags in silence. If Drewe had lived in the nineteenth century, he might well have ended up there. The building was closed in

1890 and razed in 1892. A few years later an industrialist named Henry Tate, who had made his fortune in sugar cubes, funded the impressive piece of architecture that opened in 1897 to house his collection of British art, which he had donated to the government.

Over the years the museum became home to some of the country's best-known artworks, including Henry Turner's luminous *Golden Bough;* William Blake's portrait of Isaac Newton; canine masterpieces such as Hogarth's *Self-Portrait with Dog* and Gainsborough's *Pomeranian Bitch and Puppy;* and Stanley Spencer's weird and wonderful *The Resurrection, Cookham,* a tableau mort showing a village of dead Englishmen squinting into the sunlight as they emerge from their graves. By the time the Tate began to add daring contemporary works by twentieth-century iconoclasts such as Duchamp and Francis Bacon, it was one of the world's most famous art institutions.

For the past few months Drewe had been masquerading as a rich scientist with a large collection of modern art, a front that was now well documented in Sotheby's ICA benefit auction catalog, whose acknowledgment page thanked Drewe's company, Norseland, for its "generous donation" of a Giacometti and a Le Corbusier. He had also begun his campaign of wining and dining the Tate's senior staff, many of whom had been his guests at Claridge's, where Drewe was a regular and was treated like royalty. Sometimes he came in early and sat alone, surrounded by half a dozen waiters, a sommelier, and a maître d'. From an adjacent table one might have thought he was a cultural anthropologist doing fieldwork on the aristocracy, a kind of Lévi-Strauss of the Limoges set.

Drewe believed that by now Sarah Fox-Pitt in particular had come to see him as an ally. At every opportunity he'd appealed to her enthusiasm for augmenting the Tate archives. He'd offered himself up as a middleman who could connect the Tate with important documentary records. He'd said he had evidence as to the whereabouts of some intriguing wayward papers, and he'd shown Fox-Pitt a handwritten

letter purportedly from Bill McAlister, who had since left the ICA. The letter, which Drewe had forged, described the location of a rich cache of art-related archives that had been moved to New York. Drewe proposed to retrieve them. In addition, he'd hinted at possible donations and talked compellingly about his project of putting together a computer database that would chronicle the history of contemporary British art.

Fox-Pitt had done her part to sustain the relationship with Drewe, calling him at home and inviting him to the Tate to discuss future plans. Throughout this courtship dance, despite her vaunted powers of observation, Drewe managed to impress his way into the upper echelons at the Tate. Evidently Drewe could spot psychic vulnerability much better than Fox-Pitt could spot a poseur, and he had gradually worn down her caution. He knew just the right moment to weave a little fact into the fiction, whether it was the name of a recent acquaintance such as Jane Drew or the mention of his company in the ICA catalog. Now it was time to make his move.

The two Bissières Myatt had dropped off the day before seemed perfect for the Tate: lively, colorful, pleasing to the eye. Drewe could easily whip up a credible provenance with the material he already had. He called the Tate and made the offer, and within days the paintings had been delivered to the museum.

Drewe called Myatt with the good news that the gatekeepers of the temple on the Thames were arranging a reception in their honor. He said he'd made a substantial donation to the Tate and that director Nicholas Serota and other top staffers would be in attendance. He emphasized the importance of the reception, which would give him the credibility he needed to gain access to the museum's research room. He wanted his personal art historian there to cover him in case a Tate official asked a difficult question.

"Put your best suit on," he said. "This is going to be the start of a lovely relationship."

Myatt cringed. Surely he would stumble. Never in a million years would he be able to field queries from the Tate's exalted experts. His botched answers would expose him for what he had allowed himself to become—a fake.

Drewe explained his plan: Once inside the archives he would alter the records and seed them with his own alternate history, a "reconstructed" chronicle that would include the names of real and invented collectors and would revolve around the works he had commissioned from Myatt.

The painter was dubious and apprehensive. How could Drewe possibly get away with it? How would he get past security?

"Don't worry, John," said Drewe. "Archives are on the lookout for people taking material out, not for people putting it in."

Myatt needn't have feared being cross-examined at the reception. No one in the room was aware of his discomfort. He sipped his tea in silence, and looked at the people seated around the grand oak table. Myatt had nothing to offer them. He was sitting among some of the most influential members of the art world, sophisticated and intelligent, and they had enough to talk about with Drewe, who seemed as excited about the potentials of this partnership with the Tate as they did. All eyes were on Drewe—until the moment when the two conservators came in with the Bissière panels. Myatt nearly spilled his tea.

Had he known that Drewe intended to donate *these* two pieces, he would at least have used authentic French paint from the 1950s. Technically they were quite good, he thought, but he had done them on fiberboard, an artificial wood made of sawdust, with the usual everyday house paint. The two panels of *Spring Woodland,* purportedly painted some forty years earlier, looked fresh, bright, and brand new. Myatt knew that any respectable art institution, and certainly the Tate, would inspect them closely before officially taking them into its collection.

He gripped his chair, imagining that he could detect the faint smell of the varnish Drewe had sprayed on them. He looked over at the professor. Drewe seemed oblivious.

Once the reception was over the paintings were carried down to the conservation department. Myatt was sure that if the conservators so much as touched the canvas with a fine brush, the paint would give way and the game would be up.

As the Tate brass escorted Drewe and Myatt downstairs to the gallery, one of the curators pointed at a wall. "This is where we'll hang these two wonderful pieces," he said.

Placing a work at the Tate was a remarkable achievement for any artist—forger or not—but Myatt could see only one possible end to what had transpired. He had survived many low points in his past, but none quite as devastating as this one was shaping up to be. Surely he would land in prison.

Outside, Myatt dropped his usual deference toward Drewe and exploded. "There's no way they're going to look at those panels and think they're oils from the fifties. You've got to get them back!"

Drewe protested that if he asked for the paintings back, he would suffer a terrible loss of credibility. All the effort he'd put into cultivating the confidence of the Tate's senior staff would be for naught. By this time Drewe knew quite a bit about the authentication of artworks and should have recognized that Myatt's fears were well-grounded, but his arrogance and his faith in his phony provenances may have led him to believe that the Tate would never even question whether the Bissières were genuine.

In any case, he understood that he had to appease Myatt, who seemed close to coming apart. His investment in Myatt was greater than his investment in the Tate, so he assured his partner that he would get the paintings back. In exchange, though, they would have to make a sizable monetary gift of £20,000 to the Tate. Drewe managed to convince Myatt to pay half of it.

The following day Drewe returned to the Tate to withdraw *Spring Woodland*. There was a problem with the provenance, he said, questions having to do with the previous owners. The details were vague, but the long and the short of it was that he did not want to jeopardize his relationship with the museum through even the slightest suggestion of impropriety. In place of the Bissière panels, he was prepared to offer a sizable cash donation to the Tate's archives.

Drewe was as good as his word. Within days the Tate received a check for £20,000 to help catalog the archives, along with a promise of £500,000 more to come. With this gift Drewe established himself as a respected donor, a citizen above suspicion to whom the doors of the Tate's archives would always be open. While the two Bissière fakes never found their way into the artist's canon—Myatt took them home, built a bonfire in his backyard, and burned them—dozens of Myatt's forgeries would. The history of art and the cherished integrity of one of the world's great museums were about to be irreparably compromised.

FULL SPEED AHEAD

J ohn Drewe is the most amazing man," said Sarah Fox-Pitt. "Did you know his father invented the atom bomb?"

Jennifer Booth thought it best to stifle her laughter. Fox-Pitt had been moved up to the Acquisitions Department after more than a decade as head of the Tate archives, and she was Booth's senior, but she was much too impressed by Drewe, in Booth's opinion. Booth had recently become the new head of the archives, and the more she learned about the professor, the warier she became of him. She knew he had donated a pair of Bissières to the Tate, and that the conservators had almost immediately become suspicious of them. Before they could ask him for a certificate of authenticity from the artist's estate, he had withdrawn them. In their stead, he had donated £20,000 to the archives, and Fox-Pitt had just told her that he'd promised half a million more.

After Fox-Pitt left her office, Booth looked up Drewe's application to visit the archives and discovered that he had been in a few times since

his donation but had never filled out a formal application. The prerequisite apparently had been waived.

Curious, she thought.

Several days later, Drewe came in again, checked his coat and bag at security, and walked into the research room with his legal pad and a pencil. Booth was on duty at the invigilator's desk, where all visitors were screened, and she asked him to fill out an application and provide a summary of the research he was planning to do. It was standard procedure, she said. The Tate's research room could only accommodate six people at a time, and it was generally restricted to scholars and postgraduate students who were vetted carefully.

On the application form Drewe said he was chairman of Norseland Industries and research director for a laboratory that developed marine systems. He was investigating the "collaboration between Hanover Gallery, London, and the ICA, particularly 1951–7" and might occasionally bring in two other researchers to help him.

Booth decided not to ask him for references. It seemed inappropriate at this juncture, now that his check had been banked. She assumed that the notoriously vigilant Fox-Pitt had checked him out thoroughly before giving him her enthusiastic endorsement, and she didn't want to jeopardize any future donation.

Drewe was very polite when he asked Booth if she wouldn't mind bringing out one of the Hanover's photograph albums, a pictorial record of the works that had passed through the gallery during its twenty-five years of operation. One of its most important artists was Giacometti.

Drewe sat at the dining room table in his house cutting and pasting. He had taken a photograph of Myatt's Footless Woman and titled it *Standing Nude, 1954*. He kept his titles as generic as possible, as many of the modern masters had done in the forties and fifties. From

his stash of documents, he chose an old gallery receipt recording the sale of a genuine Giacometti nude, then fashioned a new one on 1950s-era paper, indicating that the work had been sold to its current owner, a private collector named Peter Harris, in 1957. To reinforce the illusion, he forged additional pieces of provenance and added the names of other collectors and acquaintances, both imaginary and real, to the gallery ledger pages. As the coup de grâce, he took original 1950s gallery exhibition catalogs—sparsely illustrated black-and-white booklets, for the most part—scanned them into a computer, and inserted photographs of the Footless Woman and other Myatt forgeries.

He was tidy and methodical, lining up ledgers, catalogs, scribbled notes he'd found on the backs of documents—whatever best suited his purposes—to turn out brand-new provenances. He cut, pasted, and photocopied until he had produced impeccable new documents. When he couldn't find an appropriate letter or receipt, he forged one using one of his old typewriters, then pasted in a signature he'd culled from his ICA letters from dealers and collectors. He was quickly becoming a master collagist.

On his next visit to the Tate research room, he took a seat in the back. It was a narrow space, not an ideal setup from a security standpoint, because the invigilator's view was often blocked by the researcher sitting in front. Now and then Drewe looked up from his work to scan the room, which was often left unattended for a few minutes while the invigilator went into the stacks to pull out a book or a document. At an opportune moment, Drewe flipped through his notepad and pulled out a sheet of heavy black paper, the kind used in old-fashioned photograph albums. He inserted the page, with its two binder holes, into one of the Hanover albums, which now contained a photograph of Giacometti's *Standing Nude, 1954,* an awkward figure with its feet hidden by a table in the foreground.

Drewe returned the album to the front desk, thanked the invigilator, and left.

For five or six hours a day, Myatt immersed himself completely in his work. Over the months since the reception, the Sugnall farmhouse had become a factory.

Finally Myatt could paint in broad daylight. The old panic that had returned after the Tate reception and driven him to consign *Spring Woodland* to the flames was a thing of the past again. Because Drewe was manufacturing solid provenances for his paintings, he could relax. He no longer worried about producing the "perfect" forgery, because he realized that when the documentation was good enough, dealers were willing to overlook aesthetic flaws. If the provenance could be verified at the Tate, the V&A, or the British Council archives, all the better.

He was now forging works primarily in the style of Braque, Chagall, Nicholson, and Dubuffet, and each morning he would sit up in bed and say to himself, "Today is a Chagall day" or "Today is Braque day." Each artist's style presented its own technical challenge, but Myatt was painting with a clarity he'd rarely enjoyed since his music career collapsed, wrapping up Chagalls in five days and Nicholsons in a matter of hours.

With his share of the profits, and for the first time in a decade, he could finally afford the small luxuries of life. Instead of the few hundred pounds a painting he got from Drewe when they started out, he was now earning a substantial commission. Drewe was selling the paintings as fast as Myatt could produce them, and there were new shoes for the kids, trips to the cinema, and the occasional nanny.

Ironically, even though he was up to no good, he felt less like the town pariah and more like a respected member of the community. His family wasn't starving, and life was good. With his extra money, he began to donate to charity again. He even convinced a hesitant Drewe to set up an art program for students and fund the revival of mystery plays—medieval dramas based on stories from the Bible—at the Lichfield Cathedral. It would be great publicity for Norseland, he told

Drewe. The professor agreed to add his donation to Myatt's next commission.

With Drewe as his "dealer" and principal cheerleader, Myatt felt like an artist again, "a man of importance." He felt the same intensity, the same joy in painting he had experienced as a young artist. More important, he was making a living at it, and that made all the difference.

To match his phony provenances, Drewe was now showing Myatt what to fake. He sent art books, pieces of canvas of the appropriate size and age, and endpapers from old volumes. There was never a note or a return address. Myatt felt a thrill each time a package arrived from Drewe, as if he were James Bond receiving instructions from M.

One afternoon in October 1991 he drove down to Golders Green with his latest work, a Le Corbusier of a voluptuous nude standing with her hands clasped behind her head.

"That's a lovely restoration," said Drewe, who had taken to using the term to describe Myatt's forgeries. Today it seemed particularly apt, because Myatt had painted the Le Corbusier over what had once been a nice old canvas of a river landscape. His father had bought the piece at a yard sale in the 1940s, but it had languished in the attic ever since. The canvas was from Le Corbusier's time, so Myatt scraped off the river view and replaced it with his own composition. It was a common forger's trick.

Drewe invited Myatt to dine at the Spaniard's Inn, the Hampstead pub where they'd met when Myatt delivered the Footless Woman. There was business to attend to, Drewe said. After they sat down he handed Myatt an envelope containing several thousand pounds in cash.

Myatt had never once questioned him about what had sold or how much money had come in. He trusted Drewe and was grateful to him. Their relationship had become a full partnership, with Myatt suggesting which galleries Drewe should approach and helping him decide which fakes best complemented the provenances he had so thoughtfully taken off the ICA's hands. For his part, the professor encouraged Myatt

to keep a record of their transactions. "Put your business plans in writing and mail them to me," he said. It would be years before Myatt fully understood why Drewe was so keen to leave a paper trail.

Drewe finished his drink and pulled out a Sotheby's catalog for the first part of a two-part auction of impressionist and modern works scheduled for early December 1991. Inside was a full-color reproduction of Myatt's hard-fought Giacometti. The Footless Woman was now titled *Standing Nude, 1954,* and was listed next to three other Giacomettis scheduled for auction later that year. Despite the awkward table hiding the botched feet, the piece was valued at £180,000 to £250,000.

Myatt noted that the other Giacomettis in the catalog were not his, and very likely authentic. It all felt a little unreal: Officially, his work had now been deemed as good as the master's, and his talent was finally getting its due.

"People were leaping up and down buying my works," he recalled. "I was secretly pleased that my little babies were out there."

The nude still nagged him, especially the egregious amputation of her legs below the knee. He promised himself that his next Giacometti would be closer to the real thing. That night, back at home, he dove into his art books and began flipping through the pages for inspiration.

A few days later Myatt had a very good new Giacometti. He'd worked hard and stayed focused and come close to capturing the master's essence. Nevertheless, he stopped before he was quite done. It was best to leave a work unfinished and a few problems unresolved. There was no such thing as a perfect painting. Perfection gave you away every time.

Myatt left the canvas on the easel and went to bed. In the morning he made himself a strong cup of coffee and took it into the living room. He glanced at the new standing nude and felt a rush of pleasure and relief.

"Not bad," he thought.

On a scale of one to ten, he had produced only a handful of sevens and perhaps a single eight. This nude, without a doubt, was a ten—his finest achievement. Ironically, it would also be his undoing.

Paul Redfern, a burly freelance writer with a full woodsman's beard, sat on his stool at the Lamb, a Bloomsbury bar, waiting for his friend Peter Harris, who was going to introduce him to a Professor Drewe, head of a company called Norseland Industries.

When Drewe and Harris arrived, and they were all settled with their drinks, the professor told the writer that Norseland wanted a prospectus on the cultural activities it was sponsoring, which included theater events, an arts center, and an exchange program between Gloucestershire College of Arts and Technology and an art school in Leningrad. Redfern listened as Drewe told him about Norseland's £20,000 donation to the Tate archives and its intention to raise a further £500,000. Drewe wanted the prospectus sent to the auction houses so that they could see the full extent of the company's commitment to the arts. Norseland was about to place three works on the block to help fund its programs, and Drewe was hoping that the auction houses would lower their standard commission.

Would Redfern be interested in representing Norseland? In exchange for writing the prospectus and setting up appointments with the auctioneers, he would receive a commission on whatever sold.

Redfern agreed and went to work. He made contact with Christie's and Sotheby's and invited their representatives to see the three works at Norseland's office in the upscale neighborhood around Bedford Square, where Drewe had rented a small, well-appointed space with a nice view, hired a secretary, supplied vases of fresh flowers, and hung half a dozen paintings on the walls.

Redfern walked the auctioneers through the office and gave them copies of transparencies and some of the provenance documents Drewe had assembled.

A few weeks later the Sotheby's catalog for Part 2 of its December 1991 auction included two Nicholson still lifes, dated 1946 and 1955, and a Le Corbusier entitled *Femme Nue*. All three were being offered "on behalf of the Lichfield Mystery Plays." All three sold.

Meanwhile, Danny Berger was also doing very well for himself. He had made several sales abroad through a runner and art consultant named Stuart Berkeley, who had clients in Canada, New York, and Japan. When Berger gave the ponytailed runner a photograph of a Giacometti titled *Portrait of a Woman*, depicting the upper torso and face of the artist's wife, Annette, Berkeley quickly reported a nibble from a private New York dealer named Sheila Maskell.

Maskell had shown a photograph of the Giacometti to Dominic Taglialatella, a dealer with Avanti Galleries on Madison Avenue. She told him the painting was owned by a John Catch, who was selling it through a group of "very substantial" Londoners. The price was $325,000. Taglialatella had a very good client in Sweden who would probably be interested, and a few days later he and Maskell were on a plane to London to see the work.

On Drewe's instructions, Berger had rented a small warehouse opposite the Golders Green tube station, a slightly more impressive showcase than Berger's garage. Here Drewe had hung *Portrait of a Woman*, along with a handful of other works that looked as if they had been undisturbed for years. Now, as Maskell, Berkeley, and Berger looked on, Taglialatella eyed the portrait and blew some dust off the canvas. They all stood to gain thousands of pounds in commissions, and when Taglialatella agreed to the price, everyone shook hands.

As Taglialatella flew to Sweden to deliver the painting to his client, the wire transfer went into Maskell's account without a hitch, and the following day Berkeley and Berger got their cut. Each was unaware they had just handled a fake, and the lion's share of the money went to Drewe via Norseland.

The scam had taken on a life of its own.

11

AFTER GIACOMETTI

On a narrow cobblestone alley in the Latin Quarter of Paris, in one of three sixteenth-century courtyards known collectively as the Cour de Rohan, Mary Lisa Palmer managed the affairs of the Giacometti Association from an office on the top floor of an old three-story building. To the American eye the secluded Cour was so quintessentially Parisian that it was used as a backdrop for Vincente Minnelli's Hollywood musical *Gigi*. In the twenties, the photographer Eugène Atget snapped a series of iconic pictures of the courtyard with an enormous wooden bellows camera. The writer Georges Bataille threw parties here for Sartre, Simone de Beauvoir, and Albert Camus, and the artists Balthus (a good friend of Giacometti's) and David Hockney set up their easels in the Cour.

Nothing had changed much in the intervening years. Sprigs of rosemary still fought their way up through the cobblestones to the light,

and wild grapevines climbed the brick facades. What attracted Palmer most about the courtyard was its solitude. Palmer, the longtime director of the association and personal assistant to Giacometti's widow, Annette, appreciated the short distance that separated her from the bustle and flow of the city. Here she could focus on Alberto Giacometti's legacy and defend it from the vultures and forgers that had hovered since his death.

On this November morning Palmer was leafing through the latest Sotheby's catalog when she spotted something unusual. The auction house routinely sent her its glossy publications with the understanding that if she or Annette came across a dubious Giacometti, Sotheby's would hear about it.

The new catalog heralded an upcoming auction of impressionist and modern pieces featuring four works by the Swiss artist: a sculpture of a woman, a bust of the artist's brother Diego, a portrait of one of Giacometti's mistresses, and a fourth piece, lot number 48, a painting entitled *Standing Nude*.

The painting caught Palmer's eye. It was a phony.

Underneath the photograph of *Standing Nude* was a thumbnail sketch of the provenance: It had purportedly been painted in 1954 and bought by Peter Watson, a cofounder of the ICA. Watson, in turn, had sold it to the Hanover Gallery, which had then sold it to the Obelisk Gallery. Finally, in 1957, it had been bought by Peter Harris, a private collector. The piece was estimated at £180,000 to £250,000.

The provenance seemed impressive enough. The Hanover had been a prestigious gallery until it closed down, and Watson had been a wealthy collector and benefactor until he mysteriously drowned in his bathtub in 1956. It was rumored that he was murdered by a rich American lover, Norman Fowler, who was also found dead in a bathtub, some fourteen years later.

Despite the *Standing Nude*'s persuasive documentation, Palmer

remained skeptical. When she showed the catalog to Annette Giacometti, with whom she had worked for nearly two decades, Annette was struck by the odd-looking table in the foreground, which sliced the nude's lower legs off and shattered the composition. Whoever painted the picture, she thought, had probably bungled the feet, then tried to cover up the mess with a piece of furniture.

Palmer called Sotheby's, told them she had problems with the piece, and asked for copies of the provenance documents. Several days later she received a package from the auction house that included a receipt from the Hanover Gallery and another from the lesser known Obelisk Gallery, which had supposedly sold the work to Peter Harris for £150.

Palmer wasn't sure what to make of it all, but her instinct told her that the piece was wrong, and her experience had taught her that instinct was her greatest ally. The Metropolitan Museum of Art's former director Thomas Hoving, a notable fake-buster, would have agreed. He once described "that vague tug at the brain telling you that something is not quite right," a feeling often ignored by art dealers, collectors, and curators, particularly when it failed to harmonize with a deal.

> You've been waiting for that Degas pastel for years; it's the one that will flesh out your heady collection of the master. Get it quick, before the competition hears about it! You've been given a special two-day window of opportunity to make up your mind. You've simply got to snag it. . . . You know you should be calm, but this is a sure thing and you are dying to own it. Go for it.*

*Thomas Hoving. *False Impressions: The Hunt for Big-Time Art Fakes.* New York: Simon and Schuster, 1986.

Palmer had no financial stake in the transaction. Her job was to protect Giacometti's legacy, and she was determined to stop the sale of the piece. The photograph in the catalog was not sufficient proof of forgery, and the association had a standing policy of not judging a work's authenticity on the basis of a reproduction, so she called Sotheby's and made an appointment to see the Footless Woman.

Palmer flew to London and took a taxi to New Bond Street, a West End shopping thoroughfare that had been fashionable since the eighteenth century. At Sotheby's, she stepped into the lobby and went up the well-worn staircase to the viewing room, where she asked to see the Giacometti nude.

What a mess, she thought. It was definitely a fake, not even a nice try.

There were a number of giveaways, not least of which was the table in the foreground. In addition, the nude was uncharacteristically lifeless, with a series of aimless, floating brushstrokes in the background. Giacometti often painted a glimpse of his studio behind the model, with a row of canvases stacked up against the wall. Here the forger had laid in flat, abstract lines and applied a heavy coat of varnish, something Giacometti would never have done.

Palmer expressed her concerns to a Sotheby's representative, who argued that the previous owner might have added the varnish himself. He insisted that Sotheby's had done its homework. Perhaps this wasn't the best Giacometti, he said, but it was a Giacometti nonetheless. Sotheby's had performed due diligence and had found the provenance impeccable. They had also examined a photograph of the painting in the files of the now defunct Hanover Gallery. The files were stored at the Tate archives, and Palmer was urged to go and take a look at them for herself.

Palmer's infallible eye had rarely been questioned so she was slightly taken aback, but she had no intention of backing off. Since the auction

was only a few days away, she decided to stay in London and do a little footwork. She hailed a cab and asked the driver to take her to the Tate. En route she reviewed in her mind Giacometti's relationship with the Hanover.

The gallery, which had dealt with Giacometti for years, had never been a huge financial success, but it had been one of Europe's most influential showcases of contemporary art. His widow, Annette, still had occasional dealings with its founder, Erica Brausen, who had set out in the late 1940s to challenge conventional thinking. Now in her eighties, Brausen had been as fearless in her personal life as she was about the art she supported. She fled Germany for Paris in the 1930s, ran a bar frequented by artists and writers, and used her contacts with the U.S. Navy to help her Jewish and socialist friends escape from Europe during the Spanish Civil War. She herself had fled in a fishing boat and arrived penniless in London at the start of World War II. Then she began organizing small exhibitions.

It was not an easy road: Brausen was a woman in a male-dominated business, a German in a Germanophobic society, and an open lesbian (her lover was Catherine "Toto" Koopman, a former Chanel model and film actress). At the Hanover, which she opened in 1949, she repeatedly went out on a limb for unconventional artists such as Francis Bacon and Lucien Freud. Her gallery later foundered, and went under in 1973, but during its quarter century in existence Brausen had kept meticulous records, logging each sale, purchase, loan, and commission in her ledger books. These were now stored in the Tate archives.

Palmer paid the cabbie, walked into the museum, and introduced herself to the head archivist, Jennifer Booth. She asked to see the Hanover photograph albums, the visual record of all the artwork that had passed through the gallery. This old-fashioned two-ring binder was about the size of a school composition book, and its heavy black pages were brittle and stiff with age.

Palmer flipped through the relevant album until she found the Footless Woman. The details on the label below the photograph coincided with those in the Sotheby's catalog:

Nude 1954
By Alberto Giacometti G67/11
Oil on canvas: 23-7/8 × 17-7/8 ins
Signed lower right.
Sold June 16th 1957

She did not, even for a moment, consider the possibility that her judgment was off. She looked closely at the black-and-white photograph. To her trained eye, both the image and the contrast seemed a little too sharp. She had spent the past seventeen years looking at pictures of Giacomettis, and she was sure this one had been shot fairly recently.

She reminded herself of her own mantra: Where there's one fake there's another.

She turned the pages of the album until she came across a second "Giacometti," a portrait of a woman from the waist up. It was as bogus as the first one. How on earth had the two pictures ended up in the Tate's files?

Palmer doubted that Brausen would have fallen for a fake. The dealer's eye was too good, and she had bought directly from the galleries that represented Giacometti. Palmer asked to see the Hanover's sales ledgers and found the Sotheby's nude. It had the same reference number, G67/11, and the details were the same as those in the Sotheby's catalog. The ledgers also listed ICA cofounder Peter Watson, who had purportedly sold the nude to the Hanover, as the owner of three other Giacomettis. Palmer knew nearly every Giacometti in the world, and was sure Watson had never owned that many of the artist's works.

Were those other Giacomettis fakes too?

Palmer studied the ledgers, loose-leaf leather volumes held together by a thong. They reminded her of nineteenth-century accounting books. It would be easy enough to slip a page out and then replace it. Palmer scrutinized Watson's name, which had been written alongside the entries for the four works. The ink appeared to be fresh. Then she examined the entry for the Hanover's sale of the Sotheby's nude. Here a name had been scratched out and replaced with the words "R.D.S. May, Obelisk Gallery." Again the ink looked fresh.

In the archivist's parlance, the files had been contaminated.

Palmer asked Booth for the Hanover daybooks, which tracked the movement of paintings in and out of the gallery. She found a listing for G67/11, but here it was a painting that had been done in 1951. The Sotheby's catalog listed the *Standing Nude* as having been painted in 1954. The forger was off by three years. He probably hadn't bothered to doctor the daybooks, which were hard to decipher, and thus the least likely of records a dealer would consult to verify a work's provenance.

Palmer was now certain that whoever was behind the Sotheby's nude had slipped a photograph of it into the Hanover album and falsified the sales ledger. She resisted going through all of the Hanover records to check the other possible forgeries. Her immediate priority was to keep the nude from the auction block.

No doubt the Tate would not take kindly to the suggestion that its security had been breached, and Palmer still lacked absolute proof. Nevertheless, she took Booth aside, told her what she suspected, and asked for copies of the photographs of every Giacometti in the Hanover files, and of all the Hanover records that referred to Giacometti transactions. In addition, she asked Booth to check the backs of the two suspicious Giacometti photographs she'd seen and find out if they'd been stamped by the Hanover Gallery's official photographer.

To Palmer's surprise, the archivist was more than willing to accommodate her.

. . .

J ennifer Booth had been watching Professor Drewe for the better part
of a year. There was something odd about him, and she felt uneasy
whenever he came into the reading room. He dressed beautifully and
spent hours at the archives, but she sensed that behind his refined and
articulate exterior he was out of his element, not quite sure how to
behave. It wasn't that he lacked confidence but that he could be so an-
noyingly obsequious.

"I'm so sorry to be a nuisance, but could you be terribly kind and
get this material?" he'd ask in a stage whisper, ostensibly to avoid dis-
tracting the other researchers. Instead, he only drew attention to his
exaggerated mannerisms. Her staff had complained; they disliked him
and preferred not to be on duty when he was around.

Booth's regulars were serious researchers who didn't think twice
about sending her staff into the darkest corners of the stacks. By con-
trast, Drewe made an unctuous ritual of it when a simple thank-you
would have sufficed. On the other hand, while the archive had its share
of nuisance researchers on fishing expeditions, Drewe seemed to know
exactly what he was after.

After her disquieting conversation with Mary Lisa Palmer, Booth
decided it was time to sound the alarm. She walked into the office of
her supervisor, the head of the library and archives, Beth Houghton,
and told her about Palmer's visit. She said Palmer suspected that the
archives had been compromised, and that they contained photographs
of fake paintings.

Booth told Houghton that she too was suspicious. "I think Professor
Drewe is involved in something here, but I'm not quite sure what it is,"
she said. "I suggest we open a formal investigation."

Houghton stared at her. "Don't be ridiculous," she told Booth.
"He's a benefactor. He's given the archive £20,000, and the Tate can't
risk alienating him on nothing more than a hunch."

Booth was undeterred. She was guided by a code of ethics and considered herself both a scientist and a keeper of memory. She had spent her entire career safeguarding historical documents, and she could still remember the excitement and wonder of the first few years. The first time she had examined a three-hundred-year-old document, she'd felt in its delicate confection of old ink and paper an immediate and tactile connection to history.

Booth went to the stacks, pulled out the Hanover album, and began making copies for Palmer.

A SINISTER MESSAGE

From her office, Mary Lisa Palmer called Sotheby's and said she had spent hours at the Tate archives examining the records of the 1954 nude. It was her considered opinion that something was wrong with the photograph of the painting. She had no doubt whatsoever that the painting was a fake. Then Annette sent a fax to Sotheby's demanding it hold off the sale and send the nude to Paris.

The anonymous owner, however, refused to grant Sotheby's authority, and the work was never sent. The auction house still thought the provenance was solid, but Palmer wouldn't budge. The provenance material was as phony as the painting, she thought.

Sotheby's cited two experts who believed the work was authentic. One was the London art dealer Thomas Gibson, who had bought several Giacomettis from Annette in the past. The other was Erica Brausen.

Palmer telephoned the eighty-three-year-old Brausen, who sounded

weak and out of sorts. She had been down with the flu for several weeks and couldn't remember the details of the sale, but she thought it was possible she'd bought the painting from Watson.

"The provenance is good," she said. "If it's in my record, then it's right."

Palmer was hoping that Brausen would look at the painting, but the old woman's breathing sounded labored and she seemed too ill to travel. (She would die the next year.) Palmer thanked her, rang off, and called Thomas Gibson.

"The painting's a bit fishy, but the provenance is respectable enough," he told her.

"What about the varnish?" Palmer asked.

"Shouldn't be put off by that," he said, adding that aesthetic gaps and failures of judgment might exist in any given piece. While this certainly wasn't the greatest work, Gibson thought the provenance was solid.

"Anyone can fake a document," Palmer argued.

"Granted," said Gibson. "But if someone wanted to fake a Giacometti, why choose such an unattractive composition?"

Palmer asked whether he had approved the piece for Sotheby's, as the auction house had claimed.

"They have a vivid imagination," he said.[*]

M ary Lisa Palmer was not one to give up. She had devoted too much of her life to the task of bringing order to Giacometti's legacy. At his death in 1966 he left behind an estate that would later be evaluated at $200 million, but he left behind practically no documents

[*]Although instrumental to the police investigation, Sotheby's declined to comment for this book.

on what he had produced and where it went. With the help of an assistant, Annette immediately began writing galleries, collectors, and museums around the world in search of files and photographs of Giacometti's works. Her work laid the foundation for a catalogue raisonné, a scholarly listing of all of an artist's known works. Annette had several loyal assistants, two of whom would later play a larger role in the association, one Martine Neeser—today the association's president—and the fourth and last, Mary Lisa Palmer.*

When Palmer, a petite Connecticut woman with flyaway hair, walked into Annette's office in 1974, the two women got along right away. Palmer had a quiet industriousness and was almost obsessively attentive to detail, two traits particularly suited for a catalogue raisonné. She shunned "art world black," wore little or no makeup, favored functional shoes, and avoided the long, expensive lunches that were so common in the trade. A strong cup of coffee in the morning saw her through to noontime, and then she had a croque-monsieur at a local café or a sandwich at her desk.

The tables in her office were invariably piled high with material to be examined, classified, and filed away. Over the previous few years she had discovered among Annette's files dozens of casual sketches Giacometti liked to draw on whatever material was to hand. She examined them for information that might be useful for the catalogue raisonné and for a book in progress on Giacometti's writing. She had deciphered and transcribed hundreds of tiny scribbled notations, in French and Italian, he had made on drawing-paper table mats, in sketchbooks, and in notebooks, the words leaping sideways and upside down from one notebook page to the next. The book, *Ecrits,* was finally published in 1990, but work on the catalogue raisonné continued.

Once published, the catalogue would be the bible for all things Gia-

*Annette worked on the catalogue raisonné up until her death in 1993. The catalogue raisonné for Giacometti's paintings alone was ready to be published by the association in 2001 and as of 2008 still had not been released.

cometti. It would include every known fact on each work—materials, dimensions, exhibition histories, provenances, scholarly analyses—and stand as the single most important defense against the addition of frauds to the artist's oeuvre. For those in the trade, the catalogue raisonné was the ultimate arbiter: The inclusion or exclusion of a work could mean the difference between a high offer and a pass.

A catalogue raisonné could take years to compile: Dozens of dealers had to be contacted, old bills and receipts traced, records of defunct galleries resurrected, and libraries searched for references. Unlike Giacometti, Pablo Picasso had kept meticulous records and was still alive when his catalogue was being assembled. At thirty-three volumes, it was still incomplete more than three decades after the artist's death in 1973, yet at one time copies were selling for about $100,000. Jean Dubuffet was just as meticulous, and he edited the thirty-nine volumes of his own catalogue.

Palmer put everything she had into the job, and Annette treated her as part of the family. Through studying his work and long conversations with friends of Giacometti, Palmer got to know the artist whose deeply lined face she had never seen in the flesh. His work had a raw, unadulterated, mystical quality that spoke to her, and the very notion that someone would try to forge it offended her to the core. From the start she and Annette had kept careful files on the dozens of attempts to market spurious Giacomettis after his prices began to skyrocket in the 1950s, but the majority of these were fake sculptures and unauthorized bronze castings made from illegally obtained molds of the genuine works. The castings were particularly difficult to spot because they were nearly identical to the originals, except that the originals were always a hairbreadth larger, because the molten bronze in which the fakes were cast shrank slightly as it cooled. With caliper in hand, Palmer had tracked down each suspect piece until it was out of circulation.

To Palmer, any forgery was an insult to Giacometti's memory and craft. He had been a perfectionist who worked and reworked his pieces

obsessively. At one point his sculptures in progress were so tiny that, according to one of his biographers, James Lord, they fit into a matchbox he carried in his pocket. An early acquaintance once said of the bushy-haired artist, "He will either go very far or go mad."[*] Palmer was certain that Giacometti would have been furious had he lived to see his painstakingly made sculptures—and now his paintings—forged with such élan.

Palmer's confidence in her own judgment was well earned. Over the years she had handled and cataloged hundreds of Giacometti's sculptures and canvases, and had developed an uncanny knack for honing in on the bogus. By inspection alone she could determine if a piece had come from the master's hand. If she felt even the slightest nudge of a doubt, there was no talking her out of it. Hapless dealers or collectors who brought in a piece that seemed slightly off could expect no niceties. When she or Annette determined that a work was fake, they did their best to have it seized by the police in order to start the required legal verification process. Once declared a fake by the court on the basis of independent expert testimony, the court can either have the work destroyed or placed in the custody of the plaintiff, usually the association in the case of a Giacometti. The association preferred custody for purposes of evidence for future cases. So far, the courts have always sided with the association.

"I've never been wrong, yet," she once told an interviewer.

Palmer's critics thought her self-assuredness verged on arrogance, but she paid them no mind. Now she was determined to put the Footless Woman away.

After Palmer hung up with Gibson she sat drumming her fingers on the desk for a moment. There was one more call to make. She

[*]James Lord. *Giacometti: A Biography*. New York: Farrar Straus & Giroux, 1983.

phoned David Sylvester, an art critic and Giacometti scholar, and told him she was sure there was a fake in the Sotheby's catalog. Sylvester had already seen it.

"I agree completely," he said. "It's wrong."

He recounted a recent visit to a New York gallery, where he had seen another, similar fake, a portrait of a woman from the waist up. The model resembled Annette, but the head was a dreadful botch-up. "Looks more like Diego," he joked, referring to Giacometti's brother.

Palmer asked him about the provenance.

He told her that the Avanti Galleries had apparently bought the piece in London for a Swedish client. The dealer had paid $325,000 for it, and had recently put it back on the market. The provenance included personal letters from Giacometti and Peter Watson, the initial owner.

"The paperwork is astonishing," Sylvester said, "but it's still a fake. One of the Watson letters is dated two months after Watson's death."

Palmer told him that she had also seen a portrait of a woman from the waist up, in the Hanover photo album, and that she believed it was a forgery. Could it be the same piece?

A few days later Sylvester called her from the Tate.

"I'm ninety-nine percent sure it's the same painting," he said. "It's a conspiracy, a swindle."

The following day, at Palmer's urging, Sylvester called Sotheby's to say that he concurred with her opinion that the nude in the catalog was a fake. The auction house agreed to "postpone" the sale, which Palmer knew was a polite phrase for pulling the work, but turned down Palmer's request that they ship it to her. Instead, they returned the piece to the unnamed consignor.

On December 4, 1991, a day after the auction, Palmer found a sinister message on her answering machine.

"Good morning," said the caller. "I would like to notify you of the following facts concerning the Giacometti entered at Sotheby's for auction."

The work was genuine, the caller said. Furthermore, he knew that she had blocked the sale. She had seven days to inspect and certify the piece. If she failed to do so, the caller would "commence a prosecution in both the United States and France."

The man sounded polite, well-spoken, and determined. She replayed the call several times and transcribed it. She was sure she would hear from him again.

THE BOOKWORM

Every time Drewe walked into Fisher & Sperr's antiquarian book-shop, he would have been startled by the sound of the ancient doorbell, a refurbished fire alarm that shook the premises. It had been installed years ago by the shopkeeper, John Sperr, who was push-ing eighty and nearly deaf. He had rigged the alarm so he could hear customers enter before they disappeared into the maze of bookcases on the ground floor.

Fisher & Sperr sat on a corner of Hampstead Heath in the quaint neighborhood of Highgate, an area dotted with splendid seventeenth- and eighteenth-century residences. The building's white-stucco-and-beam design dated back to the 1670s, as did some of its inventory. It had been an inn and then a bakery until the 1930s, when Sperr's now-deceased partner turned it into a trove of rare and secondhand books.

Over the past month Drewe had set off the alarm half a dozen times. He would come in and work his way around the bookcases to

the small clearing where Sperr sat reading the trade journals behind a walnut desk on a raised landing, a black rotary telephone in front of him and a space heater at his feet. Even in the summer, he wore an old blue cardigan beneath several layers of fleece.

The old man had been buying and selling books from the same landing for four decades, after apprenticing at sixteen at the art bookstore across the street. Over the years he had done little to upgrade the shop, which was dark and drafty and too cramped even for a spare chair for the customers. The aged leather spines and delicate vellum had become a comfortable cocoon. Real estate in this fashionable part of London was worth much more than his inventory, but he never once considered selling, even though he could have retired on the proceeds. Instead of closing up, he had paved over the garden between the store and his apartment behind the lot and built an extension for even more books. Fisher & Sperr, with its forty thousand titles, was a bibliophile's paradise.

These days most of his customers were a nuisance, bargain hunters who ignored the first editions of Coleridge and the signed Bertrand Russells in favor of secondhand guidebooks and novels. Drewe, on the other hand, liked to linger on the old volumes and seemed to admire the artistry that went into them. Sometimes, when Sperr had forgotten that Drewe was there, the professor would reappear with something interesting and ask various questions, though he never bought anything valuable. He had asked Sperr to find some obscure eighteenth-century German math texts for him, but so far Sperr had had no success.

This morning Drewe came in with his usual greeting. "And how are we today, Mr. Sperr?"

"Very well indeed," Sperr replied with a throaty scratch. "Nothing new for you this week, I'm afraid."

Drewe browsed the shelves and pulled out a little-known work by the twentieth-century mathematician and philosopher Kurt Gödel. He

didn't buy it, and then he turned down a nice New York edition of *Das Kapital,* whose author, a bookworm himself, was buried a few blocks away in Highgate cemetery. Karl Marx had spent his happiest time in the reading room of the British Museum, and had died in London surrounded by his books.

Sperr noticed Drewe admiring a thirty-five-volume set of an eighteenth-century French encyclopedia, each volume with a pea-green cover and copper engraving. Sperr explained that it was a seminal work of the Enlightenment whose contributors included Voltaire and Rousseau. In its time it was widely considered subversive. After it was banned by royal decree, its editors were chased from one printer to another, and it had taken twenty years to complete. The *Encyclopédie* had played an important role in the ferment leading to the French Revolution.

Drewe seemed interested, but not quite enough to make an offer.

A week later, as Sperr was going for a tea break, he saw Drewe standing behind one of the bookshelves, holding the back cover of a very large book. He seemed startled and embarrassed.

"I was just coming to see you," Drewe told the old man. "I'm terribly sorry, but this must have fallen off. I'd be more than happy to pay for it."

Sperr told him not to worry, that it was not a particularly valuable book, but the professor insisted on paying for it; he liked the cover and thought he might have some use for it.

"You can have it," said Sperr. "I don't need it."

Drewe apologized again and left the shop.

Sperr made a quick calculation: This was the professor's tenth or eleventh visit, and he had spent a grand total of £10. Perhaps it was time to show him some of his better inventory.

A few weeks and several visits later, he invited Drewe to see a collection he reserved for his regular customers: first editions and other one-of-a-kind volumes, some with handmade pages and illustrations.

He guided Drewe up a narrow spiral staircase that was roped off by a blue velvet cord with gold tassels and led to a tiny rare-books room with a single window, a fireplace, and a thin red rug on the floor.

A whole shelf had been set aside for two hundred thick volumes of religious texts, each one about fifteen inches high and nine inches wide. This, Sperr said, was a compilation of all of the known research and writings of the Catholic Church from A.D. 200 to the 1400s. Written in Greek and Latin, the set was known as the *Patrologiae Cursus Completus*. Sperr had at one time owned all 382 volumes, but over the years he had sold several of them to Catholic institutions and libraries. The work was considered a milestone in Church history. Published in the mid-1800s, the *Patrologiae* included treatises on theology and doctrine, apologias, and studies of saints.

Drewe leafed through one of the volumes and noted that the title page bore a blue oval stamp with the inscription "St. Philip's Priory, Begbroke, Oxford—O.S.M." Another volume had a similar stamp that read "St. Mary's Priory, Fulham, London—O.S.M." Sperr explained that the initials referred to the Order of the Servants of Mary, a brotherhood of friars devoted to the Virgin Mother. St. Philip's and St. Mary's were two of the order's priories. Sperr had bought the *Patrologiae* some fifteen years earlier from the library at St. Philip's.

Drewe seemed fascinated. "I'd love to spend more time with this," he said.

Sperr left him alone and went off to mind the shop. He could hear the professor pacing around upstairs and wondered whether he would finally spend a little money.

I t was no news to bibliophiles that convents and monasteries often harbored valuable old books, manuscripts, and works of ecclesiastical art. Aficionados of rare books knew of dozens of great inside sto-

ries. One of the more famous concerned the near-mythical manuscript of the Lindisfarne Gospels, written and illustrated—or "illuminated"— by an eighth-century monk on a remote island in Northumbria. Over the centuries the leather-bound, jewel-encrusted volume had been transferred from one priory to the next, finally ending up in the British Museum. Book dealers dreamed of finding such ancient treasures in obscure church libraries, and were always on the lookout for oddities like the Breeches Bible or the Vinegar Bible.*

Art dealers, too, dreamed of finding rare works, paintings hidden beneath decades of soot from vigil candles and coal-burning stoves, a Caravaggio discovered in a village church in France or a Michelangelo behind an altar in Tuscany. Such miracles had taken place. Thus, Drewe reasoned, it was not inconceivable that the odd work of art might have made its way to the three-hundred-year-old former estate near Oxford that was now home to St. Philip's Priory.

Shortly after, Drewe sat down at his dining table and began what would become a long correspondence with the friars at St. Philip's. His ultimate aim, of course, was to find a weakness he could exploit to provenance another batch of fakes.

Drewe wrote that he represented two businessmen who had bought several dozen volumes of the *Patrologiae* from Fisher & Sperr. Inside, they had found sketches attributed to Peter Paul Rubens and Sebastiano Ricci, along with a number of much more recent watercolors by Graham Sutherland, a twentieth-century English artist known for his works on religious themes. The businessmen wanted to sell the works and needed written assurance that they had once belonged to the priory and

*The rare Geneva Bible of 1560 was known as the Breeches Bible because it described Adam and Eve's fig leaves as "breeches." The Vinegar Bible, published in Oxford in 1717, was so named because the parable of the vineyard was given as "the parable of the vinegar" in the heading of Luke 20. Only twelve copies were published. One of them, worth about $30,000, was stolen from a church in southwest England in the spring of 2008.

were sold according to Church bylaws. Drewe put a fake priory stamp on the back of a "Sutherland" sketch of the Crucifixion—done by Myatt, of course—and enclosed a photograph of it with his letter to the friars.

A few weeks later the priory wrote back, saying it had no recollection of owning any artworks. It made the mistake of telling Drewe that, although it had sold hundreds of books from its library, it had not kept complete sales records. Drewe replied that it was too bad the priory had been careless and "foolishly" sold off the *Patrologiae;* otherwise it would still own the works that had been found in the volumes. He insisted on a meeting, and drove to St. Philip's on the appointed day.

Although the sale had taken place many years earlier, some of the friars were still upset that such a valuable trove had been sold for a pittance. Drewe sympathized with them and told them the works belonged to Messrs. Peter Harris and Hugh Roderick Stoakes, who were willing to donate 10 percent of the proceeds of the sale to the O.S.M. This was false, of course, nor did his friends Harris and Stoakes know that they had just become the proud owners of "Sutherlands." To make the sale, however, Harris and Stoakes needed proof that the works had been at the priory and had been sold to Fisher & Sperr legitimately. Drewe hinted that the owners were considering legal action if the priory did not issue some kind of declaration to that effect.

The matter was now taken up by the overseer of the O.S.M. in England, Father Paul Addison. The U.K. branch of the order was a small, tight-knit community little more than a century old, and most of the friars knew its history well, having passed it along from one generation to the next. Father Addison discovered that none of them recalled seeing or hearing about religious works of art in the libraries of either St. Philip's in Begbroke or St. Mary's in London.

Addison knew and admired Graham Sutherland's work, particularly *Christ in Glory in the Tetramorph,* the vast green and gold tapes-

try the artist had designed for Coventry Cathedral. Addison would have remembered if any of Sutherland's religious works had ever belonged to the priories, but since it never occurred to him that Drewe was lying, he came up with reasons to question his own judgment. Many friars had died in the period since the community was founded, and the memory of such ecclesiastical works might well have disappeared with them. The assets of the order had never been fully cataloged, and it was possible that sketches and watercolors had been overlooked or misplaced or slipped between the pages of the *Patrologiae* for safekeeping. How else to explain Drewe's photocopies of several small Sutherlands with the priory's stamp on them? To Addison's knowledge, the priory had used a single stamp on its library and archival matter since the early 1900s. It was the only one of its kind, and identical to the one on the photographs.

Addison consulted his board of trustees and then wrote to Drewe.

"After proper investigation and consultation with the persons concerned . . ."

He paused at the typewriter. He did not want to deny the order a donation, nor did he want it involved in a lawsuit.

". . . All and any sales of books, maps, manuscripts, papers and drawings belonging to the English Province of Friar Servants of Mary from its Begbroke Priory during the years 1966 to 1976 were conducted with due permissions and observance of the regulations. . . .

"I hope the above declaration will leave all subsequent handlers of those books, maps, manuscripts, papers and drawings quite clear as to the origins of their acquisitions."

With full faith in Drewe's good intentions, Addison provided the details of the order's bank account, so that Drewe could wire the donation.

Now Drewe had his provenance, and several weeks later at Christie's, dealers and collectors bid on a series of Crucifixion scenes by Graham Sutherland. Each one of them bore the O.S.M. stamp.

The order never received a penny from Messrs. Peter Harris and H. R. Stoakes.

John Sperr sat at his desk, eyes peeled for Drewe. The professor had become something of an irritant. Lately, whenever Drewe went upstairs and paced, Sperr listened to the creaking floorboards and imagined the seventeenth-century building sagging, the walls straining. He suspected that Drewe was doing more than browsing, that he was looking for something specific.

Sperr checked the contact information the professor had given him and discovered that the Duke Street address did not match the postal code. When he dialed the phone number, he got an answering machine with a generic greeting. He dialed directory inquiry and found that there was a listing for a John Drewe, but at a different number.

The next time Drewe came in, Sperr was waiting for him. As usual, the professor asked to be let upstairs, but Sperr stood by the staircase to block his way.

"The rare books section is closed for renovations," he said.

Drewe was not disappointed. He had what he needed. Forging provenance had become a full-time job, and the letter from the priory could be used for dozens of fakes. When the time came for another "owner," he was confident he'd find a mark. He thanked Sperr and let himself out.

THE PAPER TRAIL

When the material she had requested from the Tate arrived in Paris in the fall of 1992, Mary Lisa Palmer examined it closely. Among the documents was a conservator's report on the two suspect photographs in the Hanover album, of the Footless Woman and the portrait of a woman from the waist up. As she had surmised, neither bore the stamp of the Hanover Gallery's photographer. Furthermore, both were printed on a shiny resin-coated paper that had not been in use until the mid-1970s, decades after the works were supposedly painted. Palmer knew that Erica Brausen had donated her records to the Tate in 1986 and strongly suspected that the phony pictures had been slipped into the archives in the intervening years.

In the Footless Woman's provenance was a handwritten letter from the owner, Peter Harris, authorizing his agent, John Drewe of Norseland Research Ltd., to sell the work on his behalf.

The names rang a bell. For years Palmer had kept a log of the calls

and letters that came to her attention, as well as the dozens of attempts to forge the master's work. In the association's records she found a batch of letters dating back to the late 1980s requesting certificates of authenticity and archival information on Giacometti. At the time, something about them rang false, and she had filed them for future reference. Now, nearly five years later, she reread them. Each one appeared to have been mailed by a different collector, but the style was very similar. Each envelope also contained a photograph of at least one dubious-looking painting.

The first letter, from a Dr. John Drewe, was addressed to Annette. Drewe identified himself as a collector of early Dutch works who had recently inherited several modern paintings, including two Giacomettis. He planned to loan these to a British gallery and needed certificates of authenticity.

Generally, such requests consisted of a few succinct explanatory paragraphs and a picture or slide of the work. Drewe's letter was three pages long and elaborate in the extreme, vague on certain key points and all too specific on others. It had a slightly unpleasant tone, by turns submissive and threatening.

Drewe was aware that the association would never certify the works without seeing them, and he volunteered to ship them to Paris. However, he said, he would agree to do so only through the auspices of the diplomatic service to protect the paintings from confiscation "according to the Geneva Convention."

"It is absolutely correct that any work which is definitely established to be a fraud should immediately be confiscated and then eventually destroyed," he wrote. "I would have to accept your judgment as the ultimate authority in this matter . . . and would be prepared to guarantee that these two paintings would then be burned in front of any witnesses you might wish to nominate."

First the disarming carrot, then the stick. Drewe followed his offer

of accommodation with a veiled threat that the reputation of the association itself might be compromised.

"An American industrialist, a prominent man of great integrity, has an affidavit and documents contending that a painting now in the vaults of a gallery, and known indubitably to be by Alberto Giacometti, was stated to be a fraud" by the association.

"I am rather anxious that, unless I am careful, an elegant and delightful painting might be destroyed needlessly. . . . Please accept my assurances that I do not believe that you could be personally responsible for such a decision: in a busy office mistakes occur easily, and art, particularly, depends so much on intuition and subjective responses, rather than formal scientific measurements."

After studying the enclosed photographs of the two works, Palmer and Annette had decided not to respond to Drewe's request. They agreed that the paintings looked fake and that the florid letter was the work of a loose cannon. They were confident that without the certificates he would never be able to sell the fakes.

Three weeks after getting Drewe's letter, however, they received a note from Phillips auction house in London asking for information on a piece that was about to go on the block. Attached was a copy of a letter from a Richard Cockcroft and a photograph showing one of the very works Drewe had tried to have authenticated. Titled *Deux Figures,* it was purportedly owned not by Drewe but by Cockcroft, who said he had bought it from E. C. Gregory. Cockcroft had helpfully provided the auction house with a purported letter from Giacometti's biographer, James Lord, stating that the work was genuine.

Palmer was livid. Cockcroft or Drewe or both were trying to go around the association, and she knew that it in the end it would just cause her more work. Eventually, all of Giacometti's works end up on her desk.

She wrote back to Phillips, told them the work was wrong, and

asked them to send it to the association. Phillips replied that they no longer had it because it had been reclaimed.

Palmer remembered another work titled *Deux Figures* from the catalogue raisonné. She consulted her records and found a picture of the original, which had been bought from the artist by E. C. Gregory, who had bequeathed it to the Tate Gallery in 1959. As far as she knew, Gregory had owned only one *Deux Figures* in his life.

Clearly, this "Richard Cockcroft" was not only copying the work but also forging part of its provenance, cleverly embroidering fact with fiction.

Three months after the arrival of Cockcroft's letter, Palmer received a bizarre phone call. In a measured tone, a Londoner identifying himself as Viscount Chelmwood said he had been referred to her by a mutual acquaintance at the renowned Wildenstein Gallery.

Chelmwood launched into a complicated story, claiming he owned a portrait that had once belonged to E. C. Gregory and was now mired in legal wrangling over its ownership. Chelmwood needed her help.

She listened quietly. The mention of E. C. Gregory made her leery, and there was something odd about the viscount's manner. He was asking too many questions about Giacometti and his acquaintances, she thought, as if he were trolling for inside information. Like any other researcher working on a catalogue raisonné, Palmer was wary of sharing information with possible competitors or dealers who might be wondering whether their paintings were going to make it into the catalogue. Depending on what ends up in a catalogue raisonné, fortunes can be lost or gained, and researchers have occasionally been threatened or offered bribes.

Finally, the viscount told her that he owned several Giacometti sketches and documents and wondered whether she would be interested in including them in her catalogue raisonné.

Palmer thanked him, said she would be in touch, and hung up. She

opened her logbook and made a note next to Chelmwood's name: "Weird."

Next she rang up their mutual acquaintance at the Wildenstein, David Ellis-Jones, to ask if he had ever heard of Chelmwood.

He had not.

Had he had a recent visit from someone interested in a Giacometti? Indeed he had.

Several weeks earlier, a "nice, modest man" named Drewe had wandered in. He was a doctor and a distant relative of the architect Jane Drew, and he had inherited a 1956 portrait of Peter Watson from his mother. It was purportedly by Giacometti, but Drewe was trying to fill in the gaps in the provenance. He showed Ellis-Jones a letter indicating that the painting had been sold through Wildenstein as part of an exchange for a Modigliani. He had several other letters referring to the Giacometti's past ownership, and he wanted to verify his research.

"Drewe's a timid amateur, ignorant but sincere," said Ellis-Jones. The painting could never have come through Wildenstein because the gallery did not deal in modern art. Worse still, Ellis-Jones thought the piece looked dubious, and he'd told Drewe to contact Palmer and ushered him out the door.

The connection between Peter Watson, E. C. Gregory, and Jane Drew was clear: They were all spokes of the ICA wheel. Each one had been an important figure in the British modern art movement.

Palmer wondered whether the inclusion of these notables in the provenances was intended to take the focus away from the fakes, to distract potential buyers with the luster of owning a work that had once been in the hands of such luminaries. She also wondered whether Cockcroft, Drewe, and Viscount Chelmwood were somehow connected. Could they be one and the same person?

She went back to her files, found the original letter from Dr. Drewe, and laid it out on her desk next to Richard Cockcroft's letter to Phillips. Her eye settled on the return addresses: Drewe lived at 30 Rotherwick Road, and Cockcroft at 20 Rotherwick. Their phone numbers were almost the same, off by just a single digit. The signatures were similar, and beneath each one the writer had typed his name and then underlined it.

Palmer checked her notes on the viscount's phone call. His complicated explanations echoed the tone of the letters: an abundance of detail coupled with a certain overall vagueness. At the bottom of her phone log she had jotted down the viscount's number. It was identical to Drewe's.

From her files she dug up a third letter containing a photograph of the same suspicious *Portrait of a Woman* that she and David Sylvester had seen in the Hanover album at the Tate. The letter was signed by John Cockett, chairman of Norseland Research, the firm Dr. Drewe had claimed to be representing as agent for the Footless Woman.

Were Drewe and Cockett colleagues? Was Cockett an alias?

This third letter had the same discursive quality as the others. Cockett said he would bring the painting to Paris for Palmer's review, but that the trip would coincide with a business venture in which he was "co-operating with the French on a project to develop new propulsion systems."

"It might not be possible to get the painting on board our aircraft if the customs indicate that it would complicate the clearance of the industrial equipment we are bringing with us," he wrote.

Cockett's signature was underlined, and the letter, like the others, contained several cc's at the bottom. Palmer suspected that these were deceptive flourishes, and that he had no intention of copying anyone. The letter was typed on what looked like expensive stationery, with fancy heraldic signs at the top, but when she ran her fingertip across the letterhead, she could tell it was not embossed. The type was smooth

to the touch, a mere photocopy. Suddenly she thought she had a clearer picture of the man: He was arrogant, a risk taker, and a cheapskate.

Curious about Norseland, Palmer phoned the Trade and Industry Department in London, which kept records of all registered British companies. She learned that Norseland was registered to a physicist, John Drewe, and his secretary and art historian, John Lawrence Myatt. The firm had never earned a cent or filed a tax return. It was a shell.

FALLING OFF A LOG

It had been a bad year for Clive Belman. The onetime jewelry sales-
man was out of work and nearly broke, living with his wife and
two kids in a house he could barely afford. On this fall afternoon,
he tossed aside the want ads and headed down Rotherwick Road to
his neighbor John Drewe's house to pick up his children, who often
played with Drewe's after school. Belman envied Drewe, who was
successful—he drove his kids to school in a Bentley—and unburdened
by life's troubles, least of all the next month's mortgage. Professor
Drewe was an accomplished Oxford graduate and nuclear physicist
who worked from home. Belman had recently discovered that they
shared an acquaintance, the Nobel Prize–winning scientist Brian Jo-
sephson, whom Belman had known as a child.

When Drewe's daughter, Atarah, answered the door, Belman could
hear Drewe calling him to come upstairs. He walked up to a small,
spare room on the second floor and found Drewe crouched on the floor

in a business suit, hammer in hand, banging away at a wooden picture frame. There were a dozen or so paintings lined up along the walls, abstract works by painters whose names Belman was unfamiliar with: Jean Dubuffet, Ben Nicholson, Le Corbusier, Alberto Giacometti.

"It's sort of a hobby of mine," Drewe said, explaining that the paintings belonged to a syndicate of scientists and businessmen who had been collecting for half a century. He served as the group's representative and occasionally restored the works and repaired their frames.

"These are quite valuable," said Drewe, gesturing at two Nicholsons. "That one's worth about £60,000, and that one"—he pointed to an abstract piece by the window—"that's about £40,000."

"I hope they're insured," Belman joked.

The collection had been stored away for years in vaults and safe houses all over England, Drewe told Belman, who stood in the doorway listening as Drewe went on to say how much pleasure he got from making the frames and being surrounded by such beauty. If Belman had looked more closely, he might have noticed that the wood Drewe was using for the frames was left over from Goudsmid's endless home renovations.

On his way home with the children, Belman could barely focus on them. The difference between his situation and Drewe's was almost too much to bear. The professor lived the easy life, while Belman, at forty-six, could scarcely find the money to fill his car with gas, let alone indulge in hobbies like picture framing. At his age he should be enjoying himself, but his life had begun a dramatic downward trajectory a year earlier, when two thugs in balaclavas burst into his jewelry store, lodged the twin barrels of a sawed-off shotgun in his mouth, and cleaned out his shop.

Belman had been robbed before, but this was far worse, and it unnerved him. His business had been losing money steadily, and he had taken out an £80,000 home equity loan to cover the losses. The jewelry

trade was a tough proposition, and a dangerous one, and soon after the robbery he decided to close down. He couldn't help but think about the value of the works in Drewe's home: One or two of them were worth enough to clear him of debt and stop the bank from foreclosing. As he approached his house he tried to ignore his worries for the children's sake. Surely, he thought, something would come along.

A week later, Drewe was standing at the door.

"What do you know about art?" he said.

"This much," said Belman, pinching thumb and forefinger together. He had a passion for bridge, not for canvas.

Belman invited his neighbor in, and over the course of the next hour Drewe explained that his syndicate needed £1,000,000 in a hurry to buy a cache of long-hidden Russian archives that would forever put to rest revisionist theories that the Holocaust was a myth. To raise the cash, the syndicate would have to sell a significant portion of its collection of twentieth-century paintings.

Would Belman consider "taking them around"?

Belman couldn't remember the last time he'd stepped into a museum or a gallery, and he wasn't exactly sure what "taking them around" meant, but it sounded like a good opportunity. Nevertheless, he asked Drewe why the syndicate didn't simply put the paintings up for auction.

Drewe said that he and his colleagues had to move quickly because someone else had also expressed an interest in the same batch of Holocaust files. There wasn't time to go to the auction houses, which planned their sales months in advance. Not only that, they charged a steep seller's commission, as well as a fee for reproducing the works in their catalogs. With several dozen works at stake, these commissions would be astronomical. It would be far more economical and much

faster if Belman agreed to act as a middleman for the works, for which he would get a 20 percent cut.

Belman was hesitant; there must be a catch. "How much will it cost me to get in?" he asked.

"Nothing," said Drewe. "The paintings are the crème de la crème, from Picasso on down. They're worth millions."

Belman, an utter novice, felt that he was probably the wrong man for the job, but the offer was a lifeline.

"You're a good salesman," Drewe said. "It'll be like falling off a log."

The professor had read his mind. It was no secret that Belman was nearly broke. He'd been open about his predicament, and everyone knew about the smash-and-grab robbery at his jewelry store. He'd always had an uncertain career, starting out as an actor at a repertory company in his hometown of Cardiff, then working in voice-overs and on radio adaptations of television shows. These were written the night before they aired, so there was little time for rehearsal. If an actor dropped a line, the others improvised. It was bare-bones theater, and Belman learned to spin on a dime and crank out his shtick on the high wire. Finally, when even these meager acting jobs had dried up, Belman took a job managing an all-night bridge club in London, confident that he understood this world as only the child of a champion bridge player could. Each hand was a new adventure that required card smarts as well as mental fortitude.

With Drewe, Belman's improvisational and mental skills would be tested again. There was a lot to learn about the art world. Belman would have to educate himself and get to know his inventory thoroughly. But what was selling if not playing a role to perfection? He could do it. He knew from experience that if he was selling something even remotely interesting or worth buying, he could make a profit. As for finding the right buyer, he'd always operated on the "six degrees of

separation" principle. If you cast your net wide enough, you'd find someone who would lead you to the perfect buyer.

Belman wasn't simply interested in the money. He needed a shot of confidence, a sip of success. Drewe's proposition might just get him back on his feet. And besides, he would be helping to keep the reviled Holocaust revisionists at bay.

He shook hands with Drewe, and they agreed to talk again soon.

A couple of days later Drewe came by with two paintings, a Giacometti and a Nicholson watercolor composed of blue, red, and yellow squares and rectangles. Belman knew a little about Giacometti but almost nothing about Nicholson. He went to the library and found that the British painter had died a decade earlier, in 1982, and that he was best known for his geometric landscapes and white reliefs. A Nicholson work had recently sold at auction for more than £1,000,000, a record for a British abstract.

Drewe told Belman that his syndicate wanted £200,000 for the Giacometti and £40,000 for Nicholson's *Aegean*. He said the Nicholson had languished on consignment at a London gallery, and that its price had been reduced from £70,000. Belman began cold-calling anyone who knew anyone who might be even vaguely interested, and soon he had a bite from David Stern, a respectable dealer in Notting Hill.

The Stern Pissarro Gallery, a second-generation family business, had opened its doors in Tel Aviv in the early 1960s before branching out. David Stern, its current director, was married to Lelia Pissarro, the great-granddaughter of the French impressionist Camille Pissarro. Oil and provenance ran through the family's veins, and several generations of Pissarros had honed their talents at the easel. Lelia learned to paint on her grandfather's boat and sold her first painting when she was just four years old, to Wally Findlay, a well-known New York dealer who sometimes, on a whim, bought work from artists' children.

David Stern guarded the Pissarro legacy and specialized in sales of the family's work, but he was always looking for additional business. He told Belman he might be interested in the two works.*

At Belman's home a few days later, Stern examined the Giacometti and the Nicholson. As Belman filled him in on the syndicate's attempts to acquire the vitally important Russian archives, Stern took his time studying the works. Belman had imagined a short meeting and a rapid appraisal, but the dealer checked the canvases thoroughly and turned them over to examine their frames. He took them out to the garden and held them up to the light, and then he leaned them up against the wall and photographed them from several angles.

"Clive," he said, "I've been in this business for twenty-five years. It takes twenty years to build up a reputation and two minutes for it to go up in smoke."

Belman, who was feeling a little anxious by now, was relieved when Stern finally said he was considering Nicholson's *Aegean* and wanted to examine the documentation.

Provenance is a fluid construct. A single piece of memorabilia can bring to life an otherwise moribund pile of receipts and invoices. A fully loaded provenance, with details of a work's trajectory through the marketplace, can add substantially to the price. Further, if there's any hint that the work was once associated with celebrity or scandal, infamy or criminal endeavor, its value may increase significantly. (Collectors have been known to arrange to have a painting stolen and subsequently recovered.) More often, however, a work's provenance might consist of a single bill of sale, one catalog, or a passing mention in an old letter.

For *Aegean,* Drewe had provided Belman with a sensational provenance, including a handwritten letter from Barbara Hepworth, a major

*The account of Belman's dealings with Stern is based on interviews with Belman. Stern declined to comment.

British sculptor and Ben Nicholson's second wife, to Margaret Gardiner, an early member of the ICA and a patron of the arts who had once donated seventeen tons of Nigerian hardwood to Hepworth for use in her work. Drewe told Belman that the letter, which mentioned *Aegean* in passing, had accompanied the painting for years as part of its provenance.

Drewe had also supplied Belman with photocopies of various receipts, several of them marked with a rectangular stamped impression reading, "For Private Research Only/Tate Gallery Archive." This indicated that the originals were tucked safely away at the Tate. Other documents showed that the original buyer of *Aegean* was Jacques O'Hana of the O'Hana Gallery, who had acquired it from the artist for £900 in 1955. The work had later been bought by Peter Harris, a collector who was based in Israel and was a member of Drewe's syndicate. The receipts had all been signed by either Harris or O'Hana. One further document lending weight to the work's authenticity was a 1950s exhibition catalog that included a black-and-white photograph of it.

Belman sent Stern a transparency of the painting, along with the provenance. Stern was evidently impressed. He told Belman that he had a potential buyer in New York, an art consultant who worked out of her East Side apartment and had done business with Stern in the past. The consultant had a corporate client who seemed interested.

On a July morning in 1993, Belman landed at John F. Kennedy International Airport to deliver *Aegean*. With the small painting tucked safely under his arm, he folded himself into a waiting cab and went straight to the consultant's office. She examined the work and its provenance, seemed pleased with both, and immediately agreed to buy the piece for £35,000. When Belman returned to London a few days later, Drewe paid him his £7,000 commission.

The job could not have gone more smoothly. It was the easiest seven grand Belman had ever made, and he promptly phoned his bank manager and told him to call off the wolves.

The sale of *Aegean* was the first of a string of successes for Belman, who no longer lay awake at night worrying about how he was going to take care of his family. He was selling to dealers in London and New York, calling friends for new leads, dropping hints at parties, and talking up his inventory to his old mates in the gem game. The word had gone out that he had important connections in the art world.

Occasionally, Drewe would dangle transparencies or laser printouts of the syndicate's more expensive Chagalls, Monets, and Picassos, but he rarely gave Belman the really good stuff. All in due time, he'd say. Belman could hardly complain. He was happy with what he'd been getting, and whenever his friends came by, he'd march them through the collection.

"That's a Giacometti," he'd say proudly. "That's a Ben Nicholson."

He refined his pitch, read up on the artists, spent time at the museums, and even sat through the occasional lecture. Once, he took the train down to the Cornish seaside town of St. Ives, which had been a haven for Ben Nicholson, Barbara Hepworth, and Henry Moore, and roamed along the cliffs and down by the coves, soaking in the atmosphere. After all, he was in the art business now.

THE BOW TIE

Peter Nahum was a familiar face to the legions of dedicated viewers of the BBC's *Antiques Roadshow*. He wore a bow tie and wire-rimmed glasses, and had an easy manner. He was a natural for television, and had been the *Roadshow*'s expert in nineteenth- and twentieth-century paintings since 1981. It was great fun. On one show, a Scotswoman from Inverness unwrapped a painting she had bought at a yard sale for fifty pence. Nahum quickly identified it as a valuable work by the nineteenth-century "queen of cat painters," a Dutch artist named Henriëtte Ronner-Knip. The work sold at auction for £22,000. When a banker brought in a collection of twenty-five Filipino watercolors he'd inherited from his grandfather, Nahum knew right away that it was gold, worth £240,000, as it turned out.

Nahum's favorite was an episode in which an elderly couple brought in a watercolor of a moonlit desert scene. They'd kept it in a cardboard tube since the 1930s, and were on the verge of throwing it out, when

they decided to come on the show on a lark. It took Nahum all of ten seconds to recognize a long-lost watercolor by Richard Dadd, a solid mid-Victorian painter who had done much of his work while confined to an asylum after murdering his father. As soon as Nahum laid eyes on the piece, his brain began to spin. It was in perfect condition.

"It can't be!" he thought. "I've never seen anything like it in this condition, it's too good."[*]

The old couple sold the watercolor to the British Museum for £100,000.

A fixture on the lecture circuit, Nahum knew the art world intimately, having spent seventeen years at Sotheby's working the gavel and the sales floor. It was said that Sotheby's was filled with dealers fobbing themselves off as gentlemen while Christie's was a bastion of gentlemen who desperately wanted to be dealers. As a teenager Nahum had aspired to both. He started at Sotheby's at age eighteen, earning eight pounds a week as a clerk on the bustling auction floor. It was hair-raising, adrenaline-fueled work. A first-rate auctioneer could sell nearly two hundred lots in an hour, and it was Nahum's job to stay abreast of the bids, convert currencies, and keep the sale ledgers up-to-date while he kept an eye on the room. He memorized the faces of important clients, and was occasionally asked to bid on their behalf. The learning curve was sharp, and he quickly rose in rank to become a senior director and department head.

After nearly two decades of feeding the art machine and pulling paintings off old ladies' walls, Nahum left Sotheby's in 1984 and opened the Leicester Galleries on Ryder Street. The timing was good, for the market was soaring. He was as tough as his clients, none of whom were pussycats, and he kept a constant watch on the auction houses, where he had witnessed toe-curling manifestations of greed and cun-

[*]Madeleine Marsh, "COLLECTABLES/On the Roadshow to Riches," *The Independent* (London). Jan. 17, 1993.

ning. During his career he had experienced moments of fantastically good fortune as well as downturns so nasty—particularly in the early 1990s—that his bankers found reason to doubt his capacity to perform miracles.

Nahum's gallery, whose centerpiece was a plush velvet showroom hung with placid landscapes and seascapes, sat off one of the main thoroughfares of central London, in an elegant district of high-end shops and boutiques crammed with tourists carrying turquoise bags filled with chocolates and teas from Fortnum & Mason. There were frequent drop-ins at the gallery, and Nahum kept his ear cocked for the telltale accent of cash-heavy Americans, Germans, and Japanese. His experience had taught him that the rarest treasures could be found in the most unlikely places, so when Clive Belman walked in with a painting under his arm one day in the fall of 1993, Nahum went up to him and politely asked what he could do for him.

With all the patience in the world, he helped Belman unwrap a small wooden panel of the Crucifixion by Graham Sutherland. Christ was depicted as an emaciated figure against a yellow background, and Belman explained that the panel was one of a series of working sketches for the Crucifixion scene in Sutherland's famous tapestry in Coventry Cathedral. He told Nahum he was selling the work on behalf of his neighbor, John Drewe, a physicist who was conducting research into long-hidden Holocaust archives.

In Nahum's opinion, the work was unremarkable, but it had a solid provenance. He remembered that not long ago Christie's had auctioned a similar group of Sutherland Crucifixions with identical provenance: They had all come from St. Philip's Priory in Begbroke. On the back of Belman's panel was the priory stamp and the inscription "Father Bernard F. Barlow, Graham Sutherland, Crucifixion of our Lord— study in oil—loaned Jan 1972 to Oxford University Bod Library reference R203."

Nahum assumed that Christie's had checked with the monastery

and vetted the provenance of the other Crucifixions, but to be on the safe side, he decided to take Belman's over there for an informal evaluation—which was easy enough to do, since his gallery was right next to Christie's back door. Sometimes, when he opened up shop in the morning, he found boxes of spent champagne bottles that had been left outside overnight. Nahum believed that such luxuries, which were financed by the auctioneers' usurious commissions, were outrageous. Still, the auction houses were useful when he needed to unload mediocre works that he considered unworthy of his own clientele.

Christie's estimated Belman's Sutherland panel at about £15,000. Nahum thought that was high and offered Belman £5,500. Belman accepted and made out a receipt in the name of John Drewe at Airtech Systems.

A few weeks later Belman was back with two more pieces, both by Ben Nicholson and both from the collection of John Cockett. Nahum remembered that he had seen one of them a year or so earlier in a vault in Golders Green, where he had gone with an artist and runner named Stuart Berkeley. At the time Nahum thought the work was either badly restored or the product of one of Nicholson's off days, and his opinion hadn't changed.

The second painting, titled *Mexican,* was no better than the first, but it was commercial enough, with skewed geometrical shapes and an abundant palette. Nahum thought he could probably find an American buyer for it. The back of the stretcher was signed and dated by the artist, and there were two labels, one from Galerie de Seine in Belgrave Square, London, the other from New York's Willard Gallery. The documentation seemed solid. The piece was dated 1953 and had been bought from Nicholson by E. J. Power, a businessman and future Tate Gallery trustee. Belman showed Nahum an old receipt for the work, along with a 1950s catalog from the Galerie de Seine that was titled

"Paintings by Five Artists From St. Ives" and contained a photograph of the painting. Finally, the provenance included a letter to Belman from the Nicholson scholar and former Tate head Alan Bowness, who had seen a transparency of the work and accepted it as genuine.

"The fact that it was shown at a reputable gallery and illustrated in the catalogue would seem to confirm the attribution," Bowness wrote.

Belman told Nahum he wanted £40,000 for *Mexican*. Nahum sought a second opinion from a curator at the Tate, who thought the piece was genuine but second-rate. After a third expert confirmed that Nicholson's signature on the stretcher was authentic, Nahum pooled his resources with another dealer and paid Belman £35,000 for the painting. Then he put it in storage and decided to wait until the next auction at Sotheby's in New York.

Shortly after the purchase, Nahum got a phone call from Drewe, who wanted some information on a painting Nahum had on consignment, Claude Monet's *Cleopatra's Needle and Charing Cross Bridge*. Drewe had a private client for the piece, and asked whether he could borrow a transparency. Nahum declined. Dealers rarely shared transparencies with intermediaries, particularly unfamiliar ones. Top-tier dealers observed certain trade rules, and it was Nahum's experience that runners often felt free to break them. A clever middleman with a borrowed transparency could slice a dealer's commission in half. Nahum preferred to conduct his business with a work at its source.

The Monet was at the restorer's, he told Drewe, but the professor was welcome to take his client there to examine it. Collectors love private viewings, the more remote the location the better. It gives them a sense of exclusivity and a feeling that they are getting a jump on the market.

Drewe said he would bring his client to the restorer's that afternoon, but he asked Nahum to stay away from the showing. This was not an unusual request in the business, and Nahum agreed to it. He told Drewe

that he had another appointment in any case and would be busy all afternoon.

By sheer coincidence, Nahum's meeting was canceled, and he went back to the gallery to finish up some work. As he was reading his mail, a man in a chauffeur's uniform came in and announced that he was there to pick up the Monet transparency for Dr. Drewe.

Nahum told him the transparency wasn't available. The chauffeur bristled and said Mr. Nahum had specifically left instructions for him to pick it up.

"Awfully bad luck," said the dealer. "I'm Peter Nahum, and I told Dr. Drewe very clearly that he couldn't have it."

The driver skulked off.

An hour later the phone rang. It was Nahum's restorer, calling to say that he had recognized Drewe's "private client" as a former auction house employee who had been fired for stealing. Nahum had been expecting a call from Drewe with an update on the Monet, but he never heard from him. Just as well, he thought.

In a matter of weeks Belman was back at the gallery with another painting for Nahum from Drewe's collection. The dealer took him aside and told him he wanted nothing more to do with the professor.

"I'll never do business with him again," he said.

INTO THE WHIRLWIND

These people are all barking mad," Belman muttered to himself as he left Nahum's gallery. By now, he'd been around the art business long enough to know that it was a small world, rife with competition, vile gossip, and eccentricity of every sort, and that it was almost entirely unregulated. Many of the dealers he'd worked with wouldn't last five minutes in another business. They would be blacklisted, fined, or jailed. Drewe fit in perfectly.

Belman had been selling paintings for him for two years now. The professor seemed to have an inexhaustible supply of them, as well as an array of personal causes ranging from Holocaust archives to student grants and religious orders. Drewe was fond of peppering the newspapers with letters to the editor, and one of them, published in the London *Times,* made reference to art that had been confiscated by the Nazis from European Jews. It had helped Belman sell a painting whose proceeds were destined for Drewe's latest pet project, an Auschwitz

memorial charity concert. Occasionally Belman wondered whether Drewe's paintings were fake or stolen, but the fact that they had passed muster with some of the biggest dealers in town reassured him.

Drewe's behavior, however, was becoming a principal source of irritation and a cause for concern. He was increasingly unpredictable, and lately his demeanor set Belman's heart racing every time they did business together. Often, after Belman had set up a deal, Drewe would fail to deliver on a promised painting. If the sale did go through, Drewe demanded his money immediately once the painting changed hands. In one instance, Belman recalled Drewe telling him that he'd hacked into the computer system of the dealer's bank and watched the transaction take place in real time.

"I've got friends in powerful places," he said.

From that day on Belman began to feel a certain nostalgia for the old days behind the jewelry counter.

Not long after the unpleasant visit to Nahum's gallery, Drewe invited Belman and his wife over for dinner. The evening was a disaster. Drewe and Goudsmid screamed at each other while the children fought. It was chaotic, a free-for-all, and Belman swore to himself never to return.

The next day, as Belman sat in his living room, Drewe came up the driveway in a brand-new Jaguar. He wanted to talk about a fresh consignment, he said. Neither of them brought up the shouting match of the night before. Drewe had another business proposition: He was selling surplus military equipment for a Middle Eastern country, and suggested with a straight face that some of Belman's art contacts might be interested. He said he could get his hands on anything from an F-16 on down, and hinted that he had connections to the Ministry of Defence, MI5, and MI6.

"He just threw it out there," Belman recalled. "I thought he was just another mad boffin." England was full of them.

When Belman tried to change the subject, Drewe insisted that he

come outside and see the Jaguar. He said he had paid for it with money from John Catch, whom Belman already knew as Drewe's "sugar daddy," a Scottish nobleman and art collector. Drewe walked Belman to the trunk of the car and opened it. Inside Belman saw guns.

"What the hell do you want all those for?" Belman asked.

"For my own protection," Belman recalled Drewe saying.

Belman knew that Britain's gun laws were notoriously tough, and he asked Drewe to leave. The professor insisted it was all legitimate, and that he had a license to carry weapons.

"You've nothing to worry about," he said. "I know everyone from the pope down."

Belman rolled his eyes and went back inside. Drewe could talk the hind legs off a donkey. In the living room he noticed that Drewe had dropped a letter on the couch—perhaps intentionally, but he couldn't resist having a look. It was a clinical diagnosis describing Batsheva Goudsmid as suffering from Munchausen syndrome by proxy, in which the mother fakes or induces illness in her children in order to gain attention and sympathy as the "worried parent."

Increasingly alarmed by Drewe's behavior, Belman considered cutting his ties with him: The man was clearly insane. Belman had an offer to work at an air-conditioning supplier, and while it wouldn't be nearly as interesting as selling art, it would provide a steady income and a world without surprises. Before he could break it off with Drewe, however, he had a bite on another painting. He promised himself that if the sale went through, it would be his last.

At a dinner party he met an art expert and lecturer named Maxine Levy, who knew her way around the business and had contacts. Belman mentioned that he had several paintings for sale, including an untitled 1938 watercolor by Ben Nicholson worth about £15,000. Levy thought she could place it, and within a week she called to say she had found a buyer at Gimpel Fils Gallery.

Rene Gimpel was a fourth-generation dealer whose father had been

Nicholson's principal dealer in the 1940s and 1950s. A soft-spoken man with sloping shoulders, he looked more like an impoverished painter than a gallery owner. He examined Belman's painting and found that it was slightly damaged in one corner. There were faintly visible black lines beneath the watercolor, as if the artist had sketched something in and then changed his mind.

The work's impressive provenance included handwritten letters and newspaper clippings. Receipts and invoices showed that it had passed through the hands of several well-known Nicholson collectors, including Cyril Reddihough, an early supporter of his work, and William Copley, a Beverly Hills dealer with ties to the surrealists. The documentation also included a photograph of the watercolor in a copy of the catalog for a 1957 exhibition at London's Gallery One titled "The Road to Abstraction." Clearly visible on the first page was a red oval stamp bearing the inscription "St. Philip's Priory OSM Oxford."

Gimpel arranged for Nicholson expert and former Tate Gallery director Alan Bowness to see the work, and Bowness seemed satisfied that it was genuine. Gimpel phoned Levy and told her he wanted it.

Levy called Belman, who in turn called Drewe.

The professor immediately upped the price to £18,000.

Belman was used to this kind of behavior from Drewe, but Levy was outraged.

"This is no way to conduct business," she told Belman.

"I'm sorry," he said. "My hands are tied."

Levy called Gimpel, who reluctantly met the new price.

Belman closed the deal and breathed a sigh of relief. He thought he was finally free of John Drewe.

About a mile from Belman's home, Danny Berger's unlikely little garage on Finchley Road had become a popular viewing room for runners, gallery owners, and curators from London, Paris, and New

York. Business was good, but Berger was getting the runaround from Drewe, who was slow in paying commissions. Whenever Berger insisted on his share, the professor would explain that there were problems at home and he was having trouble making ends meet.

One day he surprised Berger at the garage. He said he was embarrassed to ask but he needed a £3,000 loan for the mortgage. Berger thought it was the least he could do, and wrote him a check. Several months later Drewe had not returned the money, and when Berger asked him for it, the professor announced that he was broke. He proposed that instead of paying Berger back in cash, he would give him paintings. Once Berger was fully reimbursed, he could buy directly from the syndicate at a substantial discount.

Around the middle of 1994, Drewe showed up at the garage again and told Berger that he'd broken up with Goudsmid and moved out. She was emotionally unstable, he said, a threat not only to her children but to herself. He had been forced to take everything he owned with him and was now virtually homeless. Berger felt sorry for him and agreed to store some of his belongings. Soon the garage was filled with frames and boxes of documents and several trunks—one of which, Berger couldn't help noticing, had guns in it.

Drewe asked for another loan, and said that if he couldn't repay it in a timely manner, Berger could simply take another painting. Berger knew that the value of the works in his garage far exceeded the loans, which now totaled about £30,000. The risk seemed minor, and he was sure he was getting the better end of the deal. After six years selling paintings for Drewe he considered the professor a friend, and wrote Drewe another check without delay.

Despite the fact the Drewe had been using Hugh Stoakes's name on his false provenances for a long while, Stoakes had not been in contact with his childhood friend in years. Drewe had always been

one of the few who appreciated him, but their friendship was inter-
rupted when Stoakes turned seventeen and won a full scholarship to
study philosophy and psychology at Oxford, an adventure that lasted
a mere four months. He began drinking heavily and ignoring his aca-
demic responsibilities. On the night before a crucial biology exam that
required dissecting and describing a rabbit's digestive system, he blew
all of his meager allowance at the pub. When he saw the bunny the next
morning, he gagged, walked out of the exam room, and packed his
bags. He'd had enough.

Over the next few years he made his way across Europe, drank a lot
of ouzo, and taught English wherever he could find a job. Whenever he
was home for a visit he would get in touch with his childhood friend.
Drewe would invariably show up in a brown suit and tie, and the two
of them would again disappear into an imaginary world of gravity-
defying scientific theories and Nobel prizes.

On one occasion, in the early seventies, Drewe stayed with Stoakes
for a whole week, which did not please Stoakes's parents at all. They
had long ago taken a dislike to him. There was something about
his tight smile and rigid walk, something shifty and unsavory that
rubbed them the wrong way. Whenever Mrs. Stoakes saw Drewe march
up to the house, his torso thrust forward with an exaggerated momen-
tum, his arms swinging in time with his stride, her hackles would go
up. She felt that he was carrying some hidden burden, something much
too heavy for so young a man.

About two years later, the two friends went on a picnic. They sat
together until twilight, eating and talking about politics and sex. Drewe
told Stoakes that he had completed a doctorate at Heidelberg and Kiel
universities in Germany, and had taken a job with the Atomic Energy
Authority at Harwell. He was now involved in nuclear research. None
of this seemed fanciful to Stoakes, who had always been convinced that
his twenty-seven-year-old friend was headed for the bright lights. Drewe
had taken a flat in Golders Green, and after they'd finished all the food,

Drewe invited Stoakes up. The flat was musty, filled with dark, heavy furniture left behind by a former tenant: an enormous mahogany wardrobe, a sideboard, and a file cabinet covered with documents. They settled in and began to brainstorm the way they had in the old days. Drewe sketched out a blueprint for an article on hydrostatics, and Stoakes took notes and typed them up. They labored for weeks on the piece, cutting, pasting, and editing. Stoakes smoothed it out until they were both satisfied, and Drewe put his name on it.

When the paper was rejected, Drewe said he'd outdone them again. He'd gone one step beyond where the journal editors believed the leading edge to be. It was only a matter of time before the custodians of the various scientific disciplines would have to acknowledge his contributions.

As far as Stoakes could tell from their infrequent meetings, Drewe kept himself in good physical shape. His clothes seemed tidy enough, in a thrift-shop sort of way, nothing fancy. He was tall and sturdy now, his youthful nervousness gone. In its stead was a minus, a vacancy. He had about him "the air of a masked ascetic, a disordered sainthood," Stoakes recalled.

A few years later the two friends met up again in Leicester Square. Drewe seemed even taller and more solidly built than Stoakes remembered. Over drinks Drewe talked about his hopes and fears. He felt undervalued, he said, but he intended to rectify that state of affairs. He proposed that they collaborate again. This time they would focus on the philosophy of science. Stoakes would provide the conceptual framework and Drewe the technical details. They fell into their old colloquy, and Stoakes felt that their boyhood intimacy had been refreshed.

In a mellow mood, they strolled across the square and saw *Apocalypse Now* in velvet comfort in front of a mammoth screen and a mountain of blaring speakers. Stoakes was blown away by Francis

Ford Coppola's combination of Conrad, Vietnam, and psychedelics, but the experience seemed to have little effect on Drewe, who was aroused only by the airborne weaponry and the apparent effects of a B-52 on the jungle foliage. Apparently, neither the film's grandeur and tragedy nor its politics made the slightest impression on him. This did not surprise Stoakes, who considered his friend a nuts-and-bolts man, a technician and cold-fusion genius. Poetry was for those who had time for it.

After the film they took the tube to Drewe's flat, where Stoakes was to spend the night. Drewe confided for the first time that he was involved in a romantic relationship with a woman named Batsheva Goudsmid. Before they turned in they vowed to work together again soon. In the morning, Drewe excused himself and said he had to leave. He did not want to overextend his energies. They would meet in a week or two, he assured his friend. Stoakes thanked him, and Drewe waved cheerily, with a strained smile.

They would not see each other again for well over a decade.

During those years Stoakes often imagined Drewe's comfortable and successful life, while his own life took a decided turn for the worse. He suffered from intense depression and was drinking heavily again. His marriage collapsed, and there was an ugly custody battle over his daughter. He fled southwest to the old port city of Exeter, where he managed to gain employment as a nurse, treating patients with end-stage dementia. His salary was barely enough to live on, and he had moved his few possessions into a mobile home. The same man who used to spend all-night sessions discussing arcane mental challenges with his soul mate now anesthetized himself in front of the TV for hours on end.

Then, one clear, cold day in 1994, he picked up the phone, tracked Drewe down through his mother, and called his old friend. They had a lot to catch up on. Drewe told him that his relationship with Batsheva

Goudsmid had gone to hell, and Stoakes confessed to the loneliness that now marked his own life. When he mentioned to Drewe that he had changed his Christian name from Hugh Roderick to Daniel, Drewe reacted palpably, something Stoakes would only later fully understand.

A few days later Drewe arrived in Exeter in a Bentley. They talked about old times, and Stoakes felt as if his long-lost brother had returned in the form of a great bird swooping down to pull him out of the muck and save him. Drewe said that Goudsmid, whom he had once loved, had become a danger to his children. He had tried but failed to have her committed. He claimed that Goudsmid had conspired with her father, a former Mossad agent, to destroy his career and take the kids away from him. She was an unrelenting harpy, a "savage" with powerful friends in Israeli intelligence. She had made bomb threats against him and had managed to freeze his bank accounts. Drewe broke down in tears when he talked about the children, and Stoakes was moved. "That grabbed me," he later recalled.

But Drewe went on to say that he had his own powerful contacts who could be convinced to act on his behalf, and Stoakes's too. Drewe waxed eloquent about their shared history and suggested they throw in their lot together. They were brothers in arms in a common struggle. He invited Stoakes to his new home in Reigate, two hours away by train.

When Stoakes arrived at the station a day or two later, Drewe was waiting for him in the Bentley. As they drove up to the house, Stoakes admired the impressive garden. Inside, he saw that Drewe had turned the living room into a workshop. There were picture frames in various stages of deconstruction, a mountain of clippings, sheets of foolscap, stacks of letterhead and file folders, pots of glue, rulers, and utility knives.

Drewe made tea and invited Stoakes to spend the night. They had a

great deal to talk about. The following morning, Drewe was up early and in good spirits. He sat his friend down and told him he'd had a vision, something they could work on together. He had a plan, a proposition.

"Listen," he said. "Listen to me."

STANDING NUDE

Armand Bartos Jr. was at work in his Upper East Side duplex in Manhattan when the long-awaited painting came in from Sheila Maskell, a New York–based private dealer and runner. Every once in a while, when she came across something really special, she would put in a call to Bartos. The last time they did business, she'd hooked him up with a *Smoker,* one of Tom Wesselmann's many quintessentially American pop art pictures of erotic red lips puffing on a cigarette.

Now she had something rarer and considerably pricier: *Standing Nude, 1955,* by Alberto Giacometti. Pieces from this period rarely came on the market, and Bartos was delighted to have one within reach. It had been painted a few years after the struggling artist finally gained international recognition. Its source, Maskell said, was the same group of "very substantial" Britons who had sold two other Giacomettis to

Bartos's colleagues at the Avanti Galleries, a portrait of a woman from the waist up and another standing nude.

Bartos had already seen a high-resolution transparency of the work, on the basis of which he could tell that the canvas was cracked with age and might have been improperly stored. Maskell said the piece had been hidden away for years. Its condition was clearly a problem, but one within the range of a restorer's ability. More important to Bartos was that the painting appeared to be superior in many respects to other Giacomettis of the same period. It was clear, precise, and fully articulated: Potentially, it was a real find.

Bartos had a good eye long before he went into the business. He was brought up in a cultured household, and as a young man he studied art history; for a time he considered himself a serious painter. He taught art at private schools in Manhattan, but eventually admitted to himself what he had long suspected—that he didn't have the goods to make it as an artist. He decided to move on to the business side. If he couldn't create art, at least he would wrap himself around the best of it. In an ideal world, he would live with Lichtensteins and Picassos and immerse himself in what another dealer described as "the last great luxury."[*]

To ease the transition, he took a job in the print department of Christie's New York branch, and then, after many years, struck out on his own. At six foot five he stood out even among the idiosyncratically beautiful people of the art crowd. With his thin, athletic frame and elongated Roman face, he looked rather like a Giacometti sculpture himself. He brought a genial manner and abundant knowledge to his work, and within a few years he was one of the city's prominent dealers, with a fairly dazzling collection of modern and contemporary masters housed in his thirty-five-hundred-square-foot duplex. He had several small Picassos, a Shawn Scully, works by Donald Judd and Dan

[*]Richard Polsky. *I Bought Andy Warhol*. New York and London: Bloomsbury, 2005.

Flavin, and a Calder mobile that hung over the dining room table. Some of these he owned outright, others were on consignment. Ever since he first set eyes on the transparency of *Standing Nude* he'd been imagining how it might look on the wall.

He unsealed the wooden crate, pulled off the bubble wrap and brown construction paper, and removed the cardboard that protected the canvas. Once he stood it up against the wall, it was immediately apparent that the transparency had not done justice to the work itself. Emerging from the depths of the canvas, nearly four feet tall, was a two-dimensional female figure with a searching, almost haunted look. In the lower right-hand corner, in a thick script of black paint, was Giacometti's unmistakable signature. Bartos was bowled over.

"It's the best one I've ever seen," he said to himself.

He looked through the provenance. There were receipts and invoices going back to the work's creation, and catalogs from exhibitions where it had been shown over the years. Nearly every document was stamped "For Private Research Only/Tate Gallery Archive."

Before he bought the painting outright, he thought it would be prudent to show it to some of his colleagues, and to his restorer. The damage and the cracks were more extensive than the transparency had revealed. Paint cracks were quite common in older works. Bartos knew that most of the aging in an oil painting occurs during the first five years, although it takes about fifty years for it to harden thoroughly. When it does, it often develops a fine web of cracks.

This Giacometti was in far worse shape. It looked like it was flaking off in sections, perhaps because the canvas had relaxed on the stretcher over time. His restorer said he could get the painting back in shape for less than $10,000.

The initial feedback from colleagues was good. During two separate flybys, experts from Sotheby's and Christie's estimated that once restored, the piece could fetch between $350,000 and $550,000 at auction.

Maskell's client was asking only $200,000 in return for a quick deal. Bartos stood to make a handsome profit. Sensing that Maskell was open to negotiation, he offered $175,000, and she accepted without hesitation.

When the work came back from the restorer several months later, it looked stunning. Bartos hung it up in the studio and decided to hold on to it until the right buyer came along. There was no hurry.

"It's a great piece that has fallen through the cracks," he told a friend. "It's what every dealer dreams of."

It was exactly what Myatt had dreamed of when, determined to make up for his failure with the Footless Woman, he stood before the easel and painted his perfect ten.

THE POND MAN

On the night of January 17, 1995, as a belt of cold rain moved eastward across England, Horoko Tominaga chose to stay in and watch television. The young Japanese student had rented a basement room in a run-down Victorian boardinghouse on the edge of Hampstead, a subway stop away from Drewe's neighborhood. Even though she had to share a bathroom and kitchen with several other foreign students, the rent was cheap and the Heath was close enough that she could always go out for a stroll whenever she felt cramped or homesick. Tonight the BBC was showing *Pride and Prejudice* and *Sounds of the Eighties*.

Tominaga flipped through the channels.

In Japan, a massive earthquake had shaken the city of Kobe.

In Texas, a retarded man convicted of murder was executed after the newly inaugurated governor, George Bush, turned down his appeal for clemency.

A little after nine Tominaga heard one of her housemates, Gina, coming downstairs to use the bathroom. An hour later Sandor and his girlfriend, Gyongyver, both Hungarian students, stumbled in from an evening on the town. Tominaga could hear them chatting and laughing upstairs. Around midnight she decided to turn in. She snapped the hall light on and walked to the bathroom. A man was standing inside, in the shadows. She couldn't see his face.

"Who are you?" she asked, alarmed.

The stranger said he had a meeting with the landlord, David Konigsberg, and was looking for his room. Tominaga led him up the darkened stairway to Konigsberg's room on the first floor and knocked on the door. There was no answer. The man asked to borrow Tominaga's cell phone to call the landlord, but again there was no answer. Then he asked if he could wait in the hallway until Konigsberg returned. Tominaga felt uncomfortable leaving him there, but this was a boarding-house, after all; strangers came and went.

She returned to her room in the basement, locked the door, and turned out the light. About thirty minutes later she heard footsteps moving quickly down the stairs, across the basement floor, and out the back door.

Tominaga had finally fallen asleep when a faint smell of smoke followed by a tumble of footsteps and shouts from upstairs jolted her out of bed. Wide awake, she opened her door and saw another of her housemates racing down the stairs toward the kitchen, shouting, "David's room's on fire!"

Tominaga helped him fill a saucepan with water and ran back up to the landlord's room with him. A wastebasket filled with paper was ablaze, and the flames were already licking at the ceiling. Tominaga and her housemate ran downstairs screaming. As the smoke detectors went off, they fled out the back door.

Outside, Tominaga looked up at the house through the rain and saw one of the other students crawling out of her bedroom window on the

second floor, then shimmying down a drainpipe to safety. The young Hungarians, Sandor and Gyongyver, were still trapped inside. Their only way out was through the window and onto the roof.

Sandor went first so he could pull Gyongyver up to safety. He climbed out and reached down for her, but she was frozen with fear, unable to move a muscle. Sandor screamed for her to climb, but the heat and smoke were unbearable. He pulled away, ran across the roof, and jumped to an adjoining building.

When he looked back, she was gone.

The next day Detective Richard Higgs sat at his desk in the Hampstead police station reading the preliminary reports on the fire at 49 Lowfield Road. By the time the firefighters had arrived at the scene, the three-story boardinghouse was nearly gutted. The investigators had determined that the fire spread too quickly to have been an accident. Higgs noted that none of the doors had been locked and that the fire alarms were intact.

All the students had escaped without life-threatening injuries save for Gyongyver: She had either slipped or jumped from the top floor and was found unconscious in a basement well. Her condition was critical, with severe burns and carbon monoxide poisoning from the smoke. Her ribs and pelvis had been fractured in the fall, and she was not expected to pull through.

If anyone had asked Higgs, a former fraud investigator, about his approach to detection and police procedure, he would have described himself as a "pond man." An investigation was like a pond: You threw a pebble in and watched the ripples. A good detective began in the quiet center, then proceeded methodically to the bank. Somewhere in between, he got his man.

Higgs set the file out on his desk: He had witness statements, photographs, the medical examiner's report, the fire marshal's log, and the

police report. In light of the young woman's critical condition, the fire had been bumped up to a high priority. Nevertheless, Higgs knew that his chances of finding the culprit were slim, no matter how many detectives he had on the case. Arthur Conan Doyle once said that forensic science was unique because with most sciences, "you start with a series of experiments and work forward. But in forensic science we have the finished product and we have to work backward." This was particularly problematic in the case of arson, where the statistics were not in Higgs's favor: Only about 16 percent of all arson crimes were solved, compared to an average of 28 percent for other crimes. Arson was particularly tough to prove. The evidence was destroyed by the fire, and the possible motivations were myriad, ranging from murder and intimidation to revenge and hate crimes.

Higgs had considered all these, and none seemed to apply. He had quickly ruled out the most obvious suspects. In 98 percent of all murders in Europe, it was a spouse or close relative who pulled the proverbial trigger, but most of the Hungarian woman's family lived abroad, and her boyfriend, initially a suspect, had been cleared. He had been severely burned on his legs and chest while he stood on the roof screaming for his girlfriend and trying to pull her out. When she died nearly one month after the fire, he would blame himself for her death and be placed under psychiatric observation.

As for the other students, all of whom were foreigners, none had reported racial or xenophobic harassment, which meant this probably wasn't a hate crime. Higgs also had to rule out pyromania: Firebugs tended to work serially, using the same modus operandi over and over again. In this case, there were no other reports of arson in Hampstead or in the surrounding neighborhoods.

There was another possibility. Arson was often used to cover up other crimes, such as fraud, and Higgs thought there were two possible suspects in this regard. The first was the stranger Tominaga had seen in the bathroom. With her help, the police put together a computerized

composite of a man in his forties, of average height and weight, wearing glasses and a mustache. The second suspect was the landlord. Detectives had recovered enough charred documents from his room to fill a Dumpster—among them, mail-order invoices addressed to different people, suspicious mortgage applications, and requests for rent aid, a state system set up to help landlords unable to rent out their premises. That was odd, Higgs thought, since Konigsberg had no vacancies when his boardinghouse burned down.*

Higgs's investigators discovered that a few days prior to the fire, one of Konigsberg's tenants had threatened to report him to the rent aid agency. Maybe the man had been spooked enough to burn whatever incriminating evidence was in the room and the fire simply got out of hand. Higgs tracked Konigsberg down to a shabby camper, where he had been living since the blaze.

The landlord had a solid alibi, but Higgs suspected he was hiding something. He ordered three of his men to trace Konigsberg's movements and reconstruct a minute-by-minute account of where he'd been in the hours leading up to the fire and what he'd done the following day. Higgs also wanted a full report on any other businesses Konigsberg was involved in.

Meanwhile, Higgs combed through the witness statements and noticed that one of the tenants at the boardinghouse had previously rented a room from Konigsberg at another address: 30 Rotherwick Road in nearby Golders Green. Why was Konigsberg renting out rooms in a house owned by someone else, a woman named Batsheva Goudsmid? It was a bit of a puzzle.

After twenty-nine years on the force, Higgs was weeks away from retirement. This would probably be his last case, and he had no intention of leaving it unsolved. He was determined to lock up the Hamp-

*Konigsberg was not formally charged with any crime.

stead firebug and leave a tidy office behind. Besides, it was always nice to get out of the station.

Higgs got into his unmarked car and drove the short distance to Rotherwick Road.

B atsheva Goudsmid stood in the doorway, in jeans and a sweater. She looked as if she'd been up all night. Higgs told her about the fire and asked her what she knew about David Konigsberg. She shook her head.

He's a crook, but he had nothing to do with the fire, she said, and suggested that the police would be better off looking for her ex-partner, John Drewe. "He kidnapped my children and brainwashed them. He's stolen all my money."

Higgs wondered whether she was mentally unstable. The more she talked about Drewe, the more agitated she became. Her voice went up an octave, and she started shaking. She said that Drewe had convinced their family doctor and a child psychologist that she was abusing their two children. He had submitted reports stating that she had killed the family pets, locked her daughter in the bathroom, and set a hallway on fire. He had also convinced the child psychologist to write a damning medical report that had gotten Goudsmid fired. More recently, he had told family court that she was mentally ill and an unfit mother, and persuaded them to grant him custody of the children.

They're all lies, she insisted.

Goudsmid told Higgs that she and Drewe had two Le Corbusier works that were now hanging on the walls of the family doctor's office. She believed that Drewe had bribed him with art. She said Drewe was still hounding her, and had recently reported to the police that she was trying to commit suicide.

"Four policemen broke the door down," she said. "I was stark naked

in the bath. He's trying to get me committed to an asylum so that he can take my house." On another occasion, she continued, Drewe had sent nurses to her home to take her away, and she had been forced to hide in her neighbor's gardening shed.

"I want him arrested! He's a crook and a murderer. He's the one who started the fire."

"Why would he do that?"asked Higgs.

Konigsberg had something on him and he was blackmailing John, she claimed.

Goudsmid explained that she had met Konigsberg a year before at a community meeting organized by their local synagogue. She asked him to help her rent out four rooms in her house while she visited her ailing father in Israel, and he agreed to make the arrangements. She claimed that when she returned a few weeks later, she discovered that he had rented out the entire house to half a dozen students and pocketed the money. He had also taken several paintings, she claimed, along with a pile of incriminating correspondence that he was using to blackmail Drewe. She alleged that a few days before the fire, Drewe had called her to ask about the landlord. He wanted to know whether Konigsberg lived alone and what kind of locks and alarms he had at the boardinghouse. She was sure that Drewe had burned down the house because he couldn't find the documents.

"What was in those documents?" Higgs asked.

Goudsmid suspected it had something to do with art. Over the years she had seen a stream of paintings and documents come and go from Rotherwick Road. Drewe always said that the paintings were gifts from his mentor, John Catch, but she no longer believed it. They were either stolen or forged.

Higgs put down his notebook and took a hard look at Goudsmid.

Her torrent of accusations was suspect: She had issues with Konigsberg, who she claimed had cheated her, and she had a mountain of

grudges against Drewe, who had left her after a thirteen-year relation-ship and now had custody of their two children. Higgs had spent too many hours around interrogation tables and drunk too many cups of tea in the presence of practiced circumnavigators not to know that in cases involving egregious marital dysfunction, one had to stay on one's toes. Here, a nasty custody battle appeared to have sent Goudsmid over the edge. Her partner had abandoned her and taken her children away. She was paranoid and inconsolable, a classic jilted woman.

He asked Goudsmid for Drewe's phone number and thanked her for her time. As far as he was concerned, she was one of the most disagree-able people he had ever interviewed, but still he felt a small dash of sympathy.

Back at the station, he searched for any mention of Drewe in the database. The professor had no priors. He was now living with a Dr. Helen Sussman in Reigate, an affluent town in Surrey, fifteen miles from London. The detective picked up the phone and dialed Drewe's number.

The man who swept into Hampstead Station was not what Higgs expected. Goudsmid had described her ex as a lout and a bully, an unscrupulous schemer who was capable of murder. The police thought they were in for a long and fruitless afternoon searching through the detritus of a marriage gone sour, but the gentleman who stood before the desk sergeant seemed poised and cooperative.

Everything about Professor John Drewe suggested confidence and accomplishment. He wore a tailored suit and spoke with an upper-class accent. He seemed relaxed and waited quietly for the detectives to es-cort him to one of the interrogation rooms.

Once they were seated, Higgs told him about his meeting with Goudsmid and described her long list of allegations.

She's a disturbed woman, Drewe said calmly. If the detectives had any doubt, they could check with Social Services, which had been to see her several times and could verify her mental state. He admitted that he and Goudsmid had been through a messy breakup, and that he had been granted initial custody of the children, but he said they were still squaring off with family court. Meanwhile, the children were living with him and his new partner, whom he planned to marry, and were in a stable environment.

Goudsmid was bitter and angry, he told the detectives mournfully. The poor thing would say anything. He had let her stay at Rotherwick Road, even though he owned half of it, and he was paying for the children's expenses.

The police wanted to know how he knew Konigsberg. Had he ever been in the house on Lowfield Road?

The professor had never heard of the man, nor had he set foot in the place, and he had an alibi: He had been with his fiancée on the night of the fire.

Where was he currently teaching, and how long had he held that post?

Drewe did not see how any of this related to the investigation. There was no need to go into it. Suffice it to say that he was a nuclear physicist and a businessman with interests in Britain and on the Continent. He had had dealings with Her Majesty's government and had contacts at every level, including the Secret Service. Then he apologized to the officers, saying that he had several meetings ahead of him and that there was nothing else he could do for them. They were free to contact him if they had any more questions. With that he left the station, slipped into the back of his Bentley, and drove away.

"What an arrogant bastard," thought Higgs. "He acts like he's doing us a favor. He expects us to tip our caps."

Higgs was determined not to let his personal feelings compromise his professional judgment, but it struck him that Drewe was unusually

composed throughout the interview. Higgs had been around long enough to know that even the most innocent of citizens tended to be nervous when they were hauled down to the station.

The professor seemed a little too relaxed. The detective figured he was looking at the next ripple in the pond.

MYATT'S BLUE PERIOD

John Myatt put on his best suit and headed down King Street to Christie's, where a crowd was spilling out of cabs and limos and into the lobby. The women were wearing their good jewelry, and Myatt could smell the powder and perfume. Feeling under-dressed and fidgety among the tuxedos and Chanels, he made his way to the salesroom and took a seat toward the back. About two hundred serious collectors and dealers sat in reserved seats, holding marked catalogs and numbered paddles and waiting for the bidding to kick off. Each year the house held two major sales of contemporary art, and tonight there were Vasarelys and Oldenburgs on the block, as well as Christos and Calders, Warhols and Hockneys.

And Dubuffets, half a dozen of them, courtesy of John Myatt and his labors during many quiet hours in Staffordshire.

Today, for the first time since he'd joined forces with Drewe, he was about to witness a sale of his work. The phones were open, and a

gaggle of Christie's staffers stood beneath a row of million-pound paintings fielding last-minute starting bids. Myatt could feel the tension in the room, an air of intense acquisitive desire coupled with unlimited resources. A handful of well-dressed men with cell phones milled about on the fringes of the crowd, just as Myatt had imagined them: slicked-back hair, wives and mistresses in Dior head scarves and Gucci shades.

He had been looking forward to this for years. A sale at a major auction house would have been an achievement for any artist, and Myatt was no exception. Tonight's event was an acknowledgment that his skills had their own peculiar value in this reptilian marketplace, and there was the added satisfaction of being in on a mammoth inside joke. He and Drewe had managed to play an extended and very profitable game of reverse blindman's bluff.

Myatt sat patiently and waited for his Dubuffets to come up. He had based these childlike renderings of cows on a series of bovine forms created some four decades earlier by the French painter, who had coined the term *art brut*. A Christie's catalog for a later auction offering a genuine Dubuffet cow would proclaim that the artist had "harnessed the actual countryside, as he has painted not with oils, but with the very stuff of nature"—a blurb that might have amused the farm boy in Myatt. He had never much fancied the originals, which Dubuffet styled after drawings made by children and the mentally ill, but he knew he could forge them without breaking a sweat. To add to the luster of the bogus cows, Drewe had put together a slick provenance package that included genuine Dubuffet documents "borrowed" from the ICA. The provenance indicated that the works had once belonged to Lawrence Alloway, a former assistant director of the ICA and senior curator at the Guggenheim Museum in New York. Drewe had even managed to get the Dubuffet Foundation to authenticate them.

Myatt held his breath as the bidding began and his drawings sold, one by one, for a total of about £60,000. He had dreamed of being

present at such an auction ever since the scam began. He'd imagined the tingle of adrenaline as the paddles went up, then a record sale, followed by a victorious stroll through the city streets with a wad of money in his back pocket. The orchestra would swell as he gulped the cold winter air, the elusive forger with the dangling cigarette, a cloak flung over his shoulder and a smile on his face. He had expected a sense of relief and accomplishment, but the reality was quite different. He felt empty and disappointed.

He went up the street to a coffee bar and ordered a cappuccino, hoping it would lift his mood. He was thousands of pounds richer now, but he felt miserable, even though things had been going quite well. While the business had never yielded enormous profits for him, there was always plenty of money in the account for his simple needs, and he had developed a solid partnership with Drewe.

Every other Thursday, Myatt would bring some new work down to London in his Rover, Drewe would show up in his Bentley, and they would have a bite together. Their lunches were always enjoyable, a chance for Myatt to break free from the routine of painting and fatherhood. Drewe would order a good bottle of wine and drink copiously, and though he tended to flirt clumsily with the waitresses, he was never unruly. Myatt considered his partner utterly without sexual charm, so he found these flirtations both amusing and sad. He knew Drewe and Goudsmid were on the skids, and guessed that Drewe needed these little stabs at happiness, which inevitably ended in failure. After lunch, Myatt would hand over one or two paintings, and the professor would promise to deliver payment in a fortnight.

Lately, though, there were times when Myatt never got paid, and he had begun to suspect that Drewe was holding out on him. The professor always had an explanation. "Recession, John," he'd say. "Business is bad. It's only going to get worse." Occasionally he'd turn up the next time with a stuffed envelope, and life would be rosy again for a while.

Myatt sat hunched over a second cappuccino. The street outside

Christie's was nearly empty except for a few well-heeled buzzards wandering up toward St. James. The limos were gone. He made a rough calculation: His profits from Drewe's game—perhaps £100,000 over eight years—amounted to just about what he would have earned if he'd stayed at his part-time teaching job. Drewe had figured out exactly how much Myatt needed to keep himself afloat, and that was exactly what he'd given him.

Meanwhile, Drewe had been raking it in. By now he'd taken half of London out for quail and venison at L'Escargot and Claridge's, and plied an ever-expanding roster of experts and curators with imported cigars and wines. He was at the top of his game, and his self-confidence seemed never to waver.

Myatt, on the other hand, felt like a petty thief. For most of his life he'd yearned for membership in the society of artists and art lovers, but after tonight's auction that world seemed as shallow and false as the scam. His skills at the easel had been eclipsed by Drewe's talent as a provider of fake provenance, and most of his paintings were horrible knockoffs anyway. If he'd signed them himself and rented a showroom, they would have been laughed off the wall. He wondered what kind of life he would be leading five or ten years from now. What would he tell his children? That he was a two-bit criminal who had squandered his talents?

So far he'd managed to lead a comfortably compartmentalized life. He did his job quietly and without bothering anyone. He was a good father, an artist, a sometime musician, an occasionally respectable member of his community. Half the time he sang with the church choir and painted portraits of the vicar. The other half, he forged pictures. The two Myatts coexisted without much fuss, as if one didn't know that the other existed.

Drewe had at least one Swiss bank account and encouraged Myatt to open one for himself and to deposit £25,000. According to Myatt, Drewe had also suggested that he open additional accounts in Russian

banks, which he claimed were the best places to hide money. He'd encouraged Myatt to invest in diamonds, as he himself had, and told his partner that he kept a stash hidden in a pouch behind his lavatory.*

"You can't go wrong with gems," he said.

Myatt was grateful for the advice but hadn't followed it. He wasn't interested in the high life, and never dreamed of buying a new house or car. All he wanted was to provide for his children. He was earning enough from the fakes, he'd told Drewe, and happy enough to be in business with him. He had never once looked back.

But now he felt a wave of shame—an unfamiliar emotion that had never been part of his repertoire. He paid for the coffee, got into his beat-up old Rover, and drove north.

At home, the children were asleep and a blank canvas was staring at him from the easel. He went to bed and woke the next morning with something akin to a hangover, which he recognized as leftover self-disgust from his night in the doldrums on King Street.

With little enthusiasm he began work on a new Braque. Using various shades of burnt sienna and dark brown, he painted recklessly and without inspiration. By the following day he'd accomplished nothing. In frustration, he dipped his brush into a can of bright red emulsion and slapped it onto the canvas. The red stood out for miles, a little dash of angry Myatt. The piece was dreadful, but he didn't care. He deserved a kick in the arse. He deserved to get caught. At the same time, he was terrified of getting caught, and he still felt some loyalty to Drewe. He had no idea how to get out of the game.

When he dropped off the Braque at their next meeting, he begged Drewe to rethink the operation. He suggested that they take a nine-

*The judge in a subsequent confiscation proceeding confirmed that Drewe had opened Swiss bank accounts. Although Drewe authorized the banks to provide the police with details, the police were not able to obtain precise details of the accounts and their contents.

month breather from the conveyor belt and do things a little differ-
ently. Rather than cranking out paintings, he would focus on a single
work, a small still life, say, or a Cézanne landscape. He had always
worked from secondhand material, and now he wanted to get his hands
on an original. He wanted Drewe to bring something genuine into
the studio so that he could sit with it and take it in. Then, if the gods
were on his side, he would go to work and produce something top-of-
the-line, something absolutely right for a change. He would re-create
the work faithfully. He would dust off his old art books and find the
perfect age-appropriate brushes and paints. Drewe's job would be
to concoct the perfect provenance, a leakproof, rock-solid archival
masterpiece.

One last glorious sale and they could both retire.

"Let's do it properly or not at all," he told Drewe.

The professor was unmoved. They were on a roll. The ship was on
course. Why spoil things?

Myatt confided his fears of ending up in prison.

"Don't worry," said Drewe. "If you put a fake work through
auction, it's the auctioneer who takes the blame. Sotheby's or Christie's
would have to reimburse the buyer. No one gets hurt. We're free
and clear."

Rubbish, thought Myatt. They would never be safe.

It occurred to him that Drewe was addicted to the con, that every
sale was like a junkie's rush to him. The money wasn't the object, it was
the scam itself. Drewe had begun to believe in his imaginary status as a
collector and to speak about the paintings as if they were authentic. Like
every bad drug run, this would all come to a dreadful end. The market
simply could not absorb the number of fakes they were producing. If
they continued as usual, they would almost certainly get pinched.

When Myatt suggested again that they slow things down, Drewe
replied that he was under intense pressure from dealers and collectors
to come up with *more* work. Some of Myatt's paintings had been

returned to him, and a few clients were asking for their money back. This was no time to turn tail. If anything, they had to expand the business, not wrap it up. He proposed to add Russian and American artists to their roster, and urged Myatt to come up with one or two good Barnett Newmans and a few Frank Stellas from his 1960s period. These were certainly within Myatt's range, and would be highly marketable.

There was an irritation and impatience in Drewe's voice that Myatt hadn't heard for years. In the early Golders Green days, Drewe had had tantrums now and then, but they were short-lived and usually provoked by a losing hand at bridge. Now the bad moods lasted for days. As Drewe obsessed over every bad transaction and cursed the dealers who had crossed him, the color rose to his scarred neck and the cork came off. A rage that had been kept under wraps swept through his system, his whole body shuddered slightly, and his facial muscles contorted. Myatt felt obliged to sit with him and ride out the storm, but the rants were becoming more and more worrisome.

Myatt wondered what had precipitated the change in Drewe. He thought back over the past year or so and recalled the many occasions on which he had witnessed or heard about Drewe's deteriorating situation at home. Once, when Myatt brought a new painting over to Rotherwick Road, he'd found Goudsmid and Drewe facing off on opposite sides of the living room. Goudsmid was in the middle of a full-blown tirade, screaming that Drewe was a liar, an impotent bastard, and a crook. Drewe stood there with no expression on his face, waited for her to finish, and then hustled the embarrassed Myatt outside. They walked to a local pub and talked until closing time.

Drewe told Myatt that Goudsmid had become dangerously unstable and suffered from a serious mental illness. She was paranoid and had been diagnosed with Munchausen syndrome by proxy. She had declared all-out war on him, and he feared she might harm the children. After one argument, he said, she had thrown boiling water on the family dog. Then she had put the pet goldfish live into the microwave.

For the next few weeks Myatt had received updates on the couple's deteriorating relationship, until Drewe finally called to say that the relationship was over, that he had left Goudsmid, taken custody of the children, and moved out to the country.

One night not long after, Drewe and Myatt met for dinner at one of their favorite Italian restaurants in Hampstead. Drewe drank heavily. Afterward they went out to the parking lot to look at a new piece Myatt had brought in. Drewe was beaming, reeking of Beaujolais and puffing on a cigar. Myatt opened the trunk of the Rover and handed him the painting, a Giacometti crayon and pencil drawing of a man standing beside a tree. Drewe held it up to the bright neon lights.

"I don't think you realize, John, that this is a classic example of the artist's work," he said. "It's powerful, simple, and symbolic. You don't know how important it is."

"I know what it is," Myatt said. "I bloody well painted it."

Drewe's jaw clenched. "Don't ever say that again," he snarled.

Myatt remembered wondering, in the wake of that incident, whether Drewe was losing touch with reality. He'd called him up the next day and again made the argument for quitting the game, but there was no getting through to him. He'd written Drewe a long and heartfelt farewell letter but hadn't had the courage to send it. It was tucked away in his briefcase.

Now a cloud hung over their friendship, such as it had been. Whenever they got together, Drewe went on for hours about his problems with Goudsmid and various art dealers, and endlessly repeated his stories about MI5, his weapons training, and his expertise in methods of interrogation, assassination, and political reprisal. Myatt could no longer follow these increasingly obsessive monologues.

One night, as they were walking through the city, Drewe pulled Myatt into an alley, opened his overcoat, and showed him a pair of

handguns tucked into leather holsters. He drew one, pointed it directly at Myatt's face, and smiled, and then laughed. He repacked the weapon and walked on as if nothing had happened.

That was the last straw for Myatt. Drewe was definitely crazy, and it was no longer a question of scaling back the business. Myatt wanted out. There was just one problem. If he quit now, he was sure Drewe would go after him, and maybe even his children. He thought the professor was quite capable of killing him. Drewe, in his paranoia, would build a case against Myatt in his head and then try to eliminate him. The two men had worked together for nearly a decade, and Myatt knew nearly every angle of the con. He knew about the professor's larcenous visits to the Tate and the V&A and the British Council, and he had met several of Drewe's runners. He knew too much.

Back in Sugnall, Myatt sat down on the sofa and had a stiff drink. What a bloody great fall from grace, he thought. From the beginning the scam had been a huge and soul-devouring mistake. He had been deceiving himself for years, ignoring the sharp end of what he was doing. He needed to talk to someone, but there was no one he could trust. He contemplated calling the police.

The phone rang. It was Drewe, calling from a service area on the highway.

"I can't talk on your private line," he said. "It's not safe. Go down to the old phone box down the lane and I'll ring you there."

Myatt put on his coat and went outside to wait for the call.

"We're in a jam, John," Drewe said. He claimed that someone was trying to blackmail him and he'd been forced to take extreme measures. "Incriminating evidence" linked them both to the scam, and he'd had no choice but to break into the blackmailer's house and "take steps."

"What steps?" Myatt asked.

"Let's just say there was a very smoky experience."

A chill ran through Myatt's bones.

"You do realize that you're part of this as well?" Drewe said.

Myatt felt sick. He thought about turning himself in, but who would care for the kids if he went to prison? He wondered whether Drewe was bluffing again in order to keep the paintings coming in. Had there really been a fire? Was this another of Drewe's extended theatrical pieces?

Myatt had painted more than 240 works for him, and Drewe must still have plenty of them. He didn't really need Myatt; he could stay in business for years without him. Myatt was expendable. He thought about those guns and the way Drewe had smiled. He felt as if he'd been swept out to sea and had to swim back to shore, somehow keeping his head above water until he could feel the sand beneath his feet. Then he could start again.

Drewe phoned a couple of days later in the dead of night. Myatt shot up in bed. "Don't call here again," he shouted. "Just fuck off."

Drewe was silent for a moment, and then he hung up.

THE CHAMELEON

Higgs was sure he was dealing with a con man.

Batsheva Goudsmid had given him a list of Drewe's acquaintances, each of whom had provided a slightly different version of the professor. Some knew him as a physicist and researcher, others as a consultant for the intelligence services. Still others described a man who had spent his time working abroad on behalf of the government in some mysterious capacity. They were all willing to vouch for him, but none of them had anything substantial to contribute to the slim profile the police had assembled.

Higgs knew that people lied all the time, and that fibbing was an integral part of everyday communication. He had seen prevaricators of every sort during his many years on the job. Studies suggesting that people lied on average once or twice a day would not have surprised him.

Drewe, however, was no mere liar. He was a mirage.

Higgs wanted to hear his voice again. He pulled out the audio-tapes of Drewe's interrogation after the fire and put on his headphones. The voice was as he remembered it, soft, elegant, and assured. Drewe sounded absolutely calm until one of his interrogators interrupted him, and then he sighed theatrically and his tone changed. When he was asked to repeat an answer, he sounded as exasperated as a teacher in a classroom of half-wits. Questioned about his stint in academe, the professor had refused to say where he taught.

Higgs put the headphones away and began calling around to the universities to see if Drewe's claims stood up. Britain's universities gave out professorships only to the most distinguished scholars, so Higgs was skeptical. He discovered that there was no record of Drewe's having taught in Britain or on the Continent, and that while he claimed to have conducted research in Russia, Germany, and France, he had never published a single paper. Higgs doubted Drewe had ties to the intelligence community, as he had claimed; if he did, MI5 would already have warned the detective off.

Rummaging through police databases, Higgs's investigators were unable to find tax or medical records, a driver's license or credit history for John Drewe. They learned that he and Goudsmid had opened a joint bank account and cosigned a substantial mortgage for the house on Rotherwick Road, but that the down payment and the risk were apparently all hers. While Higgs could find no evidence that Drewe had earned, saved, or owed any money, the man was clearly doing well for himself, for he had a bodyguard/chauffeur on retainer and a good table at Claridge's.

Higgs studied the composite of the man Horoko Tominaga had seen shortly before the fire. It bore a slight resemblance to Drewe. When he called the professor to ask a few follow-up questions, Drewe was no longer quite as affable as he had been earlier.

"Back off," he told the detective.

Drewe knew that Higgs had been asking around about him, and he

warned that this fresh round of inquiry verged on harassment. If Higgs did not leave him alone, Drewe would lodge a protest with the head of the Police Complaints Authority. He said he was good friends with the chief and mentioned him by name. Higgs suspected that he was bluffing and immediately rang the PCA to see if anyone had called to ask for the chief's name. He had guessed correctly: Just a few days earlier an unidentified gentleman had called to ask that very question. Slippery fellow, thought Higgs.

The detective had his own reasons for disliking con men. During his years on the force, he'd faced off against several of them. On one occasion he received a report from a hotel manager on Oxford Street about a suspicious-looking briefcase left in the lobby. Higgs rushed to the hotel, opened the case, and discovered a pile of financial statements, photocopied documents that were clearly cut-and-paste jobs, an assortment of IDs, some blank company stationery, and ink and rubber stamps.

As he rummaged through the briefcase, the owner returned, spotted Higgs, and bolted. The detective chased him into the afternoon traffic, dodging buses, climbing over turnstiles and store display cases, until he finally tackled him. During the struggle Higgs took a kick to the side of the head that left him permanently deaf in one ear.

The perp's rap sheet described a lifelong con artist who had recently taken a job as a night-shift cleaner at a pension fund in order to gather information about its finances. He was about to complete a wire transfer of £750,000 from its account when Higgs caught up with him. Much like Drewe, the perp was a fast talker and a persuasive chameleon.

Higgs's other close encounter with hucksters was more personal. His mother, a tough Scotswoman who had raised three children during wartime, had been conned repeatedly by phone charmers preying on

the elderly. Generally, they would call at suppertime to tell her she had won a prize she could access only by calling a certain telephone number. She would spend hours on the line, running up bills at premium rates chasing dreams.

Higgs had read up on professional scammers and found that criminologists had developed a psychological blueprint of the confidence man based on descriptions provided by their unhappy marks. Most victims recalled the con man's beautiful delivery, the effect of his purring voice on the semicircular canals of the inner ear, the perfect timber and cadence, the whiff of expertise. The come-on produced a feeling that something unprecedented was on the way, a shift in fortune, a sea change. Experts referred to this phenomenon as the "phantom dream" and considered it the basis of every decent scam. The mark always craved something that was out of reach, and the con man knew how to identify the mark's particular longing and zero in on it. A good confidence man could pick his mark out of a crowd as easily as a spotted hyena could tag a sick wildebeest. Once the game was up and the embarassed mark realized he'd been had, he would invariably stumble into the police station to describe the rake's method, his extraordinary lightness of touch, his talent for skating around craters of logic, for touching the victim deep down, in broad daylight, under the glow of his own ineffable charm.

With his pathological urge to reinvent himself, Drewe was one of a long line of con artists and fakers. London, like other major cities, had always been a magnet for dream peddlers. Over the years its detectives had seen some of the world's great con men up close. In the 1920s, a Scottish scammer named Arthur Furguson discovered that it was child's play to take visiting Americans for a ride: He sold Nelson's Column to slow-witted souvenir hunters for 600 quid a shot, offered Big Ben for a £1,000 down payment, and fobbed off Buckingham Palace for a first installment of £200. When Furguson realized that Yanks made particularly easy marks, he set up shop in the United States. In 1925, he

found a rancher willing to lease the White House for $100,000 a year. Later, less successfully, he tried to sell off the Statue of Liberty to a potential mark who got wise and turned him in. Furguson spent five years in prison but continued to ply his trade until his death in Los Angeles in 1938.

Then there was the Scottish con man Gregor McGregor, who lured hundreds of British investors and would-be settlers from London to the nonexistent country of Poyais in Central America. McGregor escaped with hundreds of thousands of pounds, leaving the settlers stranded in the jungle. A distinguished-looking British hustler named Limehouse Chappie, who worked both sides of the Atlantic, scammed passengers on ocean liners, and may have served as a model for the elegant card-sharp in Preston Sturges's *The Lady Eve*.

The Bohemian-born con man Victor Lustig, who ran his scams with an American sidekick, engineered the sale of the Eiffel Tower to a group of naïve scrap-metal dealers. Lustig would eventually set his sights on the wide-eyed rubes of the New World. With his apprentice in tow, he hoodwinked the gullible in half a dozen U.S. states, ending up in Alca-traz. His death certificate listed his profession as "Salesman."

The term "confidence man" was coined by a journalist at the *New York Herald* to describe the conduct of one William Thompson, a scam-mer and jailbird whose MO was a three-piece suit and a smile. Thomp-son would approach wealthy New Yorkers with a self-possessed air, strike up a conversation, and unleash an engaging line of prattle. "Have you confidence in me to trust me with your watch until tomorrow?" he would say, and the victim would cheerfully give up his timepiece. All well and good until July 7, 1849, when Thompson was collared on Liberty Street by an officer named Swayse just as he was taking off with his mark's $110 gold lever watch. Thompson was returned to Sing Sing, where he'd learned his silken ways.

Eight years later Herman Melville adopted Thompson's soubriquet as the title of his famously unreadable last novel, *The Confidence-Man*.

Within a decade of its publication criminologists were reporting that 10 percent of professional criminals were confidence men. The sweet-talkers, they said, had taken over the sidewalks.

Professional bilkers often say that it is impossible to con a completely honest man, that the con man relies on the greed of his "vic," on the poor fellow's unbridled imagination and his wish to dream himself out of a jam. Social scientists who have tried to chart scammer pathology describe the con man as a combination sociopath and narcissist. Typically, he is impulsive, amoral, and uncontrolled, highly intelligent, detached, misanthropic, grandiose, and hungry for admiration. Alienated and often self-taught, the con man feels unique and superior until he is trapped. Then he claims to be a victim of circumstance or of an uncaring society. He tells police that he has been knackered by circumstance, that his bitterness is a function of society's failures and the vagaries of fate. Then, on the way to the lockup, knowing that the game is up, he drops all pretense and declares that his victims deserved to be conned, that greed is a fox-trot and it takes two.

One such schemer, quoted in *The Psychology of Fraud,* a 2001 study published by the Australian Institute of Criminology, told his inquisitors that he felt entirely justified: "The [victim] had it coming. There's no harm done. He can afford it." Under questioning, he admitted that the pleasure of the scam was the point of it all. "When I score, I get more kicks out of that than anything," he said. "To score is the biggest kick of my life."

One of the more talented and famous con men was Ferdinand Demara, an American hospital orderly who assumed the identity of a doctor during the Korean War and performed a number of successful surgeries. With minimal education, he posed as a civil engineer, a sheriff's deputy, a prison warden, a doctor of applied psychology, a lawyer, a Benedictine and a Trappist monk, a cancer researcher, and an editor. While he never made much money at any of these deceptions, he gained a short-lived respectability. A brilliant mimic with a hugely

retentive memory, he studied textbooks to master the techniques he needed to perform each new character's role. Demara, who was portrayed by Tony Curtis in the 1961 movie *The Great Impostor,* once described his motivation as "rascality, pure rascality." Six feet tall and 350 pounds, he died in 1982 at age sixty after suffering a heart attack. He had two cardinal rules: First, always remember that the burden of proof is on the accuser, and second, when you're in danger, attack.

John Drewe seemed to have mastered both rules.

Detective Higgs was beginning to wonder if Batsheva Goudsmid had been conned by Drewe, and if there might not be some truth behind her accusations that he was involved in selling stolen or forged art. For weeks she had been badgering the detective to arrest Drewe, berating him and the rest of his squad. These harangues had done little to endear her to Higgs's men, serving mainly to reinforce the notion that she was off her rocker, but Higgs had come to feel that her hysteria might be justified. She had reason to think she was under attack.

Higgs called family court and was told that Drewe had indeed been granted custody of the children, and that Goudsmid was considered mentally unstable. They had based their decision, in part, on Drewe's status in the academic and scientific communities.

Higgs pointed out that there were enormous gaps in Drewe's story. "I can't find any substance to this man," he told a court official. "Something's off."

By early May, four months after the fire, Higgs still had no evidence that Drewe had a motive for setting the fire. The only strategy left was to put Drewe in a lineup and see if Horoko Tominaga could identify him as the stranger she had seen in the boardinghouse bathroom, a man of average height and weight, in his forties, with glasses and a mustache.

Higgs scheduled the lineup and arranged to have Tominaga flown

back from Japan. When she arrived at the Hampstead police station, it was too late: Drewe had already come and gone. He'd complained that the lineup was stacked against him because he was the only one wearing a suit, and would therefore stand out. Higgs knew that if Tominaga had picked Drewe out as the perpetrator, he would have been able to challenge the police successfully in court. The detective was furious: The least his colleagues could have done was loan Drewe a pair of jeans and a shirt.

He rescheduled the lineup for the following week, but when Drewe arrived he was unrecognizable. He had cut his hair short, shaved off his mustache, and shed his glasses. Tominaga looked carefully at each man but could not identify the stranger she had seen in the bathroom. Without her testimony, the police had nothing to go on—not a shred of evidence linking Drewe to arson—and they sent her home.

Neither did the police have any evidence that Konigsberg had blackmailed Drewe. The investigation was stalled.

When Goudsmid heard what had happened, she called Higgs in a rage. "You had him and you let him go?" she sputtered.

But there was nothing Higgs could do. He only had the authority to investigate the fire, and Goudsmid's suggestion that Drewe was being blackmailed by the landlord had been reduced to mere speculation. Whatever evidence there may have been of an elaborate con job had gone up in smoke.

A Loaded Briefcase

Goudsmid wandered through Golders Green in a daze. She looked unkempt and could barely eat. She had lost her children and most of her savings to Drewe, and now he was threatening to take the house on Rotherwick Road. Detective Higgs had been her last hope, and she was close to the breaking point. She went inside her home, got down on all fours in the living room with a Magic Marker, and made a picket sign that accused John Drewe of being a criminal. Then she drove to his country home and stood outside with her sign. A neighbor took pity and brought her a cup of tea. She felt as if she were going mad, but she was determined to fight until the children were back with her and Drewe was behind bars.

It would have been out of character for Goudsmid to back down. She was brought up in the shadow of the Holocaust, and her parents were both survivors. At age eighteen, like most Israelis, she was drafted into the army. Outside Tel Aviv, in former British army camps, in

hundred-degree heat, she and her fellow conscripts trained to shoot. They went out with their Uzis and practiced on cardboard cutouts, peppering the silhouettes until they were exhausted. When Goudsmid's mandatory tour of duty was over, she decided to stay on and signed up for the navy. She was focused and ambitious, and by the time she left the Israeli Defense Force she carried her training like a second skin.

Goudsmid had an air of imperviousness that could be misunderstood as intimidating. She had learned to be careful and observant, to question everything she saw. She noticed the most mundane detail, an unusual movement or suspicious package, a telltale accent in a crowd. But she had somehow let her guard down when she met John Drewe at a small get-together in London in 1980. An attentive man, he courted her vigorously. In restrospect, she could never quite explain this blunder, except to say that she was a recent immigrant, lonely, and several weeks pregnant by a former boyfriend at the age of thirty-four. She had no nearby family to speak of, and Drewe was a polite and well-to-do nuclear physicist who offered her his friendship.

On their first date, Drewe picked her up in a chauffered white Rolls. His driver wore a cap and uniform, and Drewe sat in back smiling and holding a bouquet of roses. He was good-looking, with short black hair and an athletic build, and he wore a well-tailored suit and a long coat.

"If you ever turn up in that car again, forget it," Goudsmid told him. "I'll never go out with you again."

He laughed, folded her into the backseat, and took her to a very good restaurant, where they talked for hours. He was an adviser to the Atomic Energy Authority, he said, and served on the boards of several companies, including British Aerospace. His time was his own. He worked in his lab and at home, where he wrote for the specialty journals. She noticed that he had a scar, and he explained that as a young man he'd had a passion for motorcycles, and that he'd hit a patch of ice one winter's night and slid across the road.

The next time they met she talked about her hometown, and told him how hard it was to grow up in a family that had been shattered by the Holocaust. Her parents had fled Germany and were now living in Holland, but less fortunate relatives had ended up in Auschwitz and Bergen-Belsen. More than three hundred members of her extended family had died in the camps. After the war, her parents received compensation from Germany and passed some of the money on to her. She planned to use it to buy a modest apartment in London.

Drewe was always attentive: He would open the door for her and make her dinner and put his coat over her when it was cold. He phoned her at least once a day and surprised her with flowers and the odd bit of jewelry. It was a relief having him around. One summer day he picked her up and took her to Sussex to hear Mozart at the centuries-old Glyndebourne opera house. During a long intermission they went outside and picnicked. She told him she was pregnant and wanted to keep the baby, and he promised to help in any way he could. A few months before she was due to give birth, he suggested that he move in with her so he could help her through the difficult times. She wasn't sure whether she was in love with him, but his caring presence was no small comfort, and she thought he might make a good father and provide a safety net for the infant.

Goudsmid named her son Nadav, meaning "generous of heart." A year and a half after his birth, she and Drewe had a baby daughter, whom they named Atarah, the Hebrew word for "crown." Drewe bought the children more toys than they would ever have time to play with, drove them to day care, and was gentle with them when they were sick. He was often the only father in the playground, where the nannies dubbed him "the professor."

When Drewe asked Goudsmid to marry him, she said she needed time to think about it. There was something a little off about him, she thought. He claimed to be obsessed with her but seemed happiest when he was alone, working or reading in his room. Whenever she had friends

over, he tended to stay in the background, pouring drinks and keeping the coffeepot going, but she could feel him hovering, and it always came as a relief when he disappeared upstairs. Finally she turned down his marriage proposal: The present arrangement was good enough, she said. Drewe continued to introduce her as his wife.

As she would later describe in sworn testimony, when Goudsmid bought the house on Rotherwick Road, Drewe persuaded her to put it in both their names, and to take out a mortgage for a good deal more than she had intended. He reminded her that they were about to receive £2 million from the elusive John Catch. When the money failed to materialize, he brought in several paintings, purportedly from Catch's collection, and told her the profits from the sale of the works would make them rich.

One day she looked out the window and saw Drewe crouched in the garden with a vacuum-cleaner bag and a bucket of dirt that he was smearing on a Giacometti painting. When she asked him what on earth he was doing, he said that the painting had been sitting in Catch's vault for years and looked "too fresh." Drewe was applying a traditional marketing technique that gave paintings a weathered look and made them easier to sell.

Goudsmid took little interest in Drewe's work. Their relationship had cooled considerably since they first moved to Rotherwick Road. He was always busy, on the hustle, out and about to restaurants and fancy parties, and she was doing well enough with her own career. He once invited her to a soiree at the Chinese embassy, where he introduced her to the military attaché. It was a dull evening, and she had turned down subsequent invitations.

Drewe began making occasional deposits of thousands of pounds into their joint account, but he also dipped into it heavily, burning through as much as £12,000 a month and covering the frequent over-drafts in dribs and drabs. He explained the expenses as the cost of "entertaining business clients," but she eventually stopped depositing

her salary into the account. They often fought, and she asked him several times to leave. He refused, saying it was best to wait until the children were older.

Goudsmid and Drewe slept in separate rooms and rarely ate together. She would leave the house early in the morning and work late. When he returned from his business meetings, he would shut himself up in his room with his newspapers and books. He had dozens of books on the Mossad and MI5, on science, mysticism, and the occult, and a whole section on the kabbalah. He ordered reading matter by the boxful and stored the overflow in the garage behind the Bentley.

By the time Nadav turned ten, he was a computer whiz, and Drewe began to spend more time alone with him. Goudsmid would see them in the glow of the terminal with piles of documents scattered around them. Drewe had a supply of scissors and paste, and a small box filled with rubber stamps and tools a lepidopterist might have found useful. Once, she surprised him as he was using a small paring knife on a document. He told her he had lost the receipt for one of John Catch's paintings and needed to "reproduce" it.

He also told her he had inherited a dozen guns from his father and kept them in the attic. Once, at a particularly low point in their relationship, he brought a few of them down and polished them in front of her.

Around this time Drewe made a surprising confession: Some of his paintings had come from Catch's German-born brother, a former director at I. G. Farben, the notorious German chemical company that made poison gas for the Nazi death chambers. The brother had been given the paintings in recognition of his services to the Third Reich. Goudsmid was shocked and disgusted, and in late 1993 she told Drewe she'd had enough. She'd been offered a job in the United States and was moving to California. The children would be going with her.

Not long afterward, Drewe emptied their joint account and moved out. He called her supervisors at the hospital and told them she was abusing the children. He circulated the notion that she was suffering

from Munchausen syndrome by proxy, and she was temporarily suspended from her job. Family court forbade her from making contact with her children, but she fought the court order and was eventually allowed visitation rights with the children. She was certain that Drewe had brainwashed the kids and lied to them in order to keep them away from her. Now he was after the house, and she feared she would soon be homeless.

Higgs's investigation became a lifeline: If she could get Drewe behind bars, family court would listen to her and give her children back. She had no doubt that Drewe had set fire to the house on Lowfield Road, and that he was capable of murder. In the past he'd hinted darkly at his work with Britain's intelligence services, and claimed to have loaned the Crown his expertise in defensive weaponry and traveled abroad on behalf of the foreign service.

When Goudsmid threatened to go to the police and tell them about his art scam, Drewe said it was useless. He'd been promoted to the post of chief director of the powerful MI-10—an agency that was set up during World War II for weapons and technical analysis—and no one would believe her.

Furthermore, Goudsmid claimed, he had identified her as a Mossad agent to a group of London-based Islamic militants.

"You'd better leave the country in the next ten days or I cannot vouch for your safety," Goudsmid recalled Drewe telling her. "It's much more dangerous than you can imagine. It's out of my hands now."*

In the following days Goudsmid received a number of threatening phone calls, her telephone line was cut off several times, and she was sure she was being followed. Fearing for her life, she sat down and wrote a long, rambling letter to the police commissioner on the subject of the "MI-10 Director."

*Drewe has chalked up statements such as these as an indication that Goudsmid is mentally unstable.

"I am worried for my well-being," she said. "I ask you to conduct an investigation about this & the fact that a man who has been elevated to such a high & powerful position . . . is able to terrorize so many people."

The commissioner did not reply. To him, Goudsmid had probably come across as deranged. MI-10 had been defunct for at least thirty years.

Walking along the main thoroughfare of Golders Green one day, alone and frightened, she stopped dead in front of Lindy's, a popular East European eatery across the street from the tube station. Through the window she could see Drewe and the kids. She felt as if she'd been punched in the stomach. With nothing left to lose, she went inside and began screaming at him. Drewe grabbed the children and stormed out in such a hurry that he left his briefcase behind. Goudsmid opened it, glanced inside, and took the short walk to the Hampstead police station a few blocks away.

Higgs was at his desk.

"Please look through this," she begged. "It's all the proof you'll ever need."

Inside the briefcase Higgs found a glue stick, a pair of scissors, a couple of cigars, and several cut-and-paste documents, including a booklet with photographs of artworks and some receipts. There was nothing that pointed to the fire, nothing at all that would add to his investigation, but it looked very much like a forger's kit, and when he set the contents out on his desk, he could see that the material was connected, in some nefarious and convoluted way, to the art world, about which he knew very little. However, his former colleague and good friend Dick Ellis was one of the experts at New Scotland Yard's Art and Antiques Squad, so Higgs asked an assistant to take the briefcase over to him.

He added a brief note: "This may interest you."

THE AUSCHWITZ CONCERT

Peter Nahum sat in the salesroom at Christie's and watched as his Graham Sutherland Crucifixion panel went on the block. He had lowered his asking price and paid for the color illustration in the catalog, so he was hopeful the piece would do well, but it failed to sell.

A few weeks later another work he had bought from Clive Belman, Ben Nicholson's colorful *Mexican,* went up for auction at Sotheby's in New York. Again the outcome was a disappointment: The painting sold for £5,000 less than Nahum had paid for it.

Two in a row, he thought. Was it a coincidence that both works had come from the same source? Nahum took another look at the Crucifixion panel. The signature had seemed genuine enough, but on closer inspection it looked slightly off-kilter and divorced from the composition. And when he thought twice about *Mexican,* it suddenly seemed too bright by a half.

In early 1995, Nahum got a call from a man named Hans Meyer, a Sussex horse breeder and art collector who was organizing a memorial concert for the victims of Auschwitz. The concert was to be financed through the sale of donated paintings and manuscripts. The organizers were planning a gala performance by the Auschwitz Memorial Orchestra in August, seven months hence, featuring the conductor Michael Tilson Thomas and several well-known singers. Would Nahum be interested in buying some of the donated works?

Nahum asked Meyer to send a list, and a few weeks later he received a long letter from Meyer describing works by the German artists Willi Baumeister and Max Liebermann and the Romanian painter Arthur Segal. All were in excellent condition and had good provenance, Meyer said. In addition, there were three British paintings for sale: a Ben Nicholson entitled *Barndance,* and two works by the urban landscape painter L. S. Lowry, a secretive man who had a reputation as an eccentric prankster. During his lifetime he had produced thousands of paintings and drawings, many of which depicted "matchstick men" in drab industrial surroundings. He often drew sketches on napkins and the backs of envelopes and gave them away. Dozens of these obscure Lowry pieces scattered around Britain were now worth thousands of pounds.

Meyer's letter also contained an update on preparations for the Auschwitz concert. Vanessa Redgrave had agreed to perform a spoken prologue entitled "Inherit the Truth," he said, and the conductor and brass virtuoso David Honeyball had been named musical director.

Nahum asked Meyer for photographs of the Lowry works. When they arrived and he opened the envelope, it was immediately clear that they were wrong. The figures looked mechanical, as if they had been drafted with a ruler. Meyer said they had been restored recently; they were perhaps not the best examples of Lowry's work, but they were genuine.

When Nahum saw a photograph of Nicholson's *Barndance,* he was even more suspicious. The painting was off by a mile. Was the Auschwitz concert a front for passing off fakes? If so, did Meyer know it, or was he being scammed himself?

Several days later Nahum received another letter from Meyer, this one notable for its scatterbrained urgency. "You probably know that February 1995 is the 50th anniversary of the liberation of Auschwitz by the Soviet Army," Meyer wrote. "Our committee has now made the major decision regarding the program of the concert, which consists of fewer choral works, which have been replaced by excerpts from symphonies. Later in January we have to pay a further installment to the musical director, and our immediate requirement (rather desperately) is to raise the money to do this."

The letter made reference to other works of art that would soon be available and asked whether Nahum was still interested in *Barndance.* "We have an urgent need to raise some money quickly. We would very much appreciate a quick settlement, or a deposit with the final payment at a time convenient to you. We have a guarantee of a substantial contribution ($50,000) being made at the end of January from a member in America, yet in the meantime we are scraping around for funds!"

Nahum called Meyer and asked him to send *Barndance* over. As soon as he unwrapped it, his suspicions were confirmed: It was a fake. On the reverse were two familiar labels, identical to those on the back of *Mexican.*

Nahum had spoken to other dealers and was aware of several bogus Nicholsons on the market that had come from the collection of a John Cockett. He suspected that Belman, Drewe, Meyer, and Cockett were connected. The provenances of the works were similar: They each included receipts and catalogs from the 1950s and stamps from the National Art Library or the Tate Gallery. One receipt in particular stood out. It detailed the purchase by the painter Norman Town of two

works by Nicholson; one of them was *Barndance*, purportedly made in the 1950s. Nahum knew Norman Town and thought it unlikely that the impoverished artist had ever been able to afford a Nicholson.

Fakes were nothing new to Nahum. A quarter of the works he saw every year were fakes or had serious problems of authenticity. There were several distinct levels of forgery or misattribution: the outright fake; the genuine but unsigned work to which a dealer or a restorer added the artist's signature in order to increase the price; and the piece that had been incorrectly ascribed to the artist, knowingly or not.

So many works of art flooded the auction houses that there was never enough time to catalog and check each one properly. Occasionally, the auction houses would turn a blind eye to a questionable item. In April 1989, a Russian offering in London featured two outright fakes and one dubious picture that had been badly restored and then signed by a forger. The auction house had been warned about these but had gone ahead with the sale.

In Nahum's considered opinion, it was the dealer's job, in this new world of mass-marketed art, to protect the public from fakes of every kind. Most of London's reputable dealers were dependable: If one of them sold Nahum a fake, or vice versa, the money was refunded immediately, no matter how many years had passed since the sale. Nahum didn't pull his punches when he came across a fake. Certain gallery owners might politely back out of a deal, claiming a lack of interest, but Nahum had no qualms about denouncing a work on the spot. He called Hans Meyer.

"Did John Drewe give you these paintings?" he asked point-blank.

Meyer confirmed that Drewe was the source.

Nahum said he thought the paintings were fake and ordered Meyer to take them off the market. Then he photocopied the provenance documents, photographed the front and rear of *Barndance*, gathered all the material he had on the Lowry works and the pieces from Clive Belman, and called a detective he knew on the Art and Antiques Squad.

With the casual grace derived from his years at Sotheby's, he said that he had come across evidence of a large-scale conspiracy to deceive the art market. He offered to share it with the Art Squad, and invited them to pop down to the gallery.

"I think you might want to see this," he said.

A few blocks away Rene Gimpel was having trouble selling his 1938 Ben Nicholson watercolor. He had taken it to several art fairs, shown it to clients, and hung it up in the gallery, all to no avail. He began to suspect that something was wrong with it. Gimpel knew as well as anyone that fakes were a perennial problem, and that certain crooked members of his profession resorted to moblike tactics while keeping up the appearance of propriety.

"Unlike the Mafia, the art world glitters," he liked to say.

Gimpel sent the painting to his longtime restorer, Jane Zagel, ostensibly to have a damaged section of the work repaired. What he was really after was her unbiased opinion. If she thought the work was off, he would definitely hear about it.

Zagel was one of London's top restorers. A gregarious woman with short red hair and rosy cheeks, she had been in business for thirty years. She was familiar with most forgery methods and had worked briefly in the same restorer's studio once used by Eric Hebborn, one of the twentieth century's most infamous fakers. Whenever a new piece came in, she liked to have it around the house for a few days before she touched it. She would hang it up in her studio or in the bedroom and take in the draftsmanship and brushwork, as if trying to decipher a code.

Shortly after receiving the Nicholson from Gimpel, she awoke in the middle of the night with a feeling that something wasn't quite right. She went up to the third-floor studio, switched on the light, and examined the watercolor, which was propped on an easel in the corner. The geometric shapes seemed flat and motionless, like toys in an empty

playground. There was none of the lively interplay that characterized Nicholson's abstracts. He had used layer upon layer of paint to bring his figures to life, but the shapes in Gimpel's piece had a paint-by-numbers look.

Even the most mediocre artist has his own approach, a particular variation of pressure that thins the line while rounding a curve or thickens it when it runs free, but the underlying pencil marks in the Nicholson were mechanical and unwavering. They had been made with a 3B or 4B pencil, a dark grade of lead nearly as soft as charcoal that smudged easily and tended to dull over time, but they were shiny and distinct even though the piece was supposedly painted in 1938.

Of the thousand or so pieces Zagel worked on each year, only about five of them turned out to be fakes, a relatively small number compared to the percentage of fakes in the overall art market. She was almost certain that the Nicholson was a forgery, but to prove it she would have to pick the work apart in the least invasive manner possible.

She turned the watercolor over and put it back up on the easel. It was mounted on a piece of hardboard. She removed the tacks, which she suspected had been artificially rusted with saltwater, an old forger's trick. Then she removed the hardboard and examined the paper on the back.

It was fairly common practice to use a false backing on a forgery. The forger would take a sheet of antique paper contemporaneous with the purported age of the work, then glue it on in order to disguise the modern paper or canvas. The paper on the Nicholson had an off-white tone that was appropriate to an older work, but it certainly didn't date back to the late 1930s. Zagel could tell by the texture and weave that it had been produced after World War II. She dabbed at the edges with a wet Q-tip and watched as a transparent jellylike substance oozed out—the typical reaction of modern conservation glue when it was moistened. Carefully, she peeled the paper back, revealing another sheet

of paper, this one thick and pure white, with a scrawled notation that read, "TOP—BEN NICHOLSON 1938."

This sent her into a tizzy. Top? Wouldn't Nicholson have known which side was up and which was down on his own painting? She filled an eyedropper with water and squeezed gently. A single drop landed on the paper and wobbled for a moment before it steadied itself into a perfect sphere. As paper ages, it becomes more and more absorbent. If this paper had been made in 1938, its weave would have broken down by now and the drop of water would have melted into it. The Nicholson's paper was still water-resistant, as if it had just come from an art supply shop—which it probably had, Zagel thought.

She flipped the work over and studied the composition again. Although she strongly suspected that the piece was worthless, she used extreme care to remove a tiny sample of paint. The goal of every competent restorer is to disturb the original work as little as possible, even if it is a suspected forgery. A two-hundred-year-old watercolor that had been faded by sunlight, for example, should not be returned to the owner looking as if it had been painted yesterday.

Through a microscope Zagel could see that the paint on the Nicholson was a gouache, an opaque type of watercolor. It was a cheap version, heavy in chalk of the same grade and in the same proportion found in children's poster paint. Gouache fades as it ages, many of its colors tending toward a light gray. Some gouaches are more fugitive— fade more quickly over time—than others, particularly the yellows, and ever since she had first seen the Nicholson Zagel had been suspicious of the brilliant sunburst at the edges of the composition. She zeroed in on a lemon-yellow orb.

Dabbing a #1 sable brush in distilled water—the brush was the smallest in her armory, just five hairs thick—she peered through a magnifying glass, leaned over the small sun, and touched it. The paint shifted. It was so fresh that it hadn't even bled into the fibers of the

paper. Paint, paper, conservation glue—all were of about the same vintage, going back two years at most.

Gimpel had been conned.

Zagel was curious about the labels on the hardboard, which bore the names of various galleries and collectors dating back several decades and were brown with age. Labels are generally made of cheap paper with a high acidity; after a few years they turn brittle and scratch easily. Zagel moved her finger along the surface of the Nicholson labels and felt a cottony, elastic surface. They were brand-new. When she wiped them with a kitchen sponge, the dark brown color washed off. She guessed that they had been soaked in tea or coffee. Whoever had forged the painting had also tried to fake the provenance.

It had been Zagel's experience that dealers could turn nasty when a painting's authenticity was questioned, but she didn't hesitate to give Gimpel the bad news. She had known him for years and respected his erudition and integrity.

"The Nicholson's a fake," she told him. "I'm sorry."

He had paid £18,000 for it, and Zagel decided not to charge him for her work. She told him she hoped he'd get his money back. It wasn't a very good forgery, she said, but a lot of effort had gone into it. The tacks, the labels, the false backing—even the visible pencil marks that Nicholson often left on his work—were clear signs that the forger had done his research. In fact, he had taken so much trouble with it that Zagel was sure it wasn't a one-off; there must be other similar works on the market.

Gimpel took note. Forgeries were part of the risk of doing business. They often changed hands in the shadowy parts of the art world when a new buyer tried to fob off a suspected dud on the next unwitting collector. Ironically, the longer a fake circulated and the more owners it had had, the more authentic it appeared to be. Coincidentally, Gimpel had been working on the reissue of his grandfather's *Diary of an Art Dealer* and had just come across a reference to a counterfeit in an entry

dated March 12, 1918: "A fake Gainsborough, a Blue Boy, has just been knocked down [sold] at the Hearn sale in New York for more than $32,000. It's harder to sell a genuine painting."

Every generation had its fakes, Gimpel thought. Little did he know that this one would play an important role in one of the great forgery trials of the century.

By the spring of 1995, Armand Bartos Jr. was ready to part with his flawless Giacometti. He found a prominent Korean dealer willing to pay $330,000 for the piece, with one caveat: The Korean insisted on a certificate of authenticity from the Giacometti Association in Paris. Generally, the American and British markets were less rigorous about such documentation, so Bartos hadn't gone to the trouble of securing a certificate when he bought the piece, but in Europe and Asia the certificates were often prerequisites for a sale.

Bartos readily agreed to the Korean's demand. He made copies of the provenance material, removed the transparency of *Standing Nude, 1955* from his files, and sent it all to the Giacometti Association by courier, along with a letter offering the work for inclusion in the forthcoming catalogue raisonné.

He fully expected a prompt response, and then the deal would be a snap.

Extreme Prudence

In her office in Paris, Mary Lisa Palmer opened the package from Bartos and held the transparency up to the light.

"Stand up straight!" she told the nude.

The figure was all wrong. It slouched slightly, with one foot in front of the other. That was a clear tip-off, because when Annette Giacometti modeled for her husband, she stood erect, like a sentry, with her feet together. She would pose for hours in his drafty studio, taking a break only to stoke the stove. Over the years Alberto had captured her unflagging and intense stance time and again. Bartos's figure was too casual and lacked gravity. Also, Giacometti knew anatomy very well and constructed his nudes carefully upon the skeleton. In contrast, Bartos's figure was "wishy-washy."

I can't feel the bones, Palmer thought.

The transparency's high resolution provided a good sense of the

brushwork—too good, as it turned out. Giacometti used a very fine brush to build up his figures with a series of frenetic strokes. While Bartos's piece possessed some of that same energy, the brushstrokes suggested an attempt to fill in a predetermined form rather than to build the figure up from the core.

Palmer examined the transparency again. The signature in the bottom right-hand corner wasn't right either. Giacometti hated signing his name and often did so in a hurry. He rarely bothered to dip his brush for a final flourish, and many of his signatures were not perfectly legible. This one seemed studied and unwavering, as if it had been traced in pencil and then copied over with a wet brush.

More disconcerting still was the painting's all too perfect provenance. Giacometti's attitude toward business was informal in the extreme, and occasionally the association would find gaps in provenances for paintings or identical numbering for sculptures cast in bronze. By contrast, the chain of provenance accompanying Bartos's *Standing Nude* was a wonder of documentary diligence. It was too perfect. It included a stack of invoices, receipts, and personal correspondence from previous owners. Palmer examined each item carefully and recognized a familiar pattern: The provenance was strikingly similar to that of the Footless Woman at Sotheby's. In both cases the provenance documents bore the Tate's rectangular stamp—"For Private Research Only/Tate Gallery Archive"—and both paintings had purportedly been owned by the Hanover Gallery.

Palmer turned to the catalog Bartos had included in his package, "Exhibition of Paintings, Sculpture and Stage Designs with Contributions from Members of the Entertainment World," from a 1950s show at the O'Hana Gallery. In it was an illustration of Bartos's painting. Palmer reread his letter: "I trust that the above information is sufficient for verification and inclusion [in the catalogue raisonné]."

Far from it, she thought.

PROVENANCE

. . .

As Palmer was preparing her response to Bartos, she received a request from a French media company to reproduce for a poster a Giacometti drawing titled *Standing Man and Tree*, which had recently been featured in a Phillips auction catalog. She recognized immediately that this too was a fake.

She contacted Phillips and learned that in 1990 the drawing had been "generously donated" by Norseland Industries, along with a Le Corbusier, for an ICA benefit auction organized by Sotheby's. According to the provenance, it had been owned by Peter Watson and Peter Harris, whose names Palmer recognized as previous owners of the Footless Woman. She called the ICA to see if they had any information on Norseland or Harris and was told that they did not. Then she called a curator at the Tate who told her that Harris's name had appeared in the provenance of two Bissières that had been donated to the Tate and subsequently withdrawn. The curator had met the donor, an arts patron named John Drewe, who was interested in the Tate archives. He was an odd fellow, she said, and the whole Bissière business had left an unpleasant aftertaste.

Palmer felt queasy. More than two years earlier she had accumulated enough evidence to be reasonably certain that John Drewe was involved with one or more Giacometti fakes. She had tried but failed to get Sotheby's to send her the Footless Woman. Without an actual forgery in hand, she couldn't move on the information she had because there was no definitive proof. Nor could she call the police and ask them to raid a private gallery where she suspected there *might* be a fake. Now she had to face the fact that the scam was much bigger than she had imagined. This was no longer a case of a single forged painting or artist. If her instincts were correct, someone—very possibly Drewe—had managed to penetrate the art world's inner sanctum. While forgeries

were as old as art itself, the genius of this particular scam did not lie solely in the forger's skill with a brush. It was a complex plot to corrupt the provenance process, to control the system that collectors and curators relied on to authenticate a piece of art. Whoever was behind it had gained access to the most secure databases, doctored exhibition catalogs and other historical documents, and altered important art archives.

Dealers and experienced collectors are usually wary about relying on their own critical judgment alone when it comes to a piece of art. However, when the piece has a seemingly impeccable provenance, supported by references to prestigious galleries and archives, the prospective buyer can be lulled into a false sense of confidence. In regard to Giacometti, Palmer realized, dealers and auctioneers were now more concerned with provenance than the work itself. They thought they had an option to bypass the association entirely to set up a quick sale. They could rely on the phenomenal provenance that accompanied the fraudulent art. And why shouldn't they? Good provenance was like liability insurance. If the paperwork checked out, who could accuse a dealer of knowingly selling a fake?

While Palmer was mulling over this new flurry of revelations, Bartos was bombarding her with faxes and phone calls from New York. He had a deal pending, and he needed an answer on his *Standing Nude*. Finally she wrote back and asked him to send the painting to Paris for her inspection.

Seeing the work itself only confirmed her opinion that it was a forgery. She contemplated initiating the seizure of the work but quickly decided against it. It would not be effective or efficient. Bartos and others would simply point to the paperwork as evidence of the painting's authenticity and complicate the matter.

Soon Bartos had his painting back, but no certificate of authenticity. His calls and faxes continued unabated. "I am really disappointed that

each time I call you, you are too busy to speak to me," he wrote on one occasion. "I have tried to make it clear to you that time is of the essence. I have asked you by fax and by telephone what is your procedure in terms of a certificate or letter, and I have to ask why I am not getting any response from you. Is there something else I should do? You asked me to send the painting, which I did."

Palmer wondered if he actually had a deal pending. She considered the possibility that her correspondent might in fact be John Drewe, Peter Harris, or a renegade dealer working for Drewe. An operation of this size surely required the cooperation of others. How many were involved?

Bartos had a right to expect Palmer to play by the rules and either authenticate the painting or tell him the basis for her reservations. If she was to persuade the art world's experts that the nude was a fake, she had to play the game their way, not hers. She could point to the brushstrokes or the signature, but she knew these would be considered subjective judgments by some. Instead, she had to use objective standards to prove that the provenance was bogus beyond question. She had to buy time, and the best way to do that without showing Bartos her hand was to stall him.

She decided to ask for the original documentation. In her request for the material, however, she added a key sentence. If he was honest, there would be no harm done. If he was not, she understood she was taking a calculated risk.

"I cannot yet confirm the actual state of my research. I can only advise you to use *extreme prudence* with this painting," she wrote.

Then, she got in touch with Jennifer Booth at the Tate: "I am again confronted with a certain number of documents which perplex me . . . and need your assistance."

WE'RE NOT ALONE

J ennifer Booth still had her qualms about Drewe. Though he had stopped coming into the archive himself, he was sending in his researchers. Danny Berger seemed particularly suspicious. His application to access the Hanover albums was barely literate. He wrote that he was interested in the work of "Jacamety." His visit and appearance unnerved Booth. He stayed only a few minutes, and as he flipped through the album, she realized how easy it would be for him to swap pages in the ring binder.

Meanwhile, dealers in Monaco and New York were sending Booth photocopies of receipts, correspondence, and catalogs bearing the Tate's trademark rectangular research stamp. The documents all related to Giacomettis, and the dealers wanted Booth to confirm that the originals were in the archives. Booth combed through the Hanover and O'Hana files but could find none of the original documents. She also checked the Hanover index for the names listed on the provenances.

They were nowhere to be found. She checked the application forms from researchers who had visited the Tate over the past few years, looking for those who had requested records from the Hanover and O'Hana galleries. There were several requests for the Hanover records, Drewe's among them, but he was the sole researcher given access to the O'Hana files.

Her first thought was that he had been stealing the originals, and she reported this to her supervisors. They brushed her off, suggesting that documents were occasionally lost, stolen, or destroyed in an archive the size of the Tate's. There was no need to hurl accusations.

Booth felt increasingly anxious about the integrity of the records in her charge. The sudden stream of requests for authentication could hardly be random. Again she inspected the photocopies she'd received, focusing on the Tate stamp: It looked too pristine. The archive's stamp had faint hairline cracks from constant use. Someone had forged it.

And now there was a new request from Palmer, who had sent a number of documents for Booth's review. When Booth looked at them, one letter stood out. It was from Erica Brausen to the O'Hana Gallery. The date on the letter was five months *before* the file on the O'Hana Gallery at the Tate started. Booth was now convinced that all the documents she'd been receiving lately were phony. "Despite the stamp," she wrote to Palmer, "I do not think [the documents] were ever here."

Booth again reported her findings to her supervisors, only to be told that she was being paranoid. She was insulted. She saw herself as part of an extended line of archival guardians charged with protecting the credibility of the venerated institution for which she toiled so diligently. By now she had some solid experience as head of the archives under her belt, and she knew enough not to ignore the inner voice telling her that whatever was going on in the Tate's stacks was momentous and unacceptable. The value of an archive was measured by its totality: Each document confirmed the veracity of an earlier one and supported

the next. If a single item had been doctored, the integrity of the entire collection was in jeopardy.

The word "archive" is derived from the Greek *arkhe*, meaning "government" or "order." Its opposite is "anarchy," a state without rule or order. Booth was certain Drewe was involved in precisely that: He was breaking down the system and creating chaos. Two questions remained unanswered: Why? and How?

She understood why her superiors didn't take her seriously. Her allegations must seem preposterous. After all, the higher-ups had dined repeatedly with Drewe, at the finest restaurants in the city, and they had been impressed by his poise, intelligence, and sophistication. His largesse was another significant factor. He was known to have contributed to several art-related charity events, and he had donated £20,000 to the archives, with an informal promise of an additional half million. That had been some time ago, but patience was a necessary virtue where museum fund-raising was concerned. Tate officials had every reason to believe that Drewe was a serious researcher. He had tipped them off to hidden archives they might be interested in, including a cache of ICA records that were said to be in New York. To the senior staff, Drewe was beyond reproach.

Shortly after Booth wrote back to Palmer, a man named Raymond Dunne applied for admission to the archives. His accompanying letter resembled others Booth had received from Drewe and his colleagues. Each paragraph was indented seven spaces, and the name of the applicant was typed beneath the signature and underlined.

Booth took matters into her own hands. She asked the department secretary, who shared her suspicions, to do a little detective work. The secretary dialed the phone number Dunne had listed on his application and found that it was out of order. When she drove to the address on the application, she found a boarded-up house.

When Dunne called a few days later to make an appointment, the

secretary passed the phone to Booth. "It's Drewe," she whispered. "I'm absolutely sure of it."

Booth told the caller she needed more information if his application was to go through. The man explained that he was working on his thesis, which focused on London's postwar art exhibitions. Booth was also sure it was Drewe: The same upper-class accent, the same cascade of accumulated detail and cultural references. She asked him to send a second reference letter, and he agreed to do so.

She never heard from Dunne again.

A few days later a colleague at the British Council called to warn her about a well-known researcher, Anne Massey, who had been caught photocopying material without authorization and was subsequently banned from the council archives. She told Booth to be on the lookout in case Massey tried to gain access to the Tate. Booth was surprised, because she knew Massey and respected her work.

Then Booth's council colleague mentioned that Massey had been focusing on Ben Nicholson's paintings and was working for a wealthy collector named John Drewe.

We're not alone, Booth thought.

A SLOW BURN . . .

Her worst suspicions confirmed, Mary Lisa Palmer began poring over old London telephone directories and newspaper archives. In decades of back issues of an art journal listing the exhibitions held at London's major galleries in the 1950s, she found nothing that matched the awkward title of the O'Hana catalog Bartos had sent her, "Exhibition of Paintings, Sculpture and Stage Designs with Contributions from Members of the Entertainment World." However, the defunct gallery had once held a show with a similar title, "Paintings by Stars of the Entertainment World."

Palmer speculated that this show might have provided the inspiration for the bogus catalog, which had a photographer's stamp and the name of a printer on the back. She called the printer. They had no record of any such catalog. The photographer's stamp was from Leslie & Collier Partners, the agency that had supposedly shot the pictures and

had an address that put it next door to the ICA. That was an odd coincidence, Palmer thought. She checked the records for registered British companies but could find no trace of Leslie & Collier.

Palmer held one of the catalog pages up to the light and copied down the watermark, which consisted of the word "Conqueror" over the image of a castle. Watermarks were commonly pressed onto high-grade paper to show a company's logo or trademark and add a certain prestige to an ordinary sheet of stationery. Early artisans often "signed" their paper in this manner. Palmer had worked with countless old documents and was familiar with paper textures and watermarks. She went to the association's files and unearthed a number of business and personal letters contemporary with the purported 1950s catalog and bearing the Conqueror logo. The design was slightly different from the watermark on the catalog pages: The letters over the castle on the association's letters were all uppercase and included the word "LONDON."

Palmer contacted the manufacturer of Conqueror paper and was told that the catalog watermark could not have been made in the 1950s. The design was from the 1970s, when London had been dropped from the watermark to reflect Conqueror's growth as a global brand. Bartos's catalog could not possibly be an original document.

But what of the illustrations, which showed works by Noël Coward, Peter Ustinov, Rex Harrison, and John Mills, mixed in with pieces by Nicholson, Dubuffet, Kandinsky, Chagall, and Giacometti? This made little sense. The whole thing must be an awkward copy of the genuine "Paintings by Stars of the Entertainment World" catalog. Palmer doubted that the forger would have gone to such lengths simply to include one fake Giacometti nude. Were the works by the other artists forgeries too?

She called Ustinov's office in London. The catalog listed five whimsical titles by him, including *Macbeth in Mexico* and *Mr Curtiz Directs a Battle Scene,* a reference to the filmmaker Michael Curtiz, with

whom Ustinov had worked. His secretary seemed surprised. She told Palmer that the actor was an amateur caricaturist who had never once exhibited his doodles. A Ustinov forgery would not have been worth much. Why go to the trouble of inventing fake titles for nonexistent paintings? Clearly, whoever was behind the operation was mocking the very art establishment he was scamming.

Palmer turned her attention to the booklet's serious painters. With seven works Dubuffet was more heavily represented than the others, including a series of royal playing cards and a pair of cow portraits. Palmer called the Dubuffet Foundation in Paris and asked the director whether she had seen the catalog. Yes, the director said, she had seen a copy made from the original in the archives of the National Library at the Victoria and Albert Museum. The director had a good reputation in the art world, and Palmer trusted her enough to communicate her concerns about the catalog's authenticity.

The director insisted that the Dubuffets were genuine. In fact, she had recently authenticated them, and they were about to go on sale at one of the auction houses in London. Palmer checked the records at the National Library. The "original" O'Hana catalog was indeed there, and was identical to the one Bartos had sent. Now Palmer was sure that the V&A's security had also been breached.

Next Palmer focused on the work's previous owners. She called Albert Loeb, whose father had owned the Paris based Pierre Loeb Gallery. According to the Bartos provenance, the elder Loeb had bought the work directly from Giacometti and then sold it to the Hanover. Palmer asked Loeb to check his father's files for any record of the transactions, but he could find none.

A few days later Loeb bumped into the dealer and curator Jean-Yves Mock, who was out shopping for shrimp in the Sixth Arrondissement. Mock had worked at the Hanover for seventeen years as the business partner and close friend of gallery owner Erica Brausen. When she died in his arms in 1992, Mock had inherited her personal collection.

Loeb told him about Palmer's conundrum and suggested Mock give her a call. With shrimp in hand, Mock strolled over to the association, where Palmer told him everything she knew about the forgeries and the photographs of the fake Giacomettis in the Hanover album. Mock looked over the material, inspected the Hanover label Palmer had photographed on the back of Bartos's *Standing Nude,* and assured her that it was wrong. The gallery had never used the label for anything but mailing purposes.

Mock then picked apart a January 1958 letter that Brausen had allegedly written to Jacques O'Hana. "Dear Sir," the letter began, and went on to say, "We have two paintings by Alberto Giacometti which you could show to your client. [One is a] Nu Debout 1955, 47 3/4 × 35 1/4 ins at pounds 1650—which we purchased from Pierre Loeb in 1955." The letter bore the Tate archive stamp and was the one Booth had said predated the Tate's files on O'Hana.

Mock told Palmer that her suspicions were well-founded. He had redesigned the gallery stationery shortly after his arrival in 1956, but the writer of this 1958 letter had used the old stationery. The salutation was another giveaway. O'Hana was a charming and quirky man who had built a small swimming pool in the center of his gallery. He and Brausen had been good friends, and she always addressed him as "Dear Jacques" in her letters, never "Dear Sir." The signature looked right to Mock, but it could easily have been cut from one document and pasted onto another.

Neither Palmer nor Mock believed that Brausen would have fallen for a forgery in the 1950s. As Giacometti's principal dealer in London, she had bought and sold more than six dozen of his works. They had all come from the galleries that represented him, either Gallery Maeght in Paris or Pierre Matisse Gallery in New York. She knew the material too well to let a fake slip by her. In addition, forgeries of Giacometti's paintings were rare, if not nonexistent, in the 1950s. The artist was

much more famous for his sculptures, which commanded far higher sums and were thus the first works targeted by forgers.

Palmer now felt she had a strong case that Bartos's painting was a fake, but she wanted to nab the other Giacometti forgeries as well, both those she'd seen at the Tate and those that had recently come to her attention. With Mock sitting next to her, she carefully spread out the small stack of letters, photographs, and ledger pages she had collected over the past several years. Mock was unable to recognize the handwriting on several of the ledger entries, and as they studied the material together it occurred to Palmer that they were looking at both the puzzle and its solution.

Meanwhile, in New York, Armand Bartos was doing a slow burn. Palmer's delays were inexcusable. He had bent over backward to provide her with all the necessary documentation. Early on she had hinted that she was deeply concerned about the painting, but she had failed to give a good reason. In Bartos's opinion, the provenance was impeccable and the work was first-rate. He had contacted two other respected experts, and they had confirmed his belief that *Standing Nude, 1955* was genuine. On the basis of their reports, the work had already been seen by two restorers, his own in New York and another in London.

But Bartos had also called Albert Loeb, who reported that he could find no record of his father's having bought the painting from Giacometti or sold it to the Hanover. This had shaken Bartos's confidence, so he called his runner, Sheila Maskell, and insisted that she provide an explanation for this gap in the provenance, threatening to demand his money back if she couldn't.

Until then, Maskell had kept mum about the name of her source, the London-based runner Stuart Berkeley. Runners and dealers tended

to be circumspect about their sources so that prospective buyers couldn't bypass them and cut them out of their commission. Now Maskell pressured Berkeley to recheck the provenance and return to his own source to ensure that the painting was authentic. Berkeley did so, and then he called Bartos, suggesting that the dealer hire an independent researcher to examine the Loeb gap. He recommended a London-based firm called Art Research Associates.

Two weeks later Bartos received a synopsis of ARA's report. Over the course of twelve days, two purported researchers, Robin Coverdale and Bernard Cockett, had interviewed numerous gallery employees and combed the Tate and the National Art Library at the V&A for copies and originals of documents and signatures relating to the work, as well as clear evidence that it had been shown at the exhibition cited. In the O'Hana file they had discovered a typed list of paintings bought by the gallery in 1955. This list included the *Standing Nude* and mentioned that it had originally come from P. Loeb. In addition, Coverdale had uncovered another exhibition in which the work had been shown, this one at the Hanover Gallery. The original 1956 catalog was tucked away at the V&A.

"It is our considered opinion that the exhibition record demonstrates unequivocally that the 'Nu Debout, 1955' must be an authentic painting," the report stated.

Bartos was both relieved and angry. That an exhaustive investigation had found the work "unequivocally" genuine vindicated his own critical judgment, but it also stoked his anger at Palmer. She had promised to look into the authenticity of the piece and get back to him, but she had been stonewalling him for months. He had spent far too much time and money trying to prove the work's authenticity. Meanwhile, three potentially lucrative deals had fallen apart over the issue of authentication. If the painting was indeed a forgery, where had the provenance documents come from?

Bartos knew about the legal challenges facing the Giacometti Asso-

ciation since Annette's death.* He wondered if the art world gossip about Palmer was true, that she was stubborn and deficient in scholarship.

He sent her a copy of the newly discovered 1956 Hanover catalog, the list of paintings mentioning Loeb, and a curt letter. "It is your responsibility to state clearly the reason why you believe this work is not genuine."

Palmer replied that she was still researching the documents.

Exasperated, Bartos called Sotheby's in London and consigned the painting for auction. Nearly seven months had passed since his first request for a certificate, and nothing seemed good enough for Palmer. If the auction didn't force her hand, at least he'd finally be rid of the piece.

What Palmer didn't tell Bartos was that the Hanover catalog was yet another forgery. Predictably, it bore the stamp of the V&A and contained an illustration of Bartos's *Standing Nude*. On the back cover was a photograph of another suspicious Giacometti, a 1956 *Standing Nude*, featured in an advertisement for an upcoming exhibition—also phony, no doubt.

In fact, a photograph of this same 1956 work had just crossed Palmer's desk.

David Sylvester, who was a board member of the Giacometti Association, had sent her a photograph of the nude that he had received from a man named Howard Sussman, who lived in Reigate, a London suburb twenty-five miles south of the capital. Sussman said he represented the painter's owner and wanted Sylvester to intercede on their

* In 1993, the association became engaged in a battle with the French government over Annette's will. Annette wanted the association—whose initial board members all had close ties with Giacometti—transformed into a foundation that would inherit all of Giacometti's artworks and documents that she had owned. While this would save substantial inheritance taxes, it required a difficult process to obtain government approval.

behalf and get a certificate of authenticity from Palmer. The owner, Barbara Craig, the widow of a well-known collector, had been repeatedly rebuffed by Palmer's office, Sussman claimed. His letter played on the legal problems Palmer was having with Giacometti's heirs and hinted that if Sylvester didn't help, Craig would take the "scandalous state of affairs" at the association to her cousin, "a newspaper proprietor who wishes to help her." Craig was understandably "distraught," wrote Sussman. "She is an elderly lady, and infirm. . . . [T]he sale of the painting is crucial for her."

Sylvester asked Palmer if she thought the Sussman material was from the same family of fakes they had spoken about a few years earlier. It had all the telltale signs: an impeccable provenance attached to a fake and a letter reminiscent in tone and style of the ones she had received from Drewe, Cockcroft, and Norseland chairman Cockett. Now it was connected to Bartos through the Hanover catalog.

And yet Sussman's 1956 nude was backed up by two other illustrated catalogs from two separate galleries. One of them had a stamp from St. Philip's Priory, and the second, which bore the official Tate stamp and was titled "The Contemporary Nude," was from a Gallery One exhibition. Palmer double-checked with a Tate curator and was told that the Gallery One catalog was indeed in the Tate stacks.

She was sure this was another forged piece of provenance. She would have been surer if she'd known that Sussman was the surname of Drewe's new wife.

THE ART SQUAD

At New Scotland Yard, the Art and Antiques Squad was down to a few desks and a couple of phones. The unit operated within the larger and more powerful Serious and Organised Crime Unit, which took up most of the fifth floor of the Yard's twenty-story headquarters in Westminster. Among the unit's other subdivisions were the Flying Squad, trained in high-speed chases and street ambushes, and the Kidnap Unit, whose varied tasks included the rescue of hostages and potential suicides. The Art Squad's cramped quarters in this macho milieu reflected its status as a poor cousin. Since its founding as a philatelic unit in 1969 after a series of holdups of stamp dealers, the squad's relevance and jurisdiction had been subject to close scrutiny by the Yard's upper echelons.

In contrast to the swagger of the Organised Crime Unit, the Art Squad was regarded as a kind of pantywaist protection force for the elite. If a wealthy Knightsbridge aristocrat awoke to find his Titian

gone, the case was given a lower priority than, say, a mugging in Step-ney. Art crimes were generally considered the stuff of light comedy, filler items for the BBC News entertainment segment. The unofficial position of the Yard's commissioner was that pretentious victims of art crime probably got what was coming to them, that the few Londoners who could afford great art could also survive the occasional loss, and that such relatively small misfortunes were best left to the wealthy and their insurers.

The Art Squad had known even worse times. When London was hit by a wave of armed robberies and muggings in the mid-1980s, the unit was disbanded altogether. It was a hasty decision on the part of the top brass, because the art market was heating up during this same period. Once prices rose it was only a matter of time before the trade in stolen art followed suit.

By the end of the twentieth century Interpol was ranking art crime as one of the world's most profitable criminal activities, second only to drug smuggling and weapons dealing. The three activities were related: Drug pushers were moving stolen and smuggled art down the same pipe-lines they used for narcotics, and terrorists were using looted antiquities to fund their activities. This latter trend began in 1974, when the IRA stole $32 million worth of paintings by Rubens, Goya, and Vermeer. In 2001, the Taliban looted the Kabul museum and "washed" the stolen works in Switzerland. Stolen art was much more easily transportable than drugs or arms. A customs canine, after all, could hardly be expected to tell the difference between a crap Kandinksy and a credible one.

By some estimates, art crime had become a $5 billion a year busi-ness. While New Scotland Yard largely ignored the implications of the upsurge, other cities took action. In Washington, the FBI reached out to the art community to help solve fraud cases. In Italy, the Carabinieri placed three hundred officers at the disposal of its stolen art unit. In Manhattan, a former abstract painter and art student turned police detective ran his own one-man art crime investigative unit. His name

was Robert Volpe, and he was an unorthodox, Serpico–like figure with a Dalí mustache and an Armani suit. Dubbed "the Archangel of the Art Scene," he specialized in gallery theft and went after forgers, crooked auctioneers, dealers who defrauded their own artists, and collectors who shopped at the black market. Fellow officers at the station house considered him an eccentric—some of his colleagues once hung a nude centerfold in his locker with a note that asked the eternal question "Is it art?"—but Volpe saw himself as a guardian of patrimony.

London art dealers and auctioneers soon began to demand the same level of protection that other cities provided their art communities. They pointed to the fact that London's art market was second only to that of the United States and needed much better security because of the huge sums of money involved. In appealing to the police commissioner for help, dealers and gallery owners even offered to pay the salaries of a specialized art squad and to train police in the basics of the art market. More than once, they were turned down. Finally, in 1989, the Yard relented and reinstated the Art Squad. By 1995, its skeleton staff of four detectives had many more cases than they could handle properly, and the squad was seriously underfunded.

The Art Squad was run by Dick Ellis, who had grown up around amateur painters and antiques collectors. As a young officer, he had his first brush with art thieves when his parents' home was burgled. Ellis headed down to Bermondsey antiques market, where thieves had sold their goods with impunity for years. He spotted the family silver in one of the stalls and soon collared the culprit.

Because it was so understaffed, the Art Squad chose its cases carefully, and was often forced to ignore perfectly decent leads. Among its successes: It tracked a cache of stolen manuscripts to an East London parking lot; recovered thirteenth-century Arabic documents and philosophical works by a Sufi saint; ferreted out books purloined from an ancient Anatolian library; nabbed a larcenous collector dubbed "the Astronomer," who was addicted to original manuscripts by Copernicus

and Ptolemy; and busted a multimillion-pound operation that imported looted treasure from Russia and Poland.

In the dusty cabinets of a London barrister, the squad found a thirteen-hundred-year-old gold headdress stolen from an ancient Peruvian tomb. In 1993, it recovered a Vermeer and a Goya stolen from a collector by a brutal Irish gangster known as "The General." Most famously, in May 1994, it recovered a version of Edvard Munch's *The Scream* that had been lifted out of a window of Norway's National Gallery in Oslo on the opening day of the Winter Olympics. The thieves had left a handwritten postcard: "Thanks for the poor security."

Success, however, did not lead to additional staffing for the Art Squad. Part of the problem was that London's art thieves had a peculiar working pattern: They would lie in wait for a good haul for months at a time and during these slow periods the squad would be reduced to issuing alerts on tchotchkes of little value, pink-and-blue horse-drawn carriages, tortoiseshell tea caddies, ancient Hungarian fiddles, and lost dinosaur eggs. Inevitably, the villains would reemerge as if from a winter's hibernation and go after everything that wasn't nailed down.

Europe's criminals favored the London scene: Fences were unusually civil and one could unload just about anything. For art thieves and forgers, the city had become one of the world's great crossroads for dodgy canvases. For Ellis that meant there were always too many important cases to deal with.

In September 1995 he was in the thick of things. He and two of his detectives had been working almost exclusively for more than a year on the case of a British-born Egyptian tomb raider, a former cavalryman and self-proclaimed antiquities restorer with a Cambridge degree in "moral sciences," or philosophy. Ellis had been shuttling around Europe, North Africa, and the United States trying to shut that ring down, but recently a new case had sprung up that was too rich to ignore. There was a palpable link between the contents of the briefcase

Detective Higgs had sent him, the flood of calls he'd been getting from dealers warning about a rash of forgeries, and a case the Art Squad had investigated just the previous year, involving a certain John Drewe and some paintings allegedly stolen by the Mafia.

Ellis had also received a worried call from Sarah Fox-Pitt at the Tate Gallery. She was concerned that one of their patrons—John Drewe— might be using the museum in a scheme to sell fraudulent art. She told him about her archivist's suspicions, the call from Booth's colleague at the British Council, and a recent call from Drewe's ex-partner, Batsheva Goudsmid, who claimed to have incriminating documents proving that Drewe was trafficking in forged and possibly stolen artwork.

Ellis picked up the phone and called Goudsmid. She sounded angry and upset, "a woman scorned," as he would later recall his initial reaction. He made plans to meet her at Hampstead station, and then he made another call, one that was almost second nature.

Ellis depended on detectives from the other units to help the Art Squad when it was swamped, and the most reliable and talented of these outside resources was Detective Sergeant Jonathan Searle, a Cambridge-educated art historian who worked at Special Branch, the muscle behind British intelligence on national security and espionage.

Searle was as skilled at spotting fakes as he was at grilling thugs. When Ellis told him he was interviewing a possible witness to a daring and complicated art crime, Searle was all ears. Could he put everything aside and come down to the Hampstead precinct? Ellis asked. He just wanted Searle's gut reaction. He didn't say much else, and Searle didn't ask.

Through the glass partition, Detective Sergeant Searle observed the woman in the interrogation room. She was slight, almost birdlike, and appeared to be extremely harassed, demure one moment and

raging the next. She stared at the floor, then at the wall. When he went inside, she refused to look him in the eye. When he began asking pointed questions, her expression conveyed barely restrained anger when she mentioned Drewe. In anguished, staccato bursts, she retailed old grudges and stories of criminal activity on the part of her former common-law husband. Most of what she said was irrelevant to the reason for Searle's visit, but he thought some of it might be useful.

Goudsmid described Drewe as a clever manipulator who was running a profitable forgery business in oil paintings and was likely involved in other crimes. She said she could prove it.

"He's having you all on," she added. "He's a murderer, and you're letting him get away." She added that he took her children and her money, too.

During nearly twenty-five years with Special Branch Searle had had occasion to question all manner of villains. His unit, originally called the Special Irish Branch, had been established in the late 1800s to fight Irish nationalists, but it had expanded over time. It had spied on Lenin, guarded Churchill, interrogated cold war spies, and protected IRA targets. Searle could usually tell when someone was trying to put something over on him. Goudsmid was obviously angry, but he didn't think she was lying, although the murder accusation did seem a bit extreme. He would have to ask Ellis about it. Meanwhile, he guided her back to her story gently.

Recently, she said, she had been getting angry calls from Drewe's clients, complaining about fake paintings and saying that they wanted their money back. She had been cleaning out her attic when she found bags filled with incriminating papers belonging to Drewe. Most of them had to do with art, but a few were more personal. Among them were old pay slips from an Orthodox Jewish school near Golders Green where Drewe had taught physics in the early 1980s—the same years, he had told Goudsmid, that he was a military consultant. There was also a three-page letter he had written to the police, explaining why he had

fired a gun in the school's playground. (He claimed he was conducting a physics experiment that "incorporated ballistics to study the motion of projectiles using both electronic timing, and more advanced strobo-scopic methods.") Soon after the incident, he was fired from the school, though he was never charged. Goudsmid had also found documents indicating that Drewe resigned from teaching physics at another school after his academic credentials were challenged by a colleague.

"For twenty years he called himself doctor or professor. He never even made it past [high school]! Everything he has ever told me is a lie. A pack of lies."

Searle asked Goudsmid what specific evidence she had to back up her claims that Drewe was involved in theft or forgery. She took him and Dick Ellis out to the parking lot, led them to her black BMW, and opened the trunk to show them two black trash bags filled with documents. In one of the bags Searle found letters from the 1950s, some bearing the Tate Gallery archive stamp, along with ledger pages, gallery stationery, and photographs of paintings purportedly by Giacometti, Dubuffet, and Nicholson. The other bag contained a handful of pen-and-ink sketches and a group of color photographs of paintings of the Crucifixion, each a different color—yellow, green, pink, and dark blue. Searle recognized them as Graham Sutherlands, though it wasn't clear whether they were genuine.

"This is all Drewe's," Goudsmid said. "And there's much more."

Searle pulled Ellis aside and told him it was all good, solid evidence. "Nicked or forged, you've got a case."

THE MACARONI CAPER

Ellis made a pot of tea and sat down with Searle. He explained the circumstances of the fire at the Lowfield Road boardinghouse and the subsequent lineup. Detective Higgs's investigation into the tragic death of the young Hungarian woman had hit a dead end, and although the fire was outside the Art Squad's jurisdiction, it was an indication that Drewe was a dangerous man. Ellis and his men could at least do their best and put Drewe away for fraud.

Ellis also filled Searle in on the recent stream of phone calls from suspicious art dealers and Tate curators. He had concluded that Drewe was a master manipulator who had gotten one over on the hallowed museum. "When you give an art archive £20,000, they give you the key to the door," he said.

Finally, Ellis told Searle that Drewe was already a familiar figure to the Art Squad. He had first surfaced a year earlier, when he called the Yard with inside information on a number of paintings he said

had been stolen by the Mafia and were stored at a Hampstead restaurant called the Macaroni. He invited the police to meet him at the Battersea heliport to discuss the matter, and specifically requested the presence of Charley Hill, then head of the Art Squad. Hill, who had been described by one reporter as a "solid presence and deliberately unmemorable—like Alec Guinness," was something of a celebrity. A gifted impersonator and mimic with a specialty in Mid-Atlantic accents, he had helped to recover *The Scream* by posing as an American art expert.

At the appointed time, Hill and a colleague waited at the heliport and watched as Drewe landed in a top-of-the-line Bell Jet Ranger and emerged with his two children. The heliport staff seemed to know him well and ushered the group into a conference room.

Drewe introduced himself as a scientist with twin passions, physics and the arts. He seemed bright, articulate, and engaging. Hill was impressed, but he couldn't shake the sight of the two unhappy-looking children sitting quietly in the back of the room.

Drewe launched into the Macaroni story. He said he was having dinner at the restaurant when he overheard the owner talking about a group of stolen artworks he had recently acquired. Drewe took the owner aside and told him he was an art dealer who was always looking for interesting work—if the price was right. The owner showed him several pieces, and Drewe said he might be able to fence them.

Charley Hill listened.

Drewe reached into his briefcase and handed him photographs of two paintings, one by the presurrealist Giorgio de Chirico, the other by his contemporary Filippo de Pisis.

The professor had a proposition: He would set up a sting operation at the restaurant if Charley Hill would pose as his buyer.

The detective was skeptical. What was Drewe doing in an alleged Mafia-connected hangout in the first place?

The professor leaned over and lowered his voice. "I'm a *sayan*," he

said, and explained that *sayanim* were Israeli sleeper agents living inconspicuously in cities around the world. If the Jewish state's secret service needed practical support for an assignment, the volunteer *sayan* network was there. For example, if a *sayan* worked for a rental car agency, he might provide a vehicle to a Mossad agent without asking for documentation. Similarly, a real estate agent might secure a strategically located apartment, or a doctor might treat a gunshot wound without reporting it to the authorities.

Drewe said that he had worked as an aerospace designer at a secret Israeli installation, and that the Mossad had asked him to help recover blueprints for the Stealth helicopter, documents that had been stolen by the self-same Macaroni restaurateur and his Mafia cohorts, who were planning to sell them to Arab countries.

Quite a yarn, Hill thought. He told Drewe he would be in touch.

D rewe's *sayan* claims were far-fetched but not entirely inconceivable. At least one former Mossad case officer had acknowledged the existence of this loose network of Jewish volunteers, who were known only to their spymasters. Drewe had provided accurate information on several other counts: The Stealth was indeed a military innovation available to only a few allied states, and the name and background of the Macaroni owner, a southern Italian who had a minor criminal record for assault, seemed to check out too, although there was no evidence linking the restaurant or its owner to the mob. More significantly to Hill, the de Chirico that Drewe had shown him had been stolen in Turin three years earlier and was valued in the six figures.

Hill's men discovered in their files that Drewe had also called in another tip: He had denounced a right-wing group that was circulating anti-Semitic "Chanukah cards," which was potentially a hate crime. Drewe's lead was under investigation by the Organised Crime Unit.

Hill doubted Drewe's story about his Mossad connections, but it was his habit to cultivate and run informants, and even an eccentric stoolie like Drewe could be useful. Hill had worked with far more unusual informants in the past. He decided to go ahead with the operation and asked Drewe to set up a meeting with the restaurateur. The professor offered his Mossad contacts to help with surveillance. Hill declined.

On the day of the meeting, with his team in place outside the restaurant, Hill walked into the Macaroni wearing a suit and bow tie. Drewe introduced him to the owner as an American dealer with a reputation for discretion and an elastic sense of ethics.

The sting was in play.

They ate scallops and linguine while Drewe boasted about his extensive art collection and his past donations to the Tate. Hill noted that Drewe was laying it on thick, fluffing his feathers about his "great eye" for art. Then the owner took Hill aside and led him into his private office, where he began pulling artworks from the safe. Hill recognized the stolen de Chirico and the de Pisis. There were other works too, including a dreadful "Dalí" statuette of a woman that seemed sculpted from resin and gilt. Hill said he was interested and would arrange for his restorer to return the following day with £50,000 in cash.

The next day the police moved in and arrested the proprietor. The de Chirico was returned to its owner, but the other works turned out to be fakes. The restaurateur was charged with fraud and then released on bail. When the case finally went to trial, the restaurateur's lawyers argued that their client was just a hardworking immigrant who had been set up by John Drewe. On the stand, Hill's star witness—Drewe—became a liability. The case crumbled, and the jury found the restaurateur innocent of all charges.

Drewe disappeared from the radar.

At the time Charley Hill could not begin to understand the profes-

sor's motivation. Years later, when Drewe's con artistry had been fully revealed, Hill realized the extent to which he'd been taken in.

"I frankly made a mistake," he recalled. "I was full of arrogance and self-worth after I recovered the Munch. I had been on the news and in the papers, and Drewe had obviously seen them all. He had me over completely."

Searle vaguely recalled the Macaroni case. Hill had asked him to stand by to play the role of an art expert, and Searle was ready with his kit, a little briefcase with a jeweler's loupe, a couple of small paintbrushes, a ruler, and a paint scraper. At the last minute Searle was told that he wouldn't be needed, but the episode stuck in his mind. Now he wondered whether Drewe had simply been toying with the cops or whether he had been trying to ingratiate himself in the event that his forgeries came to light. Usually informants worked with the police for money, only rarely to cover their tracks. That took a much more sophisticated kind of criminal. Ellis, pressed for time on the tomb-raider case, handed the John Drewe case over to Searle.

"I can't do both," Ellis told Searle. "It's yours."

Searle unloaded the contents of Goudsmid's bags onto his desk. Some of the documents spilled onto the floor. There were hundreds of them: photographs and transparencies; mock-ups for exhibition catalogs; receipts from galleries dating from as early as the 1950s; a letter from the sculptor Barbara Hepworth, and another from the critic and onetime ICA director Roland Penrose. Someone with good taste and a sense of art history had put together a nice little traveling museum. Still, it was unclear whether the stuff was stolen, forged, or both.

For the next several days Searle sat at a spare desk in the Art Squad office and went through the material. It was like using kitchen mitts on a jigsaw puzzle without a clear picture of the final image. He read each receipt and handwritten note, analyzed photographs and catalogs, and

sorted the evidence onto piles on the desk and on the floor. There were more than four dozen artists represented, and each got his own pile.

Once Searle had assigned every last scrap of paper to one or another artist, he broke the piles down by individual paintings. He looked for clear links to specific collectors, middlemen, galleries, and catalog entries, then recorded each name on a cheat sheet that soon resembled a genealogical tree gone haywire.

Some works appeared to have two or three entirely different provenances; others had none at all. Some had cryptic reference numbers. Some provenances stopped in the late 1950s; others corresponded to pieces that had recently been sold at auction. There were an infinite number of possible arrangements. Old letters from former ICA directors had been cut and pasted to form new ones whose meanings had been subtly altered, often to include the title of a new piece. Dozens of catalogs had their illustrations clipped out. There were enigmatic handwritten notes, presumably penned by Drewe. One read, "Change color. Does this ink change color from intense blue to black? Yes it does. YES! Print photograph Giacometti, Nicholson, Bissiere." Another note referred to a work by Ben Nicholson: "Look at Nicholson in sales ledger . . . sent back. Unsold." A third was a list of fourteen works purportedly painted by Giacometti. Next to three of the entries was the notation "have last three columns in the same ink." Searle found photographs of those fourteen works in the bags of evidence. Each had been photocopied onto a separate sheet of paper above a typed description of the work's title, dimensions, and owner.

Searle wasn't sure what was genuine and what was forged. A letter on 1950s-era paper might have been real but could just as well have been typed onto antique paper forty years later. There were letters to dealers and art experts signed by John Drewe and John Cockett, by Peter Harris and H. R. Stoakes, by Clive Belman and Danny Berger.

Searle knew that Drewe and Cockett were one and the same. Among Goudsmid's documents was a copy of John Richard Drewe's birth cer-

tificate. He was born in 1948 to Kathleen Beryl Barrington-Drew and Basil Alfred Richard Cockett, a telephone engineer and the son of a police officer. Long after his parents divorced, the young Cockett officially adopted his mother's maiden name, adding the final "e" when he was twenty-one years old. According to British records, Drewe's father remarried in 1959 and died in 1982.

Some of the more inscrutable documents had nothing to do with the art world. For example, there were letters to Drewe from the Royalty and Diplomatic Protection Department and from the commander of the Royal Navy, written on behalf of the Prince of Wales. In addition, there were receipts made out to Drewe for bugging equipment and an electronic voice-changer.

A picture was beginning to emerge of a detailed scheme to fake provenances for what Searle had to assume were fake paintings. The letters and receipts went far toward establishing the lineage of these works, but Drewe had gone further: He had somehow come up with shipping, customs, and insurance forms, as well as various reports from restorers, including one from a venerable third-generation business in London. Some of these were undoubtedly phony, but many of the letters, receipts, and catalogs bore stamps from the Tate, the V&A, and other British art institutions. Searle was sure these genuine documents had been stolen.

Having spent years around painters and restorers, Searle knew that the investigation would take months. While all fingers pointed to Drewe as the culprit, there must be others involved, but were they knowing participants or innocent bystanders? Was Drewe forging the works himself, along with the provenances, or did he have an accomplice?

Searle called Goudsmid, his only witness, and asked her about some of the names he had found in the two black plastic bags. She told him that Clive Belman was her neighbor and Danny Berger was a friend who had lost money buying paintings from Drewe. She said Berger wanted to talk to the police but was afraid of Drewe.

What about Peter Harris and Daniel Stoakes?

Goudsmid had never met either.

Who had painted the pictures?

Goudsmid could not say for sure.

"Who brought the paintings to the house?" Searle asked.

"Drewe did."

"Did they look finished?"

Goudsmid couldn't tell. Some had come in without a signature. She remembered that Drewe had a book containing the signatures of famous artists and kept it handy.

Had she ever seen him putting a signature on a painting?

No, but she had once seen one of Drewe's friends correcting or re-coloring a Nicholson painting. "I remember it very well," she said. "He used a lot of grays." This retouch man had visited them often, early on. Drewe had introduced him to her as an art historian and adviser to his art collection.

Searle's ears pricked up. "Batsheva," he said impatiently, "if you were introduced to this man you must know his name."

"John Myatt," she said.

NICKED

On a gray September morning in 1995, Myatt lay awake in bed enjoying a quiet half hour before the children had to be ushered off to school. Things had changed. He was done with Drewe and the fakes, finished with the whole sordid mess. Occasionally he thought about the professor and wondered if he would reappear, but he hoped Drewe's supply of unsold forgeries would get him off the hook. He would never see a nickel from the paintings, but it was a small price to pay for his freedom. More than the money, he wanted his dignity back.

He had been careful with the cash he'd made from Drewe's enterprise, and he now had a small measure of financial security. He'd put aside an emergency fund of £18,000 as a modest backup, and had reapplied for the teaching job he'd held nine years earlier. Perhaps as a form of self-punishment, he'd given up painting for pleasure. All his life he'd

felt the need to paint, but when he looked back on his days as an artist forger, he realized that his special skills with a brush had brought more heartache than joy. Certainly there were days when he missed being in thrall to artistic expression, but it seemed like a fair trade. He had something more precious now—peace and quiet—and he'd just bought a new keyboard and programmed it to play flute and strings and sequences of electronic Mozart.

Still, he knew that he wasn't entirely free. Of the more than 240 paintings he had produced for Drewe, at least a handful were clunkers, forgeries so poor that they would almost certainly come to light eventually. Someone would spot one on a wall and report it to a luckless collector, who would call the police. For all Myatt knew the end was a matter of weeks or months away, but he did his best to put it out of his mind.

At 6:30, he got up to wake the kids, but before he had a chance to put on his trousers, he heard a knock on the door. He dressed quickly and ran downstairs. On the doorstep stood a well-dressed man with trim blond hair. He introduced himself as Detective Sergeant Jonathan Searle and said he had a warrant to search the house for forgeries. Without a word of protest Myatt let Searle in, along with the three officers behind him. Four more officers were stationed in front of the house.

"I've been waiting for you," Myatt said.

Searle thought he looked almost relieved to see them.

Myatt's son came down to see what all the noise was about, and Myatt spoke to him gently. "They're just doing a survey of the house, dear," he said. Then he took Searle aside and asked him for a favor.

"The school bus will be here in an hour. Would you mind waiting until the children have left? Carry on with what you're doing, but I'd rather not speak to you until they're on the bus."

Searle shot a look to his partner, Bob Rizzo, a detective constable on the Art Squad.

"We're mob-handed [too much muscle] on this one," Rizzo whispered out of earshot, believing that Myatt was not likely to give them any trouble.

Searle agreed and dismissed the other officers. "Go back to Stafford and have a decent breakfast," he told them.

When Myatt's daughter came down, everyone went into the kitchen. Myatt made breakfast for the children and tea for the detectives. Searle noticed a sketch of one of the kids on the refrigerator door. It was covered with memos and phone numbers.

"That's a beautiful drawing," he said. "Did you do it?"

Myatt nodded.

The man was more than capable of churning out high-quality forgeries, Searle thought. What a waste of talent.

When the school bus arrived, Myatt took the children out and waved good-bye to them. Then he went inside, cadged a cigarette, and watched as the detectives went to work tagging and bagging stacks of drawings, notebooks, and expensive art books. Certain pages had been turned down in the books, and Searle suspected those were the works whose style Drewe had asked Myatt to forge. One rare volume was on Sutherland's work for the Coventry Cathedral tapestry, and Searle recalled the sketches he'd seen in Goudsmid's bags. When he opened a book on Giacometti, a piece of paper fell out. On it, someone had been practicing the artist's signature.

There were dozens of artworks around the house, including a Giacometti of a man and a tree in a grand arbor and several Russian-style ink sketches. In a briefcase Searle found a marginally exculpatory letter that Myatt had written to Drewe saying he wanted out.

"What else have you got?" he asked Myatt.

"You didn't check the attic," Myatt answered.

The detectives continued their search, and by the time they were done they had collected some fifty books, sketches, and letters.

Searle asked Myatt if he wanted to call a solicitor. Myatt declined. When Searle told him that he was suspected of conspiring to forge works of art, Myatt shrugged.

"Well, that's it then."

They put him in the back of a squad car and drove him ten miles to the Stafford station house, where Searle and Rizzo sat him down and asked him how he had met Drewe. Myatt told them about the ad in *Private Eye*.

"I'm not in touch with Professor Drewe anymore," he said. "He's dangerous and volatile."

Myatt kept referring to Drewe as "professor," and Searle assured him that he was not. Drewe's education was limited to an undistinguished stint in grammar school.

Myatt was surprised. He had always assumed that there was at least a kernel of truth in Drewe's account of himself as a physicist.

Searle said he wanted Myatt back tomorrow but for now the interview was over.

Riding home in the police car, Myatt wished he could float off like the angel in Corot's *Hagar in the Wilderness*. As he waited for the children to return in the school bus, his heart was pumping and he felt sick to his stomach. That evening he didn't say a word to them about what had happened. His world had just been turned upside down, and he thought he had nowhere to go. Then he remembered an old family friend who was a retired policeman. They'd sung in the church choir together and were friendly. Myatt rang him up, told him everything, and asked for his advice.

There was nothing to do but cooperate, the old cop said. Drewe would never admit his guilt, and would blame Myatt for everything. "My advice to you is not to dig yourself into a hole."

Myatt was relieved. Conceivably he could have tried to concoct an elaborate fabrication, but that probably wasn't going to work. When

he returned to the station a few days later, he was more than ready to talk.

Myatt told Searle everything he knew about the operation, including his use of house paint, a confession that shocked the detective but was later corroborated by a forensic analysis identifying a resin not available at the time the paintings supposedly had been made. Myatt said that most of the money he'd earned from Drewe in commissions had been spent—among other things, on covering half of Drewe's £20,000 donation to the Tate—but that he would turn over the £18,000 he had left.

After the initial interviews Myatt began a series of regular trips to the city to meet Searle at the Belgravia Police Station, which had jurisdiction over the part of town where the best galleries were located. The walls outside the basement interview room had been freshly painted, and dozens of Myatt's forgeries, wrapped in heavy polyethylene, were lined up in the corridors, all tracked down by police through the help of auction houses and dealers. It seemed to Myatt that although the police had already confiscated scores of pieces, they'd missed the best stuff. The really good work was still out there in penthouses and villas. Drewe had often boasted that he'd placed premium Myatts with collectors in New York and Paris, in Tokyo, Italy, and Bahrain.

As Searle brought a succession of Myatt's works into the interview room, he spoke slowly and precisely, for the record.

"Now we are unwrapping exhibit number BsG 192. Did you paint this?"

"I did."

"And do you recognize this painting over here?"

"I do."

And so on down memory lane, to the next canvas and the next, as Myatt recalled when and where he'd painted each one, occasionally noting how beautifully Drewe had framed them. The professor had never been artistically inclined, but he had an eye for presentation.

The Belgravia officers referred to the collection as "the Black Mu-

seum." They would come down to the subterranean gallery with raised eyebrows and scoff at the obscene prices that the "Sutherlands," "Dubuffets," and "Braques" might have fetched if they hadn't been pulled in. They nicknamed the Dubuffets "the BSE cows," after bovine spongiform encephalopathy—mad cow disease.

Searle took on the roles of inquisitor, aesthetic gendarme, therapist, and moral arbiter. He was convinced that Myatt was no career criminal and that he'd stumbled off the path despite his better self. Before long the two men developed a rapport and began exchanging notes on the quality of the forgeries.

"You were certainly having a good day when you did this one," Searle said, when he came across a particularly good fake. If a work was shoddy or below par, he didn't hesitate to needle Myatt: "Don't tell me you painted this one."

In the basement of the station house, Searle came to see that Myatt was technically brilliant and an excellent draftsman. He was also a skilled forger able to fake a brushstroke or a line without losing the vivacity of the original. He understood the importance of loose ends and the power of an unfinished work. Amateur forgers and restorers, in their quest for a perfect canvas invulnerable to criticism, tended to overwork a painting and lose the feel of the artist. Myatt, by contrast, seemed to work without a net and liked to leave his paintings wide open.

There were times when Searle brought in a really good piece and it took Myatt a minute or two to recognize it. Some pieces were obvious duds; others were better than he remembered them. Searle worked him so hard that by the end of the day Myatt felt as if he were back on the M6 with his shovel and pick.

ALADDIN'S CAVE

Searle's office had become a repository of letters, memos, receipts, and catalogs piled one on top of another. One particular clue showed up on document after document and appeared to be a leitmotif for Drewe's operation: "For Private Research Only/Tate Gallery Archive." To Searle this official stamp was proof that the documents had been stolen from the Tate archives. He called Jennifer Booth to tell her he was bringing over the suspect material.

When he arrived, she immediately took issue with his thesis. "I think your approach is wrong. You have to shift your focus. Drewe isn't taking archives out. He's putting them *in*."

Booth said the documents were forged. She told Searle about the discrepancies she'd discovered in the records and showed him the Hanover photo albums, which documented the gallery's acquisitions over the years. These had never been allowed out of the main reading room.

Searle opened one of the albums and found beneath each photograph a neatly typed label and reference number. He recognized the paper and format from the documents in Goudsmid's bags. Many of the paintings were familiar too, particularly two Bissières, *Composition 1949* and *Composition 1958*. Photographs of these pieces, along with handwritten memos that referred to them, were also in Goudsmid's bags.

Booth opened the Hanover sales ledgers to the two Bissières; the provenances were identical to the ones in the photo albums. She brought out the Hanover daybook and opened it to the date of the supposed sale of *Composition 1958*. There was no mention of the piece. She moved her finger down the page to the place where *Composition 1949* would have been logged. There was an entry, but it was for a work entitled *La Fenêtre*.

"The books don't match," she said.

Searle suddenly realized that the dozens of cryptic handwritten notes he had found in Goudsmid's bags were memos Drewe had written to himself, a kind of aide-mémoire. He hurried back to the Yard and checked his Bissière section.

"Re-write Bissieres," one of these scribbled memos read. "Investigate sale of G133/3 La Fenêtre—it should be reference G133/8 in Sales Ledger List."

For all intents and purposes, Drewe had become an accomplished archivist. For nearly ten years he had spent countless hours studying the dullest aspects of the art business. He had researched archival methods until he could identify and exploit gaps in the firewall designed to protect the art market's records and reputation. He had gone to infinite trouble to place his fakes next to established masterpieces so as to make them appear to be a part of art history.

Myatt was right about Drewe: The money was a side benefit. Drewe craved admiration and got it by passing himself off as a professor and physicist. When this proved insufficient, he managed to insert himself

and his false creations into the heart of the art world. In doing so he was about to make a name for himself as one of the twentieth century's greatest fakers of art.

A s Searle well knew, the art of forgery is as old as civilization. Priests in ancient Babylonia, in order to continue receiving their privileges and revenues, are believed to have faked a cuneiform script to make their temple appear older than it was. "This is not a lie," one of the forger-priests wrote on the stone tablet. "It is indeed the truth. . . . He who will damage this document let Enki [the god of water] fill up his canals with slime."*

The motivations behind forgery are as varied as the types of forgeries that have been perpetrated over the centuries, but the most common fuel has always been greed. When demand exceeds supply, the forger is never far behind. In ancient Rome, when classical Greek sculpture became a status symbol and the supply of genuine pieces was exhausted, Roman craftsmen quickly filled the void. Today, experts believe that 90 percent of "original" Greek statuary was made by Romans. During the sixteenth, seventeenth, and eighteenth centuries clandestine workshops operating across Europe produced paintings in the style of such masters as Michelangelo, Titian, and Ribera, and to this day these forgeries continue to surface. Some may never be properly identified. Forgery was so widespread that some of the masters became forgers themselves. The young Michelangelo painted a work in the style of his master Domenico Ghirlandaio and passed it off as an original after doctoring the panel with smoke to make it look older. He subsequently sculpted a sleeping cupid and sold it off as an antiquity. In the nine-

*Mark Jones, ed., with Paul Craddock and Nicolas Barker. *Fake? The Art of Deception.* Berkeley: University of California Press, 1990.

teenth century, Jean-Baptiste-Camille Corot knowingly signed copies made by others in his name. It is a long-standing French joke that of the twenty-five hundred paintings Corot produced in his lifetime, eight thousand can be found in America.*

Searle had seen enough fakes to know that it wasn't always the technical faux pas that gave forgers away. Just as often they left behind an unmistakable cultural footprint. A *Madonna of the Veil* purportedly by the fifteenth-century Florentine painter Sandro Botticelli was "discovered" in the 1920s and sold without provenance for $25,000. A celebrated find at the time, the piece was declared fake more than fifteen years later, after an art historian noticed that the Madonna looked more like a 1920s film star than a Renaissance beauty. Experts who examined the "Silent-Movie Madonna" found, among other inconsistencies, that the figure's robe had been painted with a blue pigment not developed until the eighteenth century.† At a more prosaic level, holes on the surface that looked like they had been caused by an infestation of woodworms had in fact been drilled in.

The cultural critic Walter Benjamin asserted that fakes lack the special aura an original artwork invariably carries, that the work's essence, its personal contact with a particular time and space, can never be replicated. Those who believe in the eventual triumph of good over evil posit that most fakes are eventually exposed. Others are more skeptical. History supports the second group.

The art market is a potential minefield. With so many fakes being produced, even the most experienced dealer can make a mistake. Art

*This comic nudge at credulous American collectors has been retold often, with wildly varying figures. In 1934, *Time* magazine made note of the "hoary art joke . . . that the U.S. today has no less than 30,000 Corots." In 1940, *Newsweek* wrote, "Of the 2,500 paintings Corot did in his lifetime, 7,800 are to be found in America." Later, *ARTnews* published slightly different figures, as did the *Guardian*. *Time* revisited the joke in 1990, in a piece by critic Robert Hughes: "It used to be said that Camille Corot painted 800 pictures in his lifetime, of which 4,000 ended up in American collections."
†Jones et al.

historian Bernard Berenson, who consulted for major U.S. museums and collectors and established the market for "old masters," once warned that the best of experts could be fooled. "Let him not imagine that a practical acquaintance with last year's forgeries will prevent him falling victim to this year's crop," he wrote. Berenson cautioned dealers and experts not to be swayed by provenance, which he said could be forged more easily than the work itself. His words, predating Drewe's scam by some eighty years, now seem prophetic: "[There is nothing] to prevent a picture being painted or a marble carved to correspond to a description in a perfectly authentic document. Nothing but a fine sense of quality and a practiced judgment can avail against the forger's skill."*

It is impossible to calculate the exact number of forgeries circulating at any given time, but the guardians of high art have estimated that anywhere from 20 to 40 percent of the works on the market are either fakes or genuinely old works that have been doctored to fit a more valuable style or artist. Thomas Hoving said that in his eighteen years at New York's Metropolitan Museum of Art, during which he examined some fifty thousand works, "forty percent were either phonies or so hypocritically restored or misattributed that they were just the same as forgeries." Italy's Art Carabinieri, whose job it is to police the country's cultural heritage, claimed to have seized more than sixty thousand fakes during the 1990s. And yet, despite a growing awareness of the prevalence of forgeries and an array of sophisticated technology using infrared and ultraviolet light, the most rigorous scholars and prestigious institutions can still be taken in.

The twentieth century witnessed a blossoming of inventive forgery. Han Van Meegeren was a failed artist who decided to prove his worth by painting works in the style of great artists of the past, particularly

*Berenson is a controversial figure. Some scholars claim he deliberately misattributed many works to earn the substantial commissions he charged.

the seventeenth-century Dutch artist Jan Vermeer. In the late 1930s and the 1940s, he produced some ten paintings that were accepted as genuine Vermeers and "great discoveries." Van Meegeren earned millions for his forgeries, many of which had religious themes, and fooled the leading experts, museum directors, and collectors of the day. He used badger-hair brushes so that not a single modern bristle would ever be found embedded in the paint of his forgeries. He ground his pigments in oil of lilac and made a unique resin mixture that gave the paint an enamel-like surface, and he baked the canvas in the oven for two hours to harden the paint. Van Meegeren's most notorious work was *Christ at Emmaus,* which the Dutch art historian Abraham Bredius acclaimed as Vermeer's greatest achievement.

"It is a wonderful moment in the life of a lover of art when he finds himself suddenly confronted with a hitherto unknown painting by a great master, untouched, on the original canvas, and without any restoration, just as it left the painter's studio!" Bredius wrote. "And what a picture! . . . we have here a—I am inclined to say—*the* masterpiece of Johannes Vermeer of Delft, . . . quite different from all his other paintings and yet every inch a Vermeer."*

No one can say how long these forgeries would have remained in museums and prominent collections if one of the works hadn't ended up in the possession of Nazi Luftwaffe commander Hermann Göring. After the war the work was traced back to its dealer, van Meegeren, and he was charged with collaboration for selling a Dutch national treasure to the enemy. He confessed to serial forgery, a much less serious offense, but no one would believe him. To prove it he painted a brand new fake in prison while awaiting trial. After the work was examined by a scientific commission, van Meegeren's confession was accepted.

*Gordon Stein, ed. *The Encyclopedia of Hoaxes.* Detroit: Gale Research, 1993; excerpt found at denisdutton.com/van_meegeren.htm.

"Yesterday, this picture was worth millions of guilders and experts and art lovers would come from all over the world and pay money to see it," he wrote before serving a one-year sentence. "Today, it is worth nothing, and nobody would cross the street to see it for free. But the picture has not changed. What has?"

It may be said that the art world holds no fury like the expert duped. While it seems clear that van Meegeren's success owed much to his talent, his brushwork and compositions are now criticized for their coarseness and shapelessness. Philosopher Denis Dutton has noted that a face in one of van Meegeren's "masterpieces" resembles Greta Garbo's.

Bredius's praise for *Christ at Emmaus* helps illustrate why so many scholars and institutions are duped at least once in their careers. Often experts have preconceived ideas about a certain artist or era and are just waiting to see them proven by a "rare find." Bredius was the scholar who had theorized that there might be undiscovered works by Vermeer with religious themes. In the words of Mark Jones, editor of *Fake? The Art of Deception,* the catalog for a popular exhibition held at the British Museum in 1990 (an exhibition which Drewe almost certainly visited), "Present Piltdown Man [a hoax in which an oranguntan's jawbone and a modern man's skull were claimed to be the remains of an early human] to a paleontologist out of the blue and it will be rejected out of hand. Present it to a paleontologist whose predictions about the 'missing link' between ape and man have been awaiting just such evidence and it will seem entirely credible."

Historians and dealers continue to be seduced by the notion that lost treasures are out there waiting to be found; they are willing to pay top dollar as well as lower their threshold for scrutiny. Take the Zagreb museum, which opened with great fanfare in 1987 and claimed to be the Louvre of Yugoslavia. Its curators were said to have been pressured into accepting a collection of nearly four thousand items sold to them

by a Yugoslav patriot. Museum officials insisted the collection was worth $1 billion and contained masterpieces by Michelangelo, Leonardo, Raphael, Botticelli, and Velázquez, among others. The Yugoslav government had bent over backward to facilitate the acceptance of the scantily documented works.

In his revealing opening remarks, the museum director spoke of the thrill of discovery. "Who can evoke the collector's trembling excitement as he stands before a secondhand dealer's shop and sees a rare piece of ancient glass offered at a trifling price?" he said. "Or when, beneath the superficial grime of a picture bought at auction as a mere copy, the autograph of some classic ancient painting begins to emerge beneath the restorer's hand?"

Nearly the entire collection turned out to be bogus.[*]

Some forgers work on a grand scale. Eric Hebborn, an art restorer and another failed painter, confessed in 1984 that he had produced a thousand forgeries in the style of the old masters, among them Tiepolo and Rubens, and boasted that many of his paintings had landed in esteemed collections, including those of the National Gallery in Washington, the British Museum, and the Morgan Library and Museum in New York.

To Hebborn, whose works have been described as stylistically brilliant, the production of fakes was an intellectual exercise as well as an attempt to confound a market that had rejected him. He refused—or failed—to see the criminality "in making a drawing in any style one wishes . . . [and] asking an expert what he thinks of it." He claimed to be a "fair player" in this game of wits because he was leveling the playing field. He established his own moral guideline of sorts: One of his rules was that he would never sell a work to someone who was not a recognized expert or was not acting on expert advice. "No drawing can

[*]Hoving and *ARTnews*, September 2001.

lie of itself; it is only the opinion of the expert that can deceive," he wrote in *The Art Forger's Handbook*.*

Skullduggery aside, Hebborn and his colleagues raise basic questions about what makes certain art valuable. If a drawing is a good one, does it have an intrinsic worth even if it is not by the artist it purports to be by? "It is the most tantalizing question of all," said connoisseur Aline Saarinen, quoted by the Met's Hoving. "If a fake is so expert that even after the most thorough and trustworthy examination its authenticity is still open to doubt, is it or is it not as satisfactory a work of art as if it were unequivocally genuine?"

If Saarinen had asked Picasso, the answer would have been yes. "If the counterfeit is a good one, I should be delighted," he once said. "I'd sit down straight away and sign it." In the 1940s, a dealer asked Picasso whether he would put his signature on an unsigned painting of his that a client owned. Picasso agreed, but when he saw the work he realized it was not actually his.

"How good a client is the owner?" he asked the dealer.

"One of my best," the dealer replied.

"In that case, the painting is mine," said Picasso, and signed it.†

The public is of two minds about history's great forgers. It has celebrated them as beloved outlaws and vilified them as philistine rogues. After Han van Meegeren was released from prison, most of the Dutch public saw him as a clever crook who had succeeded in fooling both the art experts and the hated Göring. Several years ago one of his works sold at auction for $88,000.

The flamboyant Hungarian Elmyr de Hory was caught in 1968 after a twenty-year career of forging nearly a thousand works, in the style of such artists as Matisse, Modigliani, and Picasso. De Hory used a num-

*Hebborn was murdered by an unknown assailant in 1996 while living in Rome.
†Alex Wade, "Cracking Down on Art Fraud," *Guardian*, May 24, 2005.

ber of aliases to sell his works, and at one time had two accomplices who not only sold on his behalf—and cheated him—but also searched antiquarian bookshops for out-of-print art books of the 1920s and 1930s, and got de Hory to produce forgeries that matched the descriptions accompanying the plates in these books. Then photographs of the forgeries were slipped into the books to replace the original illustrations, thus creating an instant new provenance and anticipating Drewe's scheme, though on a far smaller scale.

Hoaxes tend to beget hoaxes. De Hory became a celebrity and was the subject of a biography by Clifford Irving, who was later jailed for writing a wholly imaginary "authorized" biography of Howard Hughes. The de Hory story went on to become the basis for Orson Welles's 1975 pseudodocumentary *F for Fake*. Welles, of course, had famously terrified the nation in 1938 with a fake radio newscast about a Martian attack on New Jersey.

The art restorer Tom Keating became a national figure in Britain and briefly hosted his own television series after confessing in 1976 to forging more than two thousand works in the style of a hundred artists. Keating, who had begun his career as an angry young painter, was determined to honor artists who had died in poverty after being exploited by unscrupulous dealers. His goal was to undermine the system. He planted clues in his forgeries for the "experts" to find. He would sprinkle dust from a vacuum cleaner and flick spoonfuls of Nescafé in the air to simulate foxing, the greenish gray or brown mildew stains that appear on old paper. Sometimes he hid the words "This is a fake" or "Ever been had?" in lead white beneath a painting. Knowing that a personal touch excited dealers, he would scribble inscriptions on the back of his work.

"Why is it that the dealers always seem to set so much store by this kind of thing, when the paper I did it on was probably made in England in 1940 or 1950, is a mystery to me," Keating wrote in his autobiogra-

phy, *The Fake's Progress*. "I suppose the short answer is that it takes a brave man to destroy a fake, particularly if he is in the business of buying and selling pictures." After his death, one of Keating's original works sold for £274,000.

Detective Sergeant Searle believed that forgers like Keating and Myatt were "a healthy component to the art system," because they forced dealers and historians to look more closely at the works they chose to sanction—and sell—as art. Counterfeiters were necessary irritants, he thought, like political radicals. He himself had participated in anti–Vietnam War demonstrations in Grosvenor Square in the sixties, but had subsequently spent a good deal of time going after elements of the extreme left. He now believed that those "rowdies" had made their own valuable contribution to the political discourse.

"They made the politicians think about what they were doing," he said. "The same thing in art. I don't personally think a few forgeries are a bad thing. . . . Myatt's crime didn't bother me, but Drewe's crime did."

The professor had gone one step further than the garden-variety forger. He had penetrated the libraries and archives and had revised art history, corrupting the prism through which future generations would view, analyze, and learn from the country's cultural past.

"He's tampering with heritage," Searle said.

After his conversation with Booth and his epiphany at the Tate, Searle spent the next several weeks shuttling between the Yard and the archives, following Drewe's path with the aid of the requisition slips the professor had filled out. He asked the auction houses to keep an eye out for Drewe and his many aliases, and provided a list of the painters he believed were being forged. Over the past decade, he assured the auctioneers, at least two dozen works bearing Drewe's unmistakable stamp had passed through their hands. Whenever such works

were brought to his attention, Searle seized them and had Myatt identify them.

One late fall day, as he was going through his files, a colleague from the Organised Crime Unit poked his head in and announced that he'd come across something interesting at Christie's. "There's a bunch of crap in the showroom," he said, tossing a catalog onto Searle's desk. "I'm sure it's yours."

Searle flipped through the pages of "Post-War Contemporary British Art" and came across four gouaches by Graham Sutherland, one of his favorite artists. They were studies of the Crucifixion, similar to the ones he'd found in Goudsmid's bags, each painted on a background of a different color: red, yellow, orange, and green. He recognized the designs. They were based on the lower panel of Sutherland's Coventry Cathedral tapestry, *Christ in Glory,* which was depicted in a rare book on Sutherland that he had found at Myatt's. According to the catalog, Sutherland had donated the gouaches to the Order of the Servants of Mary in 1956, and they had subsequently been sold to an H. R. Stoakes. In the late 1960s, they had been part of an ICA show called "Art for the Cathedrals."

Searle looked at his cheat sheet: Stoakes's name showed up in several provenances. So did the O.S.M. stamp.

The auction was scheduled for the following day. Searle grabbed a roll of bubble wrap and headed down to Christie's. After a brief discussion with the head of the Contemporary Art department, he seized the quartet of "Sutherlands."

They were impressive additions to his collection, intentionally untidy and more like works in progress. Searle found them attractive and interesting. Myatt had paid close attention to Sutherland's method, particularly the way he thickened and thinned the line with his brush. Searle noticed that the O.S.M. stamp had been pressed onto one of the watercolors themselves, rather than on the reverse. This seemed like a dead giveaway. Drewe had gone to the trouble of paying a forger, fak-

ing a catalog, and aging the works, but then he had carelessly disfigured them.

Was it a taunt?

Tom Keating had thumbed his nose at the experts by painting subliminal scribbles on his canvases, but he'd always claimed that he wanted to get caught, and that his forgeries were an act of revenge, a blow against an unscrupulous fraternity of art dealers.

It occurred to Searle that beneath Drewe's cosmopolitan veneer he was a philistine with little feeling for the arts. He saw paintings as commodities to be traded for the best possible price. He passed himself off as a refined and cultured Englishman, but his actions defined him as a man entirely without values.

Drewe had recognized a niche opportunity in the art market. Given the number of works that passed through the auction houses each year—an estimated $5 billion worth—he had guessed correctly that the experts couldn't possibly vet each of the tens of thousands of works in the lower price ranges. He had concentrated on midrange pieces, works that would bring in a steady income without drawing undue attention.

Searle looked at his notes from Christie's and found the name of the dealer who had consigned the Sutherlands. He got into a cab and headed for Adrian Mibus's gallery.

The dealer was more than happy to tell him the whole story of his relationship with Drewe. He mentioned the fake Bissières he'd bought, the de Staël, and the works Drewe had subsequently offered him a 50 percent share in. He told Searle that he'd finally accepted Drewe's proposition because he got tired of watching these very same works sell at auction. He'd taken the four Sutherlands after Christie's auctioned a similar group of Sutherlands successfully, and he believed they were genuine.

When the detective asked if Mibus had anything to back up his

story, the dealer pulled out some documents Drewe had drawn up outlining the ownership history and the sales transactions. Then he showed Searle several other works he had accepted from Drewe in order to recoup his heavy losses. These included a Giacometti, a Ben Nicholson, and a Mark Gertler. Mibus also handed over a painting titled *Composition 1958,* purportedly by Bissière, which had been returned to him with the signature wiped off after the French dealer he'd sold it to recognized it as a fake. This last piece Searle recognized as one of the fakes Booth had shown him in the Hanover albums at the Tate—the one that wasn't in the daybook. It would make for good evidence.

Searle went back to the Yard. On the way he reflected that Drewe always seemed to manage to turn events in his favor. It was like a fixed game of craps: The deeper his marks got into debt, the more desperate they became to earn their money back. Thus had Adrian Mibus become Drewe's unwitting partner. Searle wondered how many others had been forced into the same position, how many had been duped, and how many still believed Drewe's promises.

Searle had Mibus's paintings and documents carted back to his office. They would be rich and substantial material for the trial, but Drewe would undoubtedly be a skilled liar on the stand, able to confabulate on the high wire without a net. Even under the most searing cross-examination, the detective couldn't imagine Drewe being pressured or tricked into admitting any wrongdoing on his part, so the case had to be watertight.

Then Searle got a call from Rene Gimpel. The dealer told him about the fake 1938 Nicholson watercolor he'd bought. Searle retrieved it and asked Myatt to identify it.

"I didn't paint that," Myatt said.

Searle was dumbfounded. The work's provenance had Drewe's fingerprints all over it. Was there another forger involved?

Searle had spent most of his career undercover, in the shadows. Sel-

dom had he put together a case from scratch. Four months into the investigation he had accumulated some forty paintings, each with its own attendant bundle of names, receipts, documents, and stamps. Organised Crime Unit staffers had begun to refer to his office as Aladdin's Cave. Searle didn't find that particularly funny. He feared the investigation was in danger of falling apart. He had witnesses and suspects in New York, Canada, France, and Sweden, but he still needed to interview dozens more in his own backyard. Moreover, he needed the cooperation of dealers and experts who had bought or authenticated pieces. They would all have to testify in open court. Some were cooperating, but others refused, saying it was bad for business. He was also running out of time. The longer he poked around, the more likely that news of his investigation would leak and Drewe would go underground and cover his tracks.

To make matters worse, he was now looking at the possibility that a second forger was involved. He begged his supervisors for reinforcements. He argued that in light of Drewe's corruption of the archives, the case was a matter of national importance. The cultural patrimony was at stake.

Finally, Searle's request was granted, and in January 1996 four members of the Organised Crime Unit made their way to Aladdin's Cave. Among them was a career investigator named Miki Volpe,[*] a "Geordie," or native of northeast England, from the predominately working-class city of Newcastle. Volpe, who pronounces "father" as "fatha" and "have" as "hev" and was brought up in a family of musicians, had worked the rough side in the past. He'd gone after car thieves, murderers, Chinese white slavers, Serbian gold diggers, Russian credit-card scammers, and Croats peddling bargain weaponry. With patience and a good deal of muscle, he'd smashed the strongholds of London's "snakehead" traffick-

[*]No relation to Robert Volpe, the New York art-fraud detective.

ers in human flesh and pulled smuggled immigrants out of run-down hotels to safety. On the Kidnap Squad he'd rescued two ransomed Frenchmen who had been tied up and left for dead in a cupboard.

Volpe had never heard the word provenance, but he knew how to build a case.

THE FOX

Miki Volpe took the early train from Essex, where he lived with his girlfriend, and got to the office in half an hour. Searle was waiting for him in a tiny exhibit room lined with shelves interrupted by a pair of windows, one of which looked out on the triangular Scotland Yard sign familiar to anyone who had ever watched a British cop show on television.

"Volpe" is Italian for "fox," which was appropriate for someone who looked like he'd been prowling outside the henhouse. He had a head of curly hair, a stubbly beard, and a slight limp from knocking down doors over the years. He smoked a calabash pipe shaped like a question mark, a fitting prop for an experienced interrogator.

Volpe was immediately struck by the volume of material Searle had amassed: more than three thousand exhibits, far more than they could comfortably organize into an effective courtroom presentation. Most criminal cases relied on a few dozen at most. The three additional detec-

tives assigned to the case were a mixed blessing, for they were now crowded into the Art Squad's limited space along with all the evidence.

Once the scores of faxes and photographs and documents had been placed in plastic bags and labeled, the detectives tried to narrow down the number of paintings they would use as evidence. Those that unequivocally linked Drewe to the forged provenances were set aside as court exhibits.

Searle was still unsure which of the dozens of people who had cropped up in the investigation were unwitting collaborators and which had taken an active role. He believed the art dealers had been duped, but some of Drewe's runners may have been in on the scam. Some of the dealers and collectors named in the provenance documents may have been involved too, but Searle suspected that many were figments of Drewe's imagination.

The detectives began by interviewing the experts who had given their opinions on works associated with Drewe. The Tate's former director Alan Bowness and one of its curators, Jeremy Lewison, had both failed to recognize certain Nicholson fakes, but they had done so unwittingly and seemed willing to cooperate.

Each detective had his own way of dealing with a suspect or potential witness. Volpe could be rather aggressive and tended to lean on witnesses he suspected of being accomplices. In the interrogation room he was fully charged and often brusque. He took no one at face value, including Searle's star witness. Even though Myatt had been singing like a canary, Volpe frisked him in the interrogation room before interviewing him. Searle thought this was unnecessary, a ritual act of humiliation. Volpe maintained that a criminal was a criminal and there was no gray area in between. He wanted to put Myatt on edge, to let him know that he shouldn't take anything for granted. Still, the two detectives complemented each other. Volpe could get to the heart of a case and knew what elements were required to win a conviction. Searle knew art and was the team's de facto curator.

Because the art world could arouse as much resentment as reverence, Searle decided to home in on the paintings that would not only make the best evidence but would appeal to a middlebrow jury. He began to steer away from the more abstract pieces, the ones that might prompt jurors to sneer and mutter, "I could have painted that myself!" To keep the jury from seeing Drewe as merely a mischievous prankster, a canvas pimpernel who had brought down the hoi-polloi and taken the aristocracy for a ride, Searle wanted to put "nice, pretty pictures" on the courtroom walls, works a juror could easily digest, understand, and admire. For that reason he weeded out the Dubuffet fakes Myatt had painted. Jurors might not have much sympathy for a collector who had paid several thousand pounds for a childish rendering of a cow—a *diseased* cow, at that.

There was also the issue of the director of the Dubuffet Foundation, who had authenticated eighteen of Myatt's fakes. It had taken Searle and Volpe several hours to convince her that she was wrong. When she finally acknowledged her blunder, she burst into tears. It was far too dangerous to put her on the stand. Drewe would testify that he did not know the works were fake, and his lawyer would pick the witness apart: If the director of the Dubuffet Foundation couldn't tell the difference between a fake and an authentic work, how could Drewe possibly know?

Searle needed credible witnesses, preferably victims who had never stood to profit from the con and were thus above suspicion. He and Volpe decided to focus on the Order of the Servants of Mary, which had provided provenances for a number of Sutherland Crucifixion scenes. Before making arrangements for several of the friars to come down to Scotland Yard, Searle interviewed Mibus and Peter Nahum, who had agreed to testify in court that they had received their Crucifixion pieces either from Drewe or one of his runners.

When Father Bernard Barlow walked into the interview room to examine Nahum's piece, Searle asked him if he recognized it.

"Never seen it," said the friar.

Searle said he had documents indicating that St. Philip's Priory had sold this Crucifixion scene and several other artworks to Fisher & Sperr as part of a lot of books.

Barlow conceded that he had had a hand in the sale, but he couldn't recall any paintings or drawings.

Searle turned the Crucifixion panel over and showed him a handwritten inscription: "Father Bernard F. Barlow, Graham Sutherland, Crucifixion of our Lord—study in oil—loaned Jan 1972 to Oxford University Bod Library reference R203."

"That isn't my handwriting," Barlow said. "I wasn't even in the country at the time." He pointed out that when friars entered the O.S.M., they adopted the middle name "Mary" and used it for church-related business. Thus, Barlow always signed himself "Bernard M. Barlow." The forger, unaware of this, had used Barlow's original middle initial, F for "Francis."

It was clear to Searle that Drewe had used intimidation and coercion to con the friars, and that they would make good witnesses. Drewe had duped a religious order that depended on charity, and that would not sit well with a jury.

Meanwhile, Volpe had a chat with Sperr. The bookstore owner categorically denied that there had been works of art among the books he'd bought from St. Philip's. He led the detective upstairs and showed him some of the volumes Drewe had been interested in. As they leafed through them, Sperr noticed that one of the title pages was missing. Volpe suspected that Drewe had torn out the page, which contained an impression of the O.S.M. stamp, and used it to make a counterfeit stamp.

"This is good evidence," Volpe told Searle when he got back to the Yard.

Although they could now establish Drewe's connection to the Crucifixion fakes, they wanted a bigger bang, proof that the professor had

pocketed hundreds of thousands of pounds and bilked innocent victims not only in Britain, but all over the world, from Canada to the Philippines. Searle suggested that they rein in the fake Giacomettis supposedly authenticated by documents in the Tate Gallery archives. Giacometti was a well-known figure, and even his minor works sold for six figures. A jury would be impressed with the amount of money Drewe must have made. With the right evidence, the detectives could also link him to the corruption of the archives.

Searle told Volpe about his visit with Jennifer Booth. She had mentioned that there was a Giacometti expert in Paris who could help him crack the case.

It was time to call in Mary Lisa Palmer.

For the early bird the Chunnel train from London to Paris is a silent dream of a commute, an aerodynamic wonder. This morning, as she slid past the French countryside at 180 miles an hour, Palmer was grateful for the two-and-a-half-hour ride ahead. She wanted to organize her thoughts before her meeting with Detective Searle.

Gradually she had come to appreciate the enormous scope of the con and the audacity of its mastermind. Since her conversation with Searle, she had a sense that the tide was turning in her favor. The association was no longer alone in the fight against her formidable opponent, a man who appeared to have a natural talent for manipulation.

A large overnight bag at her feet was crammed near to bursting with evidence of a new genre of art fraud. The association had expended a great deal of time, money, and effort to piece together the paper trail that documented Drewe's unprecedented scheme. She was not about to let the bag out of her sight until it was safely inside Scotland Yard.

The train pulled into Waterloo Station, and Palmer caught a taxi. As it crossed the Thames, she felt a sense of relief. Searle had told her

that the forger was under arrest and that he was cooperating with the police. That was a start, she thought.

Searle and Volpe had left word for Palmer to be escorted up to the fifth floor, where Searle had set up his Giacometti files. With relative archival clarity, he had sorted stacks of documents and drawings into individual plastic troughs, each one a different color.

Palmer sat down and began to recount a decade-long sequence of events: the bizarre letters and phone calls; the correspondence with various dealers; the phenomenal string of fakes she'd come across at the Tate and on the market. She showed the detectives a pile of photographs and letters she believed Drewe had sent her under different aliases. Each letter contained a request for the Giacometti Association's imprimatur. One of the photographs was of a pencil drawing titled *Deux Figures*, owned by "Richard Cockcroft."

Searle recognized the piece. His detectives had recently confiscated it from the home of Danny Berger, the only runner who had thus far been interviewed. Searle reached into one of his troughs and showed Palmer the original drawing.

"It's a fake," she said firmly.

She explained that the painting was an imitation of a real one in the Tate's collection. The forger misunderstood the perspective of the two figures in the authentic work. He had placed the large and small figure beside each other rather than one in the foreground and one in the background, as represented in the original work.

One of the figures was particularly bad, she said, uncharacteristically abstract and indecisive. Giacometti was allergic to symbolism. He painted what he saw. His line drawing may have been delicate and willowy, but he always conveyed a sense of a fully formed human presence: That was his genius. Finally, the signature was too neat, too perfect.

Searle brought out the 1991 Sotheby's catalog with the picture of

the Footless Woman. His team had given it a morbid nickname, "the Legs Job"—a reference to the IRA practice of kneecapping.

"That one's wrong too," said Palmer, who had been after the painting for years. Its final destination remained a mystery. For all she knew it could be hanging on a wall in Monte Carlo or gathering dust in an attic in Madrid.˙

For the next several hours Palmer filled in Searle and Volpe on her research, particularly her dealings with Armand Bartos and his *Standing Nude*. She hadn't heard from him for a while and suspected the nude might eventually come up for auction.

The detectives wondered if it was possible that one person alone had planned and carried out such a complex scam. Dozens of phony catalogs had been produced and, according to Myatt, at least two hundred paintings had gone on the market. In addition, Britain's most important archives had been corrupted. Was Drewe the front for a syndicate of crooked dealers? Was Bartos his New York connection? Searle and Volpe were aware of at least half a dozen runners who had moved pieces through London, New York, and Paris.

Palmer was very helpful and provided several good leads. The detectives were confident that she would make a fine witness in any courtroom. She had a clear expository style and could explain how she had arrived at each of her conclusions. If she could talk Volpe through the basics of art appreciation and the mazelike subtleties of provenance, she could certainly convince a jury. Unlike other experts, she had never given the nod to a single one of Drewe's fakes. She was untouchable, and her expertise was unquestionable. Now the police just needed to recover a fake Giacometti that they could prove had been sold by Drewe.

˙The Footless Woman would resurface on the market in 2001, only to disappear again. A prominent London dealer who had been duped by Drewe in the 1990s sent a photograph of the work to Palmer for a certificate. The dealer was selling it on behalf of a U.S. collector. When Palmer told the dealer that the painting was "a Drewe fake" and asked him to hand it over to the police, he said he would return it to the collector instead. It hasn't resurfaced since.

Whenever she was in London, Palmer liked to pop into the auction houses to see what was coming up. After leaving Scotland Yard, she dropped her bags off at the hotel and walked to Sotheby's, where she bumped into an acquaintance from the Impressionist and Modern Art Department.

"Surprise, surprise," he said. "Come and see what we've got for the next sale." In his office he showed her the galleys of a catalog for the forthcoming auction and turned to a picture of Bartos's *Standing Nude*.

"It's a fake," she said. "I've been in contact with the owner, and I've told him what I think about it." She warned the startled Sotheby's rep that the Giacometti Association would never approve the work and that the auction house should immediately withdraw it.

The next day she told Searle about her visit to Sotheby's. The nude was back in play, she said. Apparently Bartos had been unable to sell it privately, so he had put it up for auction.

When Bartos discovered that Sotheby's had nixed his *Standing Nude*, he knew Palmer was to blame. After all his exertions, he wasn't about to give up on the piece, which experts had assured him was authentic. He called Stuart Berkeley, who had originally shopped the piece, and told him he was coming to London. He wanted to see Berkeley and his investigators from Art Research Associates before meeting with Palmer at the archives.

"This problem is as much yours as it is mine," he told Berkeley.

Then he left a message on Palmer's answering machine saying that he stood by the piece and was flying in to prove its authenticity. Could they meet at the Victoria and Albert and go from there to the Tate? He had hired an art research firm that could guide them through the evidence: Once she saw it, he was sure she would be convinced, and they could settle the matter once and for all.

As soon as Palmer heard Bartos's message she called Detective Searle. "What should I do?" she asked. "Should I meet him?"

"Stall him a few more days," Searle said. "I need a little more time."

Searle took the forged O'Hana catalog Palmer had given him— "Exhibition of Paintings, Sculpture and Stage Designs with Contributions from Members of the Entertainment World"—and showed it to Wendy Fish at the V&A. The catalog contained an illustration of Bartos's *Standing Nude, 1955* and had the V&A emblem neatly stamped on the front cover.

Fish found a bound volume of original O'Hana catalogs and handed it to Searle. Requisition slips indicated that Drewe had consulted the volume frequently, which consisted of a dozen catalogs in chronological order from 1954 to 1962. One of them looked identical to Palmer's "Entertainment World" catalog.

The publication was made from folded sheets of paper stapled down the middle and glued to a larger folded sheet of coarse brown paper serving as a cover. This brown paper had a black, red, and blue picture on the front, and had been sewn into the binding of the volume. It appeared to be part of the original catalog. Unlike the other catalogs in the volume, which were slightly different in size but flush at the top, "Entertainment World" was off-kilter. Searle looked at its bottom edge. Trapped in the stitching between the two brown paper leaves were small fragments of paper. He guessed that these too were probably pieces of the original catalog.

Searle asked to borrow the bound volume, and took it to Adam Craske, the Yard's in-house document expert. Craske confirmed his suspicions. All the other catalogs had been printed in the 1950s with an antiquated letterpress system, but "Entertainment World" had been printed with the modern chemical process of lithography. And all the other catalogs had been stamped in ink, with a red or purple impres-

sion of a crown over an oval containing the words "Victoria and Albert Museum Library," but the stamp on "Entertainment World" had been made with a copy machine whose toner dated to the mid-1970s. Craske said he had found similar discrepancies in the Hanover catalogs.

When Searle returned the volume to the V&A library, Wendy Fish stopped him at the door. She showed him another bound volume of O'Hana catalogs that was identical to the one Searle held in his hand—or almost identical. She opened it to a catalog entitled "Painting by Stars of the Entertainment World." This had to be the original. The volume had been at the restorer's and therefore could not have been tampered with.

Drewe's mistake could be a significant plus for the prosecution.

Back at the Yard, Searle and Volpe hammered out a strategy. They called the city's most prestigious dealers and curators and asked them to be on the lookout for Drewe's fakes, and for his cohorts, if they showed up at any of the archives.

Within days they received a call from Christie's. Batsheva Goudsmid was trying to sell a suspicious-looking work attributed to Georges Braque. Searle was furious: She was potentially one of his more important witnesses, and this might make it impossible for her to testify.

He paid her a visit. "Why did you try to sell that painting?" he asked.

"I'm broke," she said. "It's worth three and a half million pounds."

Searle raised an eyebrow.

She told him that Drewe had assured her it was real and had promised to split the proceeds with her to pay back what he owed her.

"Goudsmid, these are all fakes," Searle said. "Don't you trust the police?"

Goudsmid was close to tears. "You haven't charged John with anything yet. I'm desperate. I feel like killing myself."

Searle told her to stay away from Drewe, but she was like a moth to a flame. Because of the custody battle she saw Drewe frequently, and Searle feared she might scuttle the case. If she told Drewe about the investigation, he would certainly destroy all evidence of the con.

Several days later Searle received a frantic call from Wendy Fish. "Drewe just rang. He's coming in tomorrow with a dealer from New York and the director of the Giacometti Association. He wants to see the Giacometti material."

Searle and Volpe now had a clear shot at catching Drewe, and possibly Bartos, in the act of using fake documents to authenticate a forgery. They rounded up their team and put the Victoria and Albert under close watch.

At 10:30 A.M. on the first Tuesday in April 1996 Bartos took a taxi to the Daquise, an old-fashioned Polish café next to the South Kensington tube station. He and Berkeley had planned to meet here before heading to the V&A. Though Bartos needed a stiff drink, he made do with a cup of coffee.

Palmer had been playing cat and mouse with him for weeks, making and breaking appointments. He was tired and frustrated. She had canceled again this morning, but it was too late for him to get in touch with Berkeley. Fine, then, the two of them would go to the V&A without her and examine the documents with their researcher, and Bartos would finally be able to prove beyond any doubt that the painting was genuine. If Palmer still refused to budge, he would take the Giacometti Association to court. He would argue that Palmer had disparaged a work certified as genuine by art experts, and that her capriciousness had caused the work to depreciate in value and halted its sale.

In the U.S. courts, he might well have had a case. A few years earlier

the Metropolitan Museum of Art had rejected the loan of a privately owned Seurat for a 1992 retrospective because one of the curators had expressed doubts about the work's authenticity. The owners of the painting had sued, claiming that a potential buyer had backed out after the museum lost interest in the work. The owners' lawyers argued that the Met and its curators were guilty of "product disparagement," and the case was settled out of court.

By noon Bartos and Berkeley were at the V&A library, where they met their man from Art Research Associates. He introduced himself as John Drewe and explained that he had been called in at the last minute to replace a colleague. He said that for the past quarter century he'd made his living recovering Jewish property stolen during the war, that he knew how archives worked, and that he could track down nearly anything. The V&A librarians had prepared a stack of research material, and it was waiting for them.

Drewe headed straight for the O'Hana exhibition catalog and opened it to the *Standing Nude*. Bartos was thrilled.

"There it is," he said. "Wonderful!"

Drewe opened another large black leather-bound volume, this one containing catalogs from the Hanover Gallery, and flipped to another picture of the nude. He also showed Bartos original documents that appeared to confirm the work's authenticity.

Bartos was beside himself. How could anyone have questioned the painting? He told Drewe about the work's long journey and the many obstacles that had been placed in its path.

"Mary Lisa Palmer wasted a lot of my time for nothing," he said.

"The whole thing's her fault. She doesn't know what she's talking about," said Drewe, adding that Palmer was under pressure to keep the association alive. "She's no scholar, and she has a terrible reputation."

In their excitement, the three men were talking loudly, and one of

the staffers came over and asked them to keep their voices down. They went outside, and Drewe presented Bartos with the official report from Art Research, along with an invoice for £1,140.

For all that he was overjoyed by the results, Bartos considered this an excessive sum.

"It's the standard hourly fee," Drewe said politely.

The report included several provenance documents, but Bartos was surprised to see that some of the research concerned another, unrelated Giacometti. Why should he have to pay for that? He offered Drewe £400, which Drewe promptly accepted. They walked to an ATM, and once Bartos handed the cash over, Drewe signed the invoice and left.

Bartos felt like celebrating. He was staying with an old friend in London, an investment banker with a good art collection, so he stopped at a pay phone and invited him out to dinner. The banker told him that someone named Jonathan Searle had called from Scotland Yard asking to speak to Bartos, and that he better get back to him right away.

Two hours later Bartos was sitting at the Yard with Searle and Volpe. The detectives didn't pull any punches. Why was Bartos looking at forged provenances? "We know the painting's a fake, and you know it's a fake," Volpe said. "And we know you've been trying to get it authenticated by Palmer."

"What are you talking about?" Bartos shouted. "I've spent a lot of money on this painting. I'm out thousands of dollars, and I can't sell the damn thing because of this woman. I came here to get to the bottom of it."

Bartos pulled a stack of notes, receipts, and faxes out of his briefcase, along with the original invoice from Sheila Maskell, the runner who had sold him the work. The two cops glanced through the material and realized that Bartos had been duped like all the others.

Searle walked him through the evidence and showed him the catalog Wendy Fish had found. "This is the original O'Hana catalog, Armand,"

he said. "Yours is a forgery." He assured Bartos that if he cooperated and agreed to testify in court, they could put Drewe away. Bartos might even get his money back.

The dealer was shattered. He had spent nearly a year trying to defend the work's authenticity. While he still considered it the best Giacometti painting he'd ever seen—forgery or not—he had to face facts.

He had been scammed.

Searle and Volpe now had a strong case against Drewe. Searle was pretty sure that the professor had figured out from Goudsmid that he was a suspect. He was probably hiding or destroying evidence right now. It was possible, though, that in his arrogance he might save everything, believing he could talk his way out of it. He might even relish the challenge. In any case, it was time to "spin" Drewe's home. If there was anyone who could shake him up, it was Miki Volpe.

DREWE DESCENDING

They came for Drewe early the next morning. The long-awaited bust was less than optimal for Volpe: up at 5:00 A.M. after a late night, then the drive to the train station for a somnambular trip into the city to meet up at 6:00 on the dot with his sleep-deprived team, and finally, crammed into the Zed car with a single cup of hot tea in his gut, the run past the Hampstead Heath windmill to Drewe's doorstep in Reigate, burial place of Samuel Palmer, a visionary painter whose style had been crudely mimicked in the 1970s by the avid forger Tom Keating. For insurance, Searle and the rest of the team would be making a simultaneous surprise visit to the home of Drewe's mother and stepfather in Burgess Hill.

A little after 7:00 A.M. on Wednesday, April 3, 1996, Volpe, Dick Ellis, and four other plainclothes officers pulled into the driveway of Drewe's suburban nook on Washington Close. It was common knowledge at the Yard that con men could turn nasty when they were cor-

nered, so Volpe and Ellis had brought along reinforcements. While two of the officers rushed to secure the rear of the house, the others banged on the front door until Drewe emerged, unfazed, to ask what all the fuss was about.

Volpe said he had a warrant to search the house for forged paintings and provenances, and the officers marched into the living room. His wife, Helen Sussman, insulted the detectives and made it clear she thought the idea Drewe might be involved in a serious criminal enterprise was ludicrous. Drewe asked Volpe, who was clearly in charge, if he and Sussman could go upstairs and get dressed. Volpe kept an eye on the professor as he put on a good gray suit, and then they went back down to the kitchen, where Sussman sat out the rest of the search.

"I want you to watch very carefully while we search your premises," Volpe said with uncharacteristic gravity, well aware of Drewe's high-end cognitive abilities to read a personal weakness or lack of resolve. "If anything is found which may be evidence, it will be seized. Anything you say may be given in evidence."

The team went through cabinets and drawers and coat pockets, bagging and tagging the contents. Worried that Drewe might accuse them of planting evidence, they asked again that he pay particular attention as they combed the house.

Everywhere they looked there were documents and photographs, paintings and catalog mock-ups. Tucked in the top left-hand pocket of a blue suit hanging in the cloakroom was a passport in the name of John Cockett. In a kitchen drawer, inside a plastic folder, they discovered a tight little bundle of letters and negatives. Drewe said they had to do with a Giacometti painting he had handled in his capacity as an agent for fine art.

"What's this?" asked Ellis, pulling from the same drawer a blue folder marked "Stuart" and containing material on a 1939 relief by Ben Nicholson. Drewe explained that Stuart Berkeley was one of his many associates.

Volpe and Ellis sifted through a stack of material on the dining room table, jotting a description of each document in a notebook, and popping the exhibit into an evidence bag. Soon they had accumulated hundreds of items. Volpe slipped through photographs of paintings and sculptures by Segal, Ernst, Kandinsky, and Epstein, stopping at a picture of Giacometti's *Standing Nude, 1955,* which he had seen the day before when he and Searle were interviewing Armand Bartos.

"What's this, then?" he said.

Drewe explained that several years earlier he had acted as an agent for the painting. He showed Volpe a stack of agreements drawn up between himself and his associates, who included Sheila Maskell, Clive Belman, and Daniel Stoakes. Stoakes, he said, was a well-known collector of Ben Nicholson's work and happened to be the stepson of Tewfik Pasha, the onetime deputy of the kleptomaniacal King Farouk of Egypt, an enthusiastic collector of Fabergé eggs and aspirin bottles, and the owner of the legendary 1933 Double Eagle $20 gold coin, which was now worth more than $7 million. Raymond Dunne, also mentioned in the documents, was a trusted partner in Drewe's own Airtech Systems, which developed and marketed remote-piloted vehicle technology for the aviation industry.

"Robot planes," he said to the detectives' puzzled looks.

He had a long-winded answer for every question and never seemed to falter or contradict himself. Liars of this caliber had amazing memories, Volpe reminded himself, and this was a particularly impressive performance.

As one of the officers recorded the exact time of each question and response, Drewe provided a detailed account of himself as a man with broadly varied interests, several interlocking businesses, and a dozen close associates.

At 7:40 A.M., he said he was an agent for the works of Alberto Giacometti.

At 8:05, he was an art researcher specializing in British water-colors.

At 8:15, he was a historian working on a groundbreaking study of artworks lost during World War II.

At 8:33, he was an unofficial diplomatic go-between in the process of organizing reciprocal postwar reparations between Germany and Russia through his contacts with the German Ministry of Finance.

At 8:40, queried about a group of photographs of looted paintings by the German surrealist Max Ernst, he was an entrepreneur developing a computerized art database that could link lost paintings to their owners.

At 9:21, he was the head of Norseland Research, a British partner-ship that marketed revolutionary archival methods.

At 10:20, he put in a call to his mother.

Volpe sent his men upstairs to search further. In a study they found a box containing a craft knife, surgical blades, a pair of tweezers, and a set of Sotheby's catalogs from the 1970s, with several illustrations removed and apparently replaced. On the floor was a clear plastic V&A tote bag, and in it was a British Rail ticket to London that had been punched the day before, when Drewe met Bartos at the V&A. In addition, there was a catalog from the Hanover Gallery with stitching trailing from its spine, probably because it was an original catalog that had been ripped out of a bound V&A volume. Volpe felt a small puff of satisfaction: This was physical evidence linking Drewe directly to a theft. When he asked Drewe why the catalog was in his possession, Drewe said he'd bought it at a secondhand bookshop and had the receipt to prove it.

Volpe continued his search. In another plastic bag, he found rubber stamps inscribed "Tate Gallery," "V&A," "St. Philip's Priory," and "St. Mary's Priory." In a pile of old correspondence, he found a 1957 invitation to an exhibition at the ICA gallery, as well as letters from ICA

stalwarts Roland Penrose and Lawrence Alloway. Drewe claimed that Alloway had given him the material when he was embarking on a history of the ICA around 1987. In a closet under the stairway, Ellis found cut-and-paste affidavits from solicitors, documents relating to the ownership of several paintings, and others that appeared to confirm Drewe's academic credentials.

Drewe was the quintessential pack rat; it seemed he had never thrown anything away. His house was a trove of irreconcilable odds and ends: a blue folder labeled "The Internal Geometry of Elementary Particles"; a box of letterhead from the Federal Republic of Germany, and another from the Vindesine Company, supposedly a manufacturer of anticancer drugs; copies of letters Drewe had written to members of Parliament regarding changes in Britain's bird population and its ecology; a flyer from the Zionist Foundation of Great Britain and Ireland; and a newspaper article about a recent Hampstead fire in which a young Hungarian student had died. Volpe and Ellis exchanged glances. They were aware of the fire and thought it strange that Drewe would have the article in his house. Drewe calmly told the detectives that he had the article because Goudsmid had tried to embarrass him with it: She'd sent copies to the wedding guests before his marriage to Dr. Sussman implying that he was responsible for the fire and the subsequent death.

By noon Volpe felt he had enough evidence to charge Drewe with possession of stolen items linking him to a broadscale con. While the search continued, he formally arrested the professor on suspicion of theft and conspiracy to defraud dealers and auction houses. "You do not have to say anything but it may harm defense if you do not mention when questioned something which you later rely on in court," he informed Drewe.

"The allegations are provably absurd," Drewe said, insisting that the material had been obtained legitimately for purposes of research into the ICA.

Volpe said nothing.

As Drewe was explaining that his only contact with the auction houses had been as an agent or middleman for collectors and dealers, he grimaced and put his hands to his temples. He told the cops he was "suffering from either an acoustic migraine or Ménière's disease," a disorder of the inner ear that can produce vertigo and a roaring sound in the ear. He said the condition had been diagnosed at Gatwick Park Hospital, and that the stress he was experiencing was likely to bring on "bouts of nausea and total collapse."

Moments later, Drewe requested a glass of water.

"How are you feeling at the moment?" Volpe asked him, suspecting a ruse.

"I'm feeling fine, thank you very much," said Drewe.

Volpe advised him that he could call his lawyer.

"I've got nothing to hide," Drewe said. "Carry on."

Seven hours after they began their search, the cops took a break. The professor made himself a ham sandwich, and Volpe ran out to the corner shop for bacon-and-egg sandwiches for the others. While they were eating, Drewe received a call from his lawyer. Volpe overheard the conversation.

There was no room for the smallest procedural error, and Volpe was determined to take every precaution. "I heard you tell your solicitor that you're not feeling very well, and we're trying to obtain the services of a police surgeon," he told Drewe.

"I don't want to call the police surgeon," Drewe said. "I feel able to carry on."

Volpe called the surgeon anyway. He suspected that Drewe might try to use an illness, real or imagined, to trip the investigators up. When the surgeon arrived two hours later, Volpe temporarily stopped the search while Drewe was examined. The doctor declared Drewe "fit to be detained."

Volpe walked over to Drewe. "Time to go," he said. He put on his

coat and watched the detectives file out the door carrying cardboard boxes filled with financial papers, documents, photographs, floppy disks, three typewriters, and a computer. An officer led Drewe to one of the cars parked outside, and they set off toward the Reigate police station.

Volpe stayed behind for a last look around. As he was preparing to go, he noticed a colorful Juan Gris hanging in the living room above the fireplace. He admired it for a moment, then looked at his watch and recorded the time in his notebook: 7:03 P.M. He took the painting off the wall, put it under his arm, and closed the door behind him.

At the station Volpe placed Drewe in a "custody suite" that was monitored by a closed-circuit camera. He and Ellis were afraid Drewe would allege that he'd been roughed up, which would certainly win him a mistrial. After a short conference, the detectives agreed to call it a night. It would take weeks to prepare a formal interrogation from such an abundance of material. They released Drewe on bail and ordered him to return in five weeks, on May 14.

The professor was on his best behavior now. His suit didn't have a single wrinkle, his tie was straight, and he seemed as refreshed as if he'd just swum a dozen laps and downed a perfect martini. He turned to his interrogators.

"It's been such a long day for us all," he said cheerfully. "Why don't we all go down to the pub and have a drink?"

Volpe and Ellis declined the invitation.

Over the next several weeks the detectives pulled together the remaining strands of the investigation. In quick succession, they raided the homes of the runners.

At 6:00 A.M. on a June morning they knocked on Clive Belman's door at 45 Rotherwick Road. They flashed a search warrant and told

him they were looking for forgeries and any correspondence he might have had with John Drewe.

Belman seemed shocked and immediately agreed to cooperate. His wife and his two children, both in their early teens, sat half asleep in their pajamas as the police searched the house, bagging Sotheby's catalogs, checkbooks, and a black briefcase containing a letter to the dealer David Stern and provenance for a Giacometti *Standing Nude*.

"Mr. Belman," Searle said, "I'm arresting you on suspicion of conspiracy to defraud with paintings and provenances." As his family watched Belman was placed in the back of a squad car and driven the few blocks to the Golders Green station.

When police visited the home of Stuart Berkeley, they found several box files relating to the case. Berkeley too quickly agreed to cooperate.

Their next stop was the Tate. The librarian had called to say that an art researcher named Maxine Levy had come in looking for material on Ben Nicholson. Volpe and Searle arrived to find that Levy, whom they knew as the runner who sold the fake Nicholson "1938" watercolor to the dealer Gimpel, had been at the library that morning but had slipped out for lunch. They hid behind a bookcase and waited for her. Then they watched as the diminutive young woman returned and sat down at a table in the middle of the reading room beneath the rotunda. As she was leafing through Nicholson catalogs and textbooks, Volpe tapped her on the shoulder.

"I understand you're interested in researching a particular Ben Nicholson painting," he said.

"That's right."

"Where is it?"

"I've got it here in my handbag," Levy said, pulling out a small white painting. She told Volpe she had brought it in to compare it with photographs in the archive. When Volpe identified himself as a police officer and announced that he was seizing the work, Levy burst into tears.

At 7:00 A.M. the following day, Daniel Stoakes, Drewe's childhood friend, was arrested at the nursing home in Essex where he had been working the night shift as a psychiatric nurse. The police waited an hour until his shift was over, then took him aside to say that they would be holding him on suspicion of involvement in art fraud.

"This has to do with John, doesn't it?" Stoakes said as he was being led away.

Meanwhile, in the United States, Scotland Yard detectives accompanied by FBI agents knocked on the door of two more runners. One was Clive Belman's nephew, Andrew Wechsler, who had come to the attention of the authorities through a London dealer to whom he had tried to sell a painting. Wechsler had been introduced to Drewe through his uncle, and he told police everything he knew. The other runner was Sheila Maskell, who had received *Standing Nude, 1955* from the ponytailed Stuart Berkeley. When she told investigators the story of Armand Bartos and the ill-fated Giacometti, it was clear that she had also been duped.

Back in London, as Volpe and Searle sifted through the evidence from Drewe's home, they realized that the heart of the scam was in his computer. They found templates for many of the fake catalogs he had used to provenance the forgeries, including Bartos's nude and Gimpel's 1938 Nicholson watercolor. Searle was still looking at the evidence with an eye to picking the best paintings for trial, and the evidence on the Gimpel painting was particularly strong. He had a catalog on Drewe's computer, a report from Gimpel's restorer, Jane Zagel, and testimony from Belman that he had received the work from Drewe. That Myatt hadn't painted the watercolor was a plus: It strongly suggested that a second forger was involved, and that Drewe's operation was more far-reaching than it appeared. The evidence on the Bartos nude was good too. There were catalogs, receipts, eyewitness accounts of Drewe at the V&A, and Palmer's extensive detective work. Bartos was convincing and would make a good impression on the stand.

Volpe had discovered something else during the raid on Drewe's home: a series of photographs showing a pair of hands tearing photographs out of the Hanover catalog in the bound volume. There were also photos of a forged version of the catalog superimposed on the same binder. Apparently Drewe had taken these highly incriminating snapshots himself. Psychiatrists believe that successful con artists take a special pride in their work, a "contemptuous delight . . . in manipulating and making fools of their victims,"[*] and the detectives could only wonder whether the photographs were Drewe's attempt to record his own accomplishments for his own future delight.

As they pored over statements from more than a thousand witnesses and reports from chemical analysts and document specialists, Searle and Volpe searched for further physical proof linking Drewe to the forged documents in the archives. Thus far most of the evidence was circumstantial. Volpe hoped the Hanover photo albums at the Tate might give him something more solid.

He contemplated the photographs of the Footless Woman and *Portrait of a Woman*. Nothing in Drewe's home provided incontrovertible proof that he'd taken them. Then Volpe noticed the typed labels beneath each photograph and remembered that they had seized three typewriters from Drewe's home. Searle had confiscated a fourth typewriter from Drewe's mother's house. Why would Drewe, who was so adept at computers, have four old typewriters hanging around? The labels might provide the answer.

Volpe asked Adam Craske at Forensics to analyze each of the 260 labels in the Hanover photo albums. Over time, because of damage and wear, typewriters develop faults and misalignments that render their typescript unique. By analyzing the typescript on the Hanover labels Craske determined that some 250 of them had been typed on a single

[*]Grace Duffield and Peter Grabosky, "The Psychology of Fraud," Canberra: Australian Institute of Criminology, March 2000, http://www.arc.gov.au/publications/tradi199.html.

typewriter. Another seven had been typed on a separate machine, one with damaged serifs on the lowercase *l*, *w*, and *i*. The top of the number 3 was flat rather than curved, as in the large group of labels, and certain other keys were slightly out of line, so that the characters showed up on the page as heavy on one side and light on the other.

Craske also analyzed the paper on which the labels were typed. Modern paper contains chemical brighteners that glow under ultraviolet light. Forensic specialists can tell whether a page has been added or replaced in a multipage document, and can reconstruct whole sheets of paper from shreds based on the differing luminescent intensities. Craske used luminosity as a gauge to compare the age of the labels and discovered that the group of seven glowed intensely, whereas the bulk of the others were dull. When Volpe read Craske's report, he noted that those seven labels corresponded to paintings Scotland Yard had identified as Drewe's forgeries.

Volpe wanted to establish an even more solid connection, proof that Drewe himself had typed the labels. He asked Craske to look at the four confiscated typewriters. Craske examined the typescript of each and found that the cream-colored Olympia typewriter from Drewe's mother's house matched the typescript on the seven labels.

Volpe drove to Burgess Hill to pay a call on Drewe's mother and stepfather. When the stepfather confirmed that Drewe had used the typewriter several times, Volpe had his link between Drewe and the fake provenances at the Tate.

After five weeks of sifting through evidence, scanning forensic reports, and hauling in Drewe's runners, Volpe and Searle had cornered him. Now they had to get him in the cage.

33

SOUTH

A few days before Drewe was scheduled to report at the police station for a second interrogation, someone rear-ended his car by accident. The next day Searle and Volpe received a note from Drewe's doctor stating that he had seriously injured his back and needed bed rest. The formal interrogation was postponed.

A few weeks later they received a similar note: The professor had a herniated disc and could barely move. Soon after, a third doctor's note announced that Drewe was suffering from muscle spasms in his back. In mid-June, nearly three months after the raid, the police received two more notes, which made for a total of five separate notes from four different doctors.

On June 20, an officer happened to spot a healthy-looking Drewe nimbly rooting through a trash bin outside his old house on Rother-wick Road. Goudsmid had thrown out a pile of his old books and

asked him to come by for them. The officer watched Drewe hop effort-lessly into his car and drive off.

The doctors' notes continued to come in, but Drewe's recovery appeared to be total. He was seen going about his business as if noth-ing was wrong: putting air in his tires at a garage; kissing an unidenti-fied woman in his car; pacing up and down the platform at the train station.

In mid-July, a judge ordered him to return to the Reigate police station for questioning. On the day of the interview, Searle was on his way to the precinct when he spotted Drewe walking briskly up the hill toward the station, twirling a pair of walking sticks and whistling. A few minutes later Drewe walked into the station in an altered state. He appeared to be in considerable pain. He was leaning heavily on his sticks and seemed years older than the man Searle had seen minutes earlier.

"You're looking good," Searle joked.

Drewe had brought in a top-grade criminal lawyer named Ben Rose, a young black-belt kickboxer who was known as a shrewd operator, and he immediately urged his client not to answer any questions.

In the interrogation room, Drewe ignored the advice. He straight-ened his tie, set his briefcase down, and began his usual recitation. This man cannot stop himself, thought Volpe. We're a captive audience. Volpe, Searle, and a detective named Nicky Benwell fired off questions, and Drewe seemed to thrive on the attention. He wasn't fazed in the least. It was the detectives' impression that he was pathologically inca-pable of telling the truth. Although he acknowledged that he owned the exhibits Searle showed him—fake catalogs, paintings, and letters—he wove a complicated story around each. He would not admit to having forged anything, and at every opportunity he tried to pin the con on others, mostly Danny Berger and Myatt.

Volpe caught Drewe on almost every lie. When Drewe claimed he had traveled to New York to research ICA documents, Volpe told him

U.S. immigration had no record of a John Drewe or a John Cockett having entered the United States.

Drewe shrugged. He insisted that Danny Berger and Peter Harris had sold most of the paintings. Volpe reminded him that Harris had had his voice box removed in 1991 and would not have made for a good salesman.

Why did Drewe's computer have several templates for fake catalogs, including the Hanover Gallery's?

Drewe insisted the templates were all genuine. He said his company had kept a complete database on the history of London's important galleries, but that he had nothing to do with forged catalogs. He furthermore claimed that he was computer illiterate, and that if he needed anything scanned, he relied on his son, Nadav.

Volpe asked Drewe whether he had placed false documents in the Tate and V&A archives. Drewe denied it.

"But you've been seen showing Bartos a fake Hanover Gallery catalog while you were in the V&A," the detective said. "We found the genuine catalog in a V&A bag at your home the day after that meeting. How do you explain that?"

"Berger gave me the catalog," Drewe said without hesitation.

Volpe expressed his belief that Drewe had played havoc with the records of the Whitechapel Gallery as well as galleries and museums in Brighton, Bath, and Leeds.

For a moment Drewe seemed to lose his composure. "I don't care what documents you've got," he said. "I don't care what people tell you or what statements they've given. I'll refute them. It's a stitch-up."

It was late afternoon, and the detectives told Drewe and his lawyer that they were done for the day. They would resume tomorrow.

For the next few days Drewe came in and answered their questions in greater detail. By the end of the fifth day, the police felt they had enough to counter each of his statements.

The formal interrogation was over, but Volpe could hardly contain

his irritation. For the past week he had worked hard to keep his distaste for Drewe in check. Now he wanted him to know he hadn't bought his story. When Drewe got up to leave, Volpe stopped him and pointed at the door.

"Mr. Drewe, can you tell me what color that door is?" he asked.

"Well, Mr. Volpe, it's blue," said Drewe.

Volpe thanked him. "That's the first truthful answer you've given me in five days."

B y late 1996, the detectives had winnowed down hundreds of witness statements and pulled together a solid collection of exhibits. Drewe's lawyer had agreed on a trial date.

In December, just days before the first court hearing, Drewe was rushed to East Surrey Hospital with a suspected heart attack. The judge received a doctor's note saying that Drewe suffered from unstable angina and needed eight weeks' bed rest. If at all possible, he should be spared the stress of a court appearance. A few days later Drewe was diagnosed with diabetes and hypertension and hospitalized for "urgent cardiac investigations."

Two months later the judge again ordered Drewe to appear in court, but Drewe produced yet another report urging further medical attention. Summonses went unheeded, and the prosecution received a copy of an angiogram that they would later believe to have been faked—in what perhaps was the first case of someone stealing the "identity" of the inside of another person's heart.

Finally, on May 9, 1997, thirteen months after the raid on Drewe's home, the court issued a warrant for his arrest.

"Get him here, even if he's on a stretcher," said the judge.

Two officers went to Drewe's house to bring him in. Atarah came to the door. Her father was away, she said, and then she excused herself to take a phone call. The officers waited at the door while

police traced the call to a restaurant on Marylebone Lane. Detectives rushed to the restaurant. The manager told them that a man resembling Drewe had just left, but that he had been overheard talking on the phone.

"Tell them your dad's in hospital," the diner had said into the receiver. Then he left in such a hurry that his female companion had to "trot periodically to keep up with him."

Perhaps knowing that he had exhausted the court's patience for his excuses, Drewe vanished. He'd never had much use for credit cards, so the police were deprived of a traditionally effective tool for tracking people down. They feared he might flee the country and issued an all ports warning.

For a man who incessantly dropped names, Drewe seemed to have no personal friends. However, he had a strong attachment to his mother, and Volpe thought it prudent to send an officer down to keep an eye on her home in Burgess Hill. The officer soon noticed that she rented a car once a week, always on the same day. Volpe told him to follow the rental car.

As Drewe's mother made her way south ten miles to Hove, near Brighton, the officer stayed close behind and watched her park near a pay phone to make a call. Ten minutes later a man drove up in a Mercedes. The officer, who had questioned Drewe a few months earlier, recognized him and approached.

"Hello, Mr. Drewe," he said.

Drewe calmly turned around to face him. "My name's not Drewe. It's Carnall."

"Mr. Drewe, I've interviewed you. I know who you are."

"You're mistaken," Drewe said politely.

"You can say what you want, but you're under arrest."

Drewe turned to run, but the officer jumped him, got him in a bear

hug, and cuffed him. Drewe's mother watched as her son was put in the back of the squad car and driven off.

The officer took Drewe to Belgravia station in London, where detectives were able to sketch out a timeline of his activities during his short stint away: He had rented a posh flat in Brighton under the name of Dr. Carnall and had always paid in cash. He had kept himself busy writing a letter to the *Times* criticizing the Tate's monopoly on art and mailing off a thirty-one-page *j'accuse* to the Metropolitan Police, alleging that they were involved in a widespread government conspiracy against him and were harassing him.

At the station he faked another heart attack and was taken to hospital, where he was examined, pronounced fit enough to travel, and sent back to Belgravia. As he awaited further interrogation, he fell to the floor clutching his chest. Again he was hospitalized briefly before being released into police custody.

On August 6, 1997, he was finally brought before the court. This time there would be no bail. He was remanded into custody and sent to Brixton Prison to await trial. It was clear to him by now that the Crown had a strong case, with dozens of incriminating paintings and boxes of documents as evidence of his crimes. Between visits to the prison doctor, he began to devise a surrogate defense.

For years he had been concocting alternate realities based on a heady amalgam of novels and newspaper reports, imaginary plots involving arms dealing, covert wars, and the Holocaust. Now, for the court's benefit, he would string these together to create a comprehensive tale that would clear him of all charges. He would put his improvisational skills to the test at Southwark Crown Court, where he intended to provide details of a huge government conspiracy involving the weapons trade and the intelligence services. He would have the jury in the palm of his hand, and he would return to his country home with his reputation intact, and even enhanced.

. . .

John Drewe's trial date was now fixed for September 22. His strategy was to wage a war of attrition against the Crown, to wear the prosecution down with constant requests for disclosure, including full details on the witnesses, paintings, and documents that the prosecution intended to produce in court.

Drewe had accumulated a complicated medical record and was given a bed in the prison's hospital wing. Brixton was Britain's oldest nick, and it had a reputation as one of the most squalid in London. It had introduced treadwheels in the nineteenth century as a form of punishment and had recently been hauled over the coals by the nation's corrections minister. Drewe did not want to spend any more time there than he absolutely had to.

On the opening day of the trial, he was ferried to Southwark Crown Court by private ambulance, with EMS personnel and escorts. The prison authorities had failed to provide a wheelchair for him, and when he stepped out of the ambulance to climb the courthouse steps, he saw his chance. Clutching his chest, he collapsed.

In the courtroom, Searle and Volpe heard the commotion and ran outside. Drewe was sprawled on the ground. Moments later, to the detectives' dismay, he was carried back to the ambulance and driven off. Once more he had managed to delay the trial.

When he returned to Southwark a few days later he had a front-row seat in a courtroom that resembled a combination art gallery and accounting firm, with a bank of typewriters displayed on a long table and some of Myatt's best forgeries hanging on the walls in all their bogus glory. The Crown's evidence was stacked away in a small courthouse room with wire racks holding piles of boxes, and containers loaded with exhibits covering the floor. The police report ran to more than three hundred pages, and the jury bundle was a whopping six hundred

pages long. All told, the cops had gathered some four thousand items, interviewed more than a thousand witnesses, and recovered about eighty paintings from dealers, auction houses, and collectors around the world.

The prosecution, led by John Bevan, had secured the cooperation of Drewe's runners, a handful of angry dealers and authenticators who were willing to take the stand, and a dozen former Drewe associates who had been ripped off or in other ways betrayed. To make the case manageable, only nine of the hundreds of works that had passed through Drewe's hands over the years would be entered as evidence: two in the style of Sutherland, including Nahum's panel; one in the style of de Stäel; another in the style of Bissière; plus three "Ben Nicholsons"—including Gimpel's 1938—and two "Giacomettis," one being Bartos's *Standing Nude, 1955*.

Drewe, Myatt, and the luckless Daniel Stoakes, who had knowingly posed as an art collector, were about to stand trial.

THE TRIAL

I always thought it'd be better to be a fake somebody
than a real nobody.
—TOM RIPLEY in Patricia Highsmith's
The Talented Mr. Ripley

From the first day of the trial—*Regina v. John Drewe, John Myatt, and Daniel Stoakes*—it was clear that Drewe was a courtroom buff's delight. Flawlessly attired, he carried himself with the haughty manner one would expect from a top-shelf patrician. He was never tentative and had an air of confidence about him that bordered on arrogance. Looking around the courtroom, an observer would have guessed that he was anyone but the plaintiff. He crackled with energy, perhaps fueled by the chocolate bonbons he regularly plucked from a box at his elbow and popped into his mouth. When the judge chastised him for one of these candied distractions, he explained that his diabetes required him to keep his blood glucose at a certain level.

On the second day he rose from his seat dramatically, cleared his throat, and fired his defense team. His reasoning astonished everyone. His case, he explained, was far more sinister than they could imagine. It no longer involved a handful of bad paintings. Instead, it centered on

a multibillion-dollar arms industry that sold covert weapons to nations with the British government's approval. This conspiracy of middlemen, gun runners, and Crown spies had been funded through the sale of thousands of works of modern art. When the government realized that the true story was about to emerge at the trial, it had sent its agents to silence Drewe. That he was standing before the court was conclusive proof that they had failed. Now he alone possessed the requisite skills and inside knowledge to unravel the convoluted conspiracy. He would handle his own defense, thanks very much.

Sitting high above the barristers in his seventeenth-century ceremonial wig and gown—symbols of the majesty of British law—Judge Geoffrey Rivlin listened carefully to Drewe's peculiar petition. The defendant announced that he planned to call top government officials and arms dealers to the witness stand who knew of covert weapons sales to nations, including Iran, Iraq, and Sierra Leone. Documents in his possession and eyewitness accounts of the plot would shed light on the evil forces arrayed against him. All he wanted was a court-appointed legal adviser to help him navigate the finer points of the law.

John Bevan, the prosecutor, noted that Drewe's original defense statement had made no mention of such a conspiracy.

Judge Rivlin strongly advised Drewe against representing himself, but the professor would not be deterred. Rivlin was well aware of his repeated success in delaying the start of the trial, and he probably suspected that Drewe was once again trying to drag the proceedings out. If he were to begin a protracted search for new counsel, who would need months to prepare his case, it would delay the trial "indefinitely, possibly permanently," the judge concluded. Consequently, he allowed Drewe to represent himself but refused to grant him a legal assistant.

Drewe seemed composed and confident, and appeared to enjoy his newest incarnation as a barrister. Each morning he arrived in court in a freshly pressed suit, with a silk handkerchief tucked in his top pocket

and a tie that had a snakelike pattern. His con man's sensitivity to body language, dress, and manner was especially well-honed, and enabled him to adopt the style and appearance of a successful courtroom veteran. A model of propriety, he maintained a firm but always decorous tone when addressing the judge and his adversaries at the prosecutor's table.

"With all due respect to my learned friend," he would say, or "if it pleases your lordship," or "may I respectfully draw the court's attention to . . ." With a flourish, he would address the "ladies and gentlemen of the jury," punctuating his presentation with sudden gestures and the occasional accusatory roar. A well-timed guffaw would communicate his special contempt for a contention advanced by the prosecution. It was a grand performance, worthy of Charles Laughton and Rumpole of the Bailey. One prosecutor told a colleague that if Drewe had been grounded in reality, he might have made an excellent barrister.

Drewe argued that he had been made a scapegoat by officials determined to conceal a "cesspit of corruption." Arrayed against him, he said, were the Ministry of Defence, the Crown Prosecution Service—which he accused of withholding evidence that supported his claims—Whitehall, the Art and Antiques Squad, and a cabal of auction houses. "A web of deceit has allowed art dealers to join in the horrible conspiracy," he declared, explaining that the plot involved more than four thousand paintings—many of them that proved to be fake—sold to finance the weapons deals.

These courtroom antics were widely considered a stratagem of last resort in the service of an indefensible defense, but the prosecutors had to make sure that Drewe would not sweep away a single member of the jury. The detectives in the gallery paid particular attention whenever he stood to question a witness or request a ruling from the judge, and they soon observed a pattern that would prove useful to the prosecution. Each time he made a statement that they knew to be a lie, he put his

tongue to the roof of his mouth, producing a barely audible clucking sound. Poker players call this the "tell," an almost involuntary mannerism that betrays a player who is holding a particularly good hand. Drewe's nervous tic became increasingly frequent as the trial went on.

Much of the inspiration for his new defense came from a recent and infamous case involving arms smuggling by an alleged MI6/CIA front company called Allivane. Without providing a stitch of evidence to connect his case with Allivane's, Drewe inserted details from that case into his own. Drewe argued that he had met the arms dealer Peter Harris, who introduced him to a chairman of Allivane. Drewe had set up Norseland to market works, particularly those that Allivane wanted to sell, and there had been nothing to suggest to him that they were not genuine. He said that in the course of his work he had met with high-ranking government officials associated with Allivane, including the Conservative Party's Michael Heseltine and former Soviet leader Yuri Andropov, both of whom he claimed would back up his story in court.

Even the most generous of juries would have found it hard to follow his logic. At one point a juror asked him a question via a written note to Judge Rivlin. Ten minutes into Drewe's long-winded reply, the same juror begged the judge to withdraw the question.

On several occasions, Judge Rivlin lost his patience. One afternoon, in the course of a long interrogation by Drewe of Detective Searle, he stopped the professor short. "We are in *danger of* just getting lost in millions of questions. . . . Can I remind you that before lunch you said you were just about to get to the thrust of your suggestions?"

"I was just about to do that," said Drewe, who proceeded to launch himself on a new tangent. He was pushing the limits. Once, as he was questioning a witness, he stopped, anticipating another rebuke from the judge.

"Your Honor, I am pushing ahead as fast as I can, but there are for the defense some quite important points that I have to . . ."

"Mr. Drewe, I have not said anything to you," Rivlin interrupted. "Just continue."

Whenever Drewe collided head-on with the facts, as he often did, he seemed unperturbed. He would ask a leading question intended to bolster his case and nearly always receive a reply that damaged it. "He's hoisting himself on his own petard," one lawyer was heard to whisper to a colleague.

Drewe spent an entire morning asserting that Searle—whom he sometimes mistakenly referred to as Myatt—had investigated only those paintings that had not been linked to Allivane, the company that lay at the heart of his imagined conspiracy. Drewe accused Searle of being an agent for MI5, forcing the detective to scramble in order to prove that the allegations were false.

Bevan objected. "Mr. Drewe is not an expert on Allivane. Can we draw a limit to this?"

There was little need for the prosecution to bear down on the professor, for Drewe was his own worst enemy. He exuded contempt for the Crown's witnesses and seemed unable to connect with the jury. In a stilted attempt at humor, he even corrected Judge Rivlin on his grammar while complimenting him on his craft.

A string of witnesses testified that Drewe had convinced them to sell paintings for him. Dealers and experts explained how he had persuaded them to authenticate works of art. Sir Alan Bowness, who had given his blessing to several fake Nicholsons, told the jury how Drewe's runners had approached him with pristine-looking provenances, and how he had eventually helped the police crack the case.

Librarians from the Tate and the Victoria and Albert Museum testified about Drewe's frequent and suspicious visits. Drewe protested, saying he couldn't possibly have done anything untoward without being detected by the museums' closed-circuit cameras and tight surveillance. During his years as a researcher, he said, he had visited archives in New York, France, and Germany without a single complaint.

"If indeed I had been tampering with archives, there is certainly a very serious problem, because the whole history of the Second World War would have been rewritten. I have been into just about everywhere."

Under cross-examination by Bevan, Drewe wouldn't stop talking.

"I have been cross-examining you for something like eleven hours, of which probably about one hour is me asking questions and the other ten is you answering," Bevan interrupted at one point. "Your job now is to answer questions; all right?"

"If you ask a question that needs a detailed answer, then I will give one," Drewe said. "I am the defendant and it is my future that depends on being able to present a proper defense."

"This is getting us nowhere," said the judge. "You are the defendant, but you are not in control of this trial. If Mr. Bevan asks you a simple question . . . you are under an obligation to give a simple answer."

With Myatt cooperating with police, and Daniel Stoakes's lawyer advising him not to take the stand, Drewe hogged the show, and he seemed to be enjoying the performance.

Another prosecutor mocked Drewe's exaggerated defense and his tendency to name-drop, adopt aliases, and fold random pieces of history into one another.

"In the course of the case, the jury has heard of the Holy Office, Cardinal Ratzinger, American Nazis in England. We have heard of the Bureau of State Security from South Africa, we have heard of contacts in high places, of helicopters in . . . Goodness gracious, Peking, Israel, Zaire.

"The truth is that you are Mr. Drewe, you are two sorts of Mr. Cockett, you are Mr. Sussman, you are Mr. Green, Mr. Atwood, and

you are Mr. Martin and Mr. Bayard the researcher and Mr. Coverdale, aren't you?"

Drewe did not answer.

Perhaps the most damaging testimony came from Myatt, who told the court how he had been swept up into Drewe's scheme.

"My vanity was quite ghastly, and this is the consequence of it," he said. During cross-examination, he described Drewe as his onetime "best friend." Then he called Drewe a psychopath and a liar to his face. "I was very much your creature. I found you hypnotizing, charming, challenging."

Drewe argued that Myatt had misrepresented himself, and that he had never been an artist, least of all a starving artist. Instead, he had been acting as an operative for a violent neo-Nazi group called Combat 18.

In his own defense, Drewe called his two children and his mother to the stand. When it was Batsheva Goudsmid's turn to testify, their hatred for each other was palpable. Drewe accused her of doing emotional harm to the children, microwaving their pet goldfish, and throwing boiling water on the family dog. Goudsmid tossed the charge back at Drewe, saying he had thrown the caged pet through a window.

"I wouldn't have if you hadn't ducked," Drewe replied.

When Goudsmid accused him of stealing into her house while she was away, climbing into her bed, and putting on her pink negligee, the prosecutors and detectives did their best to stifle their laughter.

Daniel Stoakes, who had also been charged with conspiracy to defraud, cut a sad figure. With his right eye inflamed by an infection, and becoming increasingly depressed as the trial wore on, Stoakes was advised by his lawyer not to take the stand. Instead, his lawyer argued that Stoakes's world had been shaken, and he felt betrayed. He and Drewe had been very close in the past, and they had bonded over their failed relationships with women and the bitter separations that followed.

When Drewe first asked him to pose as the owner of certain artworks, he had no idea that Drewe had already been using his name in forged provenances for years. Drewe said he couldn't be listed as the owner himself because he wanted to keep the money from any sale out of Goudsmid's hands, and Stoakes agreed to help his old friend out. At the time he was desperate for cash and appreciated the occasional twenty pounds Drewe offered him. It had never occurred to him that the works were fakes.

Of the dozen or so runners who had helped Drewe's scheme bear fruit, Stoakes was the only one charged. The police had found several letters of ownership he'd written to dealers and experts.

During the trial, the two old friends spoke just once. Drewe leaned over to him and said quietly, "I want you to know how sorry I am about this."

Stoakes had been warned. "Upon advice I will not speak to you," he said, and then he turned away.

For the next six months they sat side by side in court and never spoke to or looked at each other again.

As the trial was coming to an end, Drewe made a single reference to his former friend. "Daniel's been brought into a maelstrom not of his own making," he said.

Stoakes was moved, and for a brief moment thought it was a sign of sympathy, but he knew where he stood with Drewe. "I was like a ripe plum ready to be picked from the tree," as he put it.

The trial, which had been expected to last three months, had taken nearly six. In his closing argument Bevan argued that Drewe's scam had undermined art history and Britain's cultural patrimony. While his main motive had been money, the effort he put into it suggested "an intellectual delight in fooling people, and contempt for experts." Drewe was an unscrupulous user of people, "a consummate and expert op-

erator in his chosen field," "a Walter Mitty with a brass neck and criminal backbone [and] an ego the size of the Millennium Dome." The whole operation "was a waste of a clever, astute, hugely retentive brain," Bevan said. "He has wasted himself on a lifestyle which has left a trail of victims in its wake."

Toward the end of the trial Judge Rivlin advised the "long-suffering" jury to stay focused on the evidence. "You are not on a mission to clean up the art world," he said.

The jury reached a verdict in just five hours: Drewe was found guilty of conspiracy to defraud, forgery, theft, and using a false instrument with intent. He was sentenced to six years in prison.

According to one observer, Drewe muffled a parting comment that sounded as if the "professor" couldn't believe the jury did not see him as the victim. "The whole art world is corrupt," he said. "Why pick on me?"

Myatt was convicted of conspiracy to defraud and sentenced to a year.

Daniel Stoakes was acquitted. He told friends that the jury had tempered justice with mercy, that they had measured his humanity in terms of their own experience rather than by the complex arguments presented by the prosecution.

When it was time for Judge Rivlin to sum up the case, Drewe showed little emotion. He leaned slightly forward, his head to one side, and listened quietly.

"You have an extraordinary and alarming talent for manipulating people," Rivlin told him. "You were able to live very well indeed, and make a donation of £20,000 to the Tate, which I have no doubt was not seen by the Tate as a bribe but it was seen by you as one." Drewe had "spun gold" from the "expert forgeries and endless lies," the judge continued. He had targeted the vulnerable, conning his associates and runners.

"Some of these people have also been, to an extent, the victims of

your fraud. When they finally turned away from you, you did not hesitate to threaten them."

Rivlin was easier on Myatt. "You were gradually sucked into the conspiracy when I accept you were vulnerable," he said.

With that, he congratulated the jury for their "extraordinary attention." As a reward for their patience, he excused them from jury service for life.

EPILOGUE

The press covered the scam and subsequent trial with unreserved enthusiasm—"The Greatest Art Forgery of the Century!" "A Mix of Kafka and Lewis Carroll!"—and Drewe was already famous by the time he was transported from the courtroom to Pentonville in the back of a sweatbox van in February 1999. Built in North London in 1842, the city's busiest prison held twelve hundred inmates and several thousand cockroaches. Reform advocates suggested that Pentonville would have been more at home on Hogarth's Gin Lane than in present-day London. It boasted a rich musical, literary, and political history: the Irish revolutionary Roger Casement was hanged there in 1916; Oscar Wilde did time there, as did Hugh Cornwell, the lead singer for the punk/new wave band the Stranglers. A decade after Drewe's stint, the proto-punk singer Pete Doherty, who modeled himself on the elegant wastrels of the 1970s, also served a short sentence there.

On arrival, Drewe was marched down a long corridor straight to

the hospital wing. His manner had become increasingly lofty over the years, and during the first few weeks he spent as much time as he could in the wing with one complaint or another. Later, when he was thrown in with the rest of the population, he managed to establish himself as something of an expert in the intricacies of the law. It was said that he charged one inmate £10,000 to prepare a failed appeal. In the yard, among the thieves and dope dealers, miscreants and tai chi practitioners, he stood out like a sore thumb. The place was filled with immigrants from Russia and Colombia, from Jamaica and Latvia and Poland, from India and Vietnam. There was an Irish unit and a group of black gangsters from East London. Apparently, Drewe worked nights in the prison library and kept to himself until the word got out that he had a clear mind and a particular agility with paper. He was asked to offer his legal expertise several more times, and gladly gave it for whatever additional comfort he might receive in such dismal quarters.

One day in the summer of 2000, Drewe was brought up to the front office, given his old suit and the few belongings he had with him when he came in, and released. He strolled out, his long arms dangling and his head held high. He had served about four years of his six-year sentence, including time spent awaiting trial.

He appealed his conviction, claiming he had not received a fair trial and was denied proper counsel. The appeal was denied. Police estimate he made at least $2 million from the scam. Drewe returned to his well-rehearsed role as a citizen above suspicion. He lived comfortably in Reigate with Helen Sussman, his wife, and still claimed to be a physicist. Whenever reporters called, he stuck to his story. It was all the government's fault, he said. He was a victim of a cover-up involving secret arms deals with rogue countries. Whoever came along and offered him air time or ink became the subject of repeated entreaties. He would chat for hours and invariably volunteer to supply documentation—forty-two boxes of it—to prove his case. He always failed to deliver, and he consistently broke appointments.

A death in the family, he would say.

A medical emergency.

A business trip to America.

He claimed to be working on all manner of extraordinary military inventions. He filed for "technical patents" having to do with improvements to propulsion methods through the use of a spinning disk and a substitute for the liquids used in hydraulic machines. He was looking into remote-powered surveillance vehicles the size of insects. He claimed to have received funding from an American source and was conferring with the head of procurement for the U.S. Defense Department. No matter that this self-described avant-garde agitator, child of the father of the atom bomb, and doctor emeritus of all things had spent years in police custody. He was determined to make his mark on America. He was heading across the pond, to Langley and beyond. He had places to be, people to meet, many men to see.

Drewe's fifteen-year disappearance from the official record from the late 1960s to the early 1980s still puzzled his erstwhile pursuers. He had come out of the blue and conducted a sophisticated nine-year-long scam, but there was no record of his earlier activities. Even after the case was closed, some police officers wondered what he might have been up to. He had managed to elude the public record: There was no evidence of prior mischief; no link to other crimes; no medical, tax, or formal employment records.

Miki Volpe managed to track down Drewe's mysterious "sugar daddy," John Catch, the wealthy patron at the Atomic Energy Authority whose art collection Drewe claimed he was going to inherit. Catch had never collected art, as it turned out, and Volpe discovered that all records of John Cockett, as Drewe was known then, had disappeared from the AEA. Catch, of course, was surprised to learn that he'd been at the center of an art scam—less so when he learned it had been run by his former protégé, who in the early 1990s had tried to use his name as a reference on a résumé Catch knew was filled with fabrications.

In 2000, a bizarre story appeared in the *Mail on Sunday* suggesting that there had been a connection between Drewe and the "secret world," a possibility the police had never entirely discounted. The *Mail* reported that MI5 had played a practical joke on Drewe by using his home address as a front to register dozens of cars used for tracking foreign agents. According to the report, the intelligence services had targeted Drewe as payback for his public insistence that his crimes were committed at their behest. The story emerged after police traced a suspicious vehicle to Drewe's address, whereupon he revealed that his family had been receiving letters addressed to the front company for years. Drewe later claimed he had unwittingly provided "business services" to MI5, and demanded payment from its director-general, Stephen Lander.

After Drewe's release, those who had brushed up against him seemed incapable of separating fact from fiction. They believed he still had them under surveillance and that he would attempt to harm them. They advised others to keep their distance.

"Don't give him any personal information," warned a former friend. "Tell him lies. He can get in your head if he knows any little thing about you."

Other acquaintances cautioned reporters to be on their toes, not to sign anything in Drewe's presence, not to leave signed documents anywhere near him. Everyone who had ever dealt with him had taken a turn for the worse, they said. He was Hannibal Lecter with a ballpoint pen and a paintbrush.

There is no doubt that Drewe was a convincing and accomplished fabricator. Many of his interrogators, though they were not mental health professionals, considered him to fit the description of a pathological liar. Pathological liars are sometimes referred to as "folded," emotionally "enveloped" by their imagined selves, and thus "origamists," from the Japanese word for folded paper birds and animals. The origamist reflects a childhood deficit, say psychologists. If he goes unnoticed by his parents—if he is neither rewarded nor loved—he

can "become" someone else in order to seek the attention and praise that has been denied him.

Some psychologists believe that pathological liars cannot help themselves, that they have an uncontrollable impulse to deceive. Their lies simply tumble out. They connect ideas on the run and assemble disparate whoppers to produce a believable whole. Con artists and habitual liars, with their inconsistent stories about their education and family background, are also apt to be expert mind readers, with a special understanding of the psychological vulnerabilities of others. They are able to suppress and regulate their emotions and successfully mask their own nervousness. Many of these counterfeit personalities also possess exaggerated verbal skills and can lie without inhibition. Often, they have at least one other trait in common: They hold a grudge against the establishment.

There is some evidence that pathological lying is genetic and can be passed on from one generation to the next. In a study published in 1995 in the *British Journal of Psychiatry*, scientists interviewed 108 employees of a temp agency and asked them about their employment and family history. After thoroughly checking their backgrounds, the investigators discovered that 12 of the 108 interviewees had made up much of their professional and personal histories and admitted to lying habitually. After the dissembling dozen agreed to have their brains scanned, it was discovered that their prefrontal cortexes contained 25 percent more white matter than the average person's. The white matter serves as the brain's routing system, and according to the study, this extra measure of connective circuitry partially explains the liar's ability to confabulate convincingly, to tell tall tales without stumbling, and to seamlessly rattle out an imaginary narrative.*

Drewe's brain would have been a gift to any forensic pathologist.

* Y. Yang et al., "Prefrontal White Matter in Pathological Liars," *The British Journal of Psychiatry*, 2005 187, 320–325, found at bjp.rcpsych.org/cgi/reprint/187/4/320.pdf.

Volpe and Searle often marveled at the sheer volume of myth and confetti he'd managed to scatter behind him. For a long time, whenever they felt overwhelmed by the long evidentiary trail, they would repeat the mantra "Keep it simple," which served as a reminder that his massive constructs were but a series of sordid criminal transgressions, cons within cons. He had left behind him a trail so long and twisted that no one would ever be able to chart every curve and cul-de-sac. It was all a charade, wasn't it? Charlatan's debris, random bursts of lightning intended to guide the victim's eye away from the hand.

Years after the case the detectives would come across bits of data that still didn't compute, and they would file these away, along with the other irritants and intangibles that had lodged in their memories. They would express both annoyance and admiration, for Drewe had been able to juggle a dozen outrageous constructs at the same time, all the while staying several steps ahead of them. He had damaged the reputations of a good number of upstanding citizens (many of whom should have known better), and he had left dozens of victims in his wake, some of whom would try, and fail, to make sense of it all. The case of one possible victim—the young Hungarian woman who perished in the boardinghouse fire—remains open. Unless there is new evidence, it is unlikely that it will ever be "closed," especially to the satisfaction of police detective Higgs.

Questions also remained about a possible second forger. Myatt repeatedly told police he had nothing to do with Rene Gimpel's 1938 "Nicholson" watercolor and at least three other paintings. How many forgers and fakes were still in the wind?

A decade after Drewe's trial, the Art and Antiques Squad was reduced in size once more. Faced with the prospect of being shut down entirely, a new squad leader came up with a new idea—to recruit curators and art historians who would serve as "special constables" and have the power to make arrests. The Yard promised that officers from

this newly formed division, dubbed Art Beat, would be ready to patrol London's art scene by 2007.

The new squad leader did not give up. He carried on with his plan by recruiting volunteer Art Beat constables from the V&A and the British Museum and giving them four weeks' training in police procedure. He had special uniforms made up and put the new constables to work patrolling the antiques markets in Bermondsey and the gallery areas of Kensington Church Street, Bond Street, and Camden Passage.

Art crime continued to rise. The Art Loss Register, a comprehensive international database, reported that art forgery was costing the market some £200 million annually in the United Kingdom alone, the world's second-largest art market. Hundreds of collectors remained oblivious to the fact that their "masterpieces" were worthless fakes. The ALR had retrieved several thousand forgeries, but because British police were forbidden to destroy them, unlike their counterparts in France and Belgium, known fakes often reentered the market.

At the Victoria and Albert Museum, the Art Squad put together an exhibition on art forgery. The show featured Drewe and Myatt's tools and products, including forged paintings, typewriters, and phony rubber stamps. Drewe's equipment was bequeathed to Scotland Yard's infamous Crime Museum, where it was awarded a spot not far from Jack the Ripper's display and the hangman's noose.

Mary Lisa Palmer, the director of the Giacometti Association, spent the years after Drewe's trial in bitter legal skirmishes with French officials to have Annette Giacometti's will respected and the association transformed into a foundation. In 2001, the French courts ordered that the catalogue raisonné documents in the association's hands be taken away, and then had the association's bank accounts blocked. Nevertheless, Palmer and her husband, François

Chaussende, whom Annette had appointed assistant director in 1990, continued to work without pay for the next eighteen months.

In December 2003, the government formed its own Giacometti Foundation, and inherited all the works in Annette's estate. The foundation filed multiple court proceedings in an attempt to dissolve the association, and tried without success to seize the Cour de Rohan building, which Annette had designated as the headquarters for the foundation she had desired. Palmer and the association successfully fought off every attempt by the foundation to shut it down, and is suing France in the European Court of Human Rights.

The foundation was seen by some as a commercial enterprise rather than an entity devoted to protecting and promoting the artist's work. In 2006, the foundation hired the prominent Gagosian Gallery in New York to sell posthumously created sculptures and prints. Critics said the sales would cheapen Giacometti's work and provide forgers ample room to ply their trade.

Meanwhile Palmer and her husband continued with the work of the association by authenticating Giacometti paintings and sculptures, tracking forgeries, and working on the decisive catalogue raisonné.

In retrospect, she believes that if Sotheby's had been able to send the Footless Woman to Paris after it was pulled from auction in 1991, it could have been seized by police, an investigation launched, and Drewe's scheme possibly derailed.

Batsheva Goudsmid's troubles did not end with Drewe's conviction. She fought both him and the government in court over the proceeds of the sale of the house on Rotherwick Road. She spent months proving that even though Drewe had been coregistered on the mortgage, she alone had bought and largely maintained the house, which could therefore not be confiscated as part of Drewe's assets. The Crown finally agreed that Goudsmid owned the house and withdrew from the case,

but Drewe continued to fight her, asserting that she had forged his signature and had used phony documents to present her case. The judge threw out his claim, saying that Drewe was "not someone on whose uncorroborated evidence I could place any reliance," and remarking on the irony and gall of a convicted "master forger" protesting that his signature had been counterfeited. Several months later Goudsmid was hit with a lawsuit from Drewe's mother, who said she had loaned Goudsmid money and was never paid back. This suit too was thrown out.

Goudsmid never returned to work. After Drewe won initial custody of the children, she could hardly work and fight him in court at the same time. The protracted battle had left its mark. Though she tried not to think about the past, she kept boxes filled with legal transcripts and documents from the Drewe wars. She'd been through horrendous years with this man and she had lost a great deal. At least she emerged with one thing intact: Neither the police nor anyone else could ever say she'd done anything but tell the truth.

D aniel Stoakes felt similarly. He often recalled how Drewe tried to reach out to him toward the end of the trial and how he had turned away from his old friend because he felt used and heartbroken. Several years later, after it was all over, he picked up the phone and heard Drewe on the other end. He shuddered and pulled the receiver away from his ear, as if a caterpillar had crawled out of it. Then he hung up.

M iki Volpe was transferred to the Intelligence division—"Now isn't that ironic?" he said—and moved to a quiet village outside London, where he set up house with a female officer from the homicide squad. Bumblebees gathered around the roses in their backyard, where he planted a creeping vine and set up an old Chinese wrought-iron stove that kept a section of the garden warm after sun-

set. He spent his autumn evenings there, reading and smoking his cala-
bash pipe. When his retirement came through, he watched the civilians
walking to the train station and thought, "Poor sods!" He later moved
to Spain.

Jonathan Searle retired from the force and moved as far away from
London as he could without entirely vanishing. Now he spends much
of his time restoring works of art. He loves the smell of paint and
varnish and cedar, and can't think of a worse topic to talk about than
John Drewe.

After the con was exposed, an intense process of reverse screening
took place on both sides of the Atlantic. Librarians went through
their stacks, archivists scoured databases, curators lined up their col-
lections to examine and cross-reference provenances. Drewe had left his
mark on the system, a visible hairline crack. Skeptics said the damaged
archives would never regain their original pristine state, and that the
records had been forever altered.

The Tate pulled its socks up and opened a brand-new research
room with state-of-the-art technology and tighter restrictions. Staffers
were trained to examine everything that went in and out. Librarians
kept watch over the researchers as surveillance cameras scanned the
room. The Hanover Gallery archives now included a prominent warn-
ing from the police department directed at future researchers: "This
documentation may have been compromised."

John Myatt too was famous when he arrived at Brixton Prison after
the trial. In the reception area, which smelled of carbolic soap and
soiled clothes, he was strip-searched, measured, weighed, and photo-

graphed. Prisoners in flip-flops, vests, and baggy trousers loitered at the top of the stairs with their towels slung over their shoulders. In the hexagonal administration block at the heart of the jail, the clock had stopped.

Myatt had been warned about the filth and monotony of prison life. The director-general of the prison service himself had referred to Brixton as a "hellhole." Inmates sometimes spent twenty-two hours a day in their cells, and three quarters of the eight-hundred-strong population had reading and writing skills below those of the average eleven-year-old.

Myatt's blockmates nicknamed him "Picasso," and soon he was doing portraits of them in exchange for phone cards. He painted a picture of a notorious rapist who had been "chemically castrated," and another of one of the prison wings, which he had to sketch on the sly to avoid the security cameras. Another showed the inside of an inmate's cell with a lewd portrait on the wall.

In his own cell, behind the coils of razor wire and the blackened brickwork of the drab Victorian building, Myatt's belief in the power of prayer flourished. He felt a constant and comforting link to his church and his community. He knew that back in Sugnall his reputation remained intact, and that the townsfolk held church vigils for him and prayed for his well being and swift return. As a homecoming surprise, they had begun to refurbish his kitchen. Early mornings in his cell, before he opened his eyes, he imagined himself back on the farm.

In June 1999, after serving just four months of his one-year sentence—a stint his fellow prisoners called "a shit and a shave"—Myatt was sprung for good behavior. As he left he swore that he would never paint again, and that if he ever made any money, he'd give it to his church.

The day after he got out he received a cheerful and unexpected call from Searle, who wanted to know about his future plans. Myatt told him that he was putting his paints away for good.

"Big mistake," said the detective. "You have a God-given talent. You know, you could still make a living off it." He asked whether Myatt would be willing to paint a portrait of his family. Myatt said he'd think about it.

Myatt was nearly broke. Most of the £100,000 he'd earned from Drewe had already been spent on the kids, who were in boarding school, and he'd given a good deal to the church and the Salvation Army. The £18,000 he had when he was caught had been handed over to the police. Over the next few days he reapplied for his old teaching job and began conducting the church choir. He joined a small, dedicated chorale that specialized in medieval music, and every so often he played piano for them. He was ill at ease without a paintbrush in his hand, but he reminded himself that he'd been given a second chance and had vowed never to return to his old ways.

Then, Searle called again. "I'll pay you five thousand pounds for the portrait," he offered.

The thought of making money legally by painting appealed to Myatt. It was also a relief: Giving up painting was a promise he knew would be difficult to keep, like a smoker who claims he's going to quit for good.

"Okay," Myatt responded.

He traveled to London to Searle's house, where he met his wife and four children, ate a beautiful meal, and then took out his brushes. When the portrait was done Searle put the painting up in his dining room and proudly showed it off to his colleagues.

Soon the word was out that Myatt was back in business. He was surprised to hear from one of the prosecutors who had put him away. The man said he wanted a Myatt for himself, so Myatt pulled out his turps again, cleaned his brushes, bought a few tins of paint, and set up his easel. In the full light of day, with the windows open and Bach on the stereo, he finally felt that he was doing good, honest work, and whenever a new commission came in, he went at it with a vengeance.

By September 2002 he had set up his own legitimate business, Genuine Fakes. His first show was a roaring success: He sold all but three of sixty-five paintings, and commissions began to come in from Italy and the Philippines, from the United States and Canada. He was asked to lecture on the business of art fraud, and sat on panels next to art experts and detectives. Inevitably, someone would come up and commission a new piece.

Within a couple of years genuine Myatt fakes were hanging in ski lodges in Aspen, and in Tuscan villas. He ran the business with his new wife, Rosemary, a potter and a member of the church choir. Friends said he would have been lost without her. He must have been doing something right, he thought. He was working at what he loved and living with someone he adored. Visitors noted that he was open and articulate, loved to laugh, and often sounded like an excited boy, speaking in vivid metaphors and lyrical bullet points rather than whole sentences.

When the Giacometti Association asked him to photograph each new fake so that they would have a record of his work, he agreed. He had no plans to go back to Brixton Prison. Clients who asked for Braques and Picassos sometimes requested that he refrain from placing his indelible "Genuine Fakes" inscription on the back of the piece. He refused. Experts had warned him that a client could simply reline one of the canvases and pass it off as an original.

He often thought about the dozens of pictures he'd made for Drewe, the ones that had vanished over the years. He knew that each time they changed hands, the provenance became more solid and detection less likely. Whenever he saw his work in a museum or auction catalog, he kept it to himself. Blowing the whistle wouldn't benefit anyone, he thought. If he were to reveal the true nature of the work, it could cost an innocent collector a lot of money. Furthermore, he had a personal interest in the continuing existence of his paintings. Once a forgery was discovered, its life was over. The painting disappeared into a kind

of artistic limbo, the resting place for all fakes. By his own reckoning, some of the work he'd done for Drewe was quite good, and he didn't want any of it destroyed. The paintings that had made their way safely into collections and museums were now part of the history of art.

When the media sought Myatt out in Staffordshire, he refined his story. The press portrayed him as a reformed antiestablishment figure, a charming farm boy who had put one over on the hoity-toity set. The story also had a moral, a shout-out to the art world to wake up and look at art for what it *was,* not for what it was worth. Sometimes Myatt told interviewers that Drewe's scam was an extended piece of conceptual art, a subversive work that employed as its medium the vagaries of the art market.

Myatt and Rosemary moved to a sixteenth-century farmhouse they restored near Stafford, not far from the run-down house he had inherited from his parents. There were seven acres surrounded by rolling hills and dotted with cows and a Druid mound that the local witches visited on Halloween. Myatt set up his studio in a sunlit stone barn next to the house. He dreamed of a future in which he could retire from the business of genuine forgeries and devote himself to his own genuine Myatts. He had learned a good deal from the artists he'd copied over the years, and he could always knock out an "after," but he wasn't sure what his own work looked like. On the rare occasion when he summoned the nerve to face his own stuff, he froze up. He feared that he might not be up to it. Most of all, he feared failure.

In 2004, Myatt got a call from Sky TV asking whether he wanted to host a ten-part series in which he would teach aspiring artists how to paint in the style of the world's greatest artists. The show was called *Mastering the Art,* and Myatt did very well by it. He stood affably on a hillside with his easel and taught the basics of forgery, many of them learned from Drewe: how to rub soil onto canvas to replicate a Braque finish, how to use coffee to age a painting a hundred years. In 2009, Sky

televised him again, this time in a six-part series, on portraiture in which he paints celebrities in various styles while interviewing them.

Myatt had come a long way. He found it curious that despite all his transgressions, he had been rewarded in the end. He had joined forces with a man sometimes described as fundamentally evil, but in return he had been blessed. He was fifty-nine years old, in love, and enjoying financial success. His works were now selling for up to £50,000. He still recalled Drewe's moments of kindness and encouragement, and often reminded himself that if he'd never stepped over the line, if he hadn't met Drewe and gone to prison, he would never have hit pay dirt. It was all a great mystery. In the late afternoon, when he walked his property with his energetic dog Henry, he felt happier and richer than ever.

Crime did pay.

"I know I've been very lucky," he told the London *Sunday Times* in 2007. "I f***d up but I've been given a second chance. And there's nothing illegal this time. All my paintings are marked as fakes. In fact, I quite like the idea that people can look at my paintings and decide whether they like it or not without all that high-art bollocks. They haven't got to stand in front of it and say: 'Oh, it's a Van Gogh, so we have to like it.' It gives people a chance to see past all the toffey-nosed, art-critic bullshit. I mean, 40 million quid for a painting! Why can't these people give the money to the Salvation Army or build a new wing at the local hospital?"

Myatt began receiving increasingly important commissions, particularly from the United States. He loved the Americans. One New Yorker wanted a Picasso so large that Myatt would never be able to get it out of the studio. Six feet by six feet was the limit, he told the Yank.

"That's okay, John," said the American breezily. "You make it as big as I want it and you'll find a way."

John and Rosemary visit New York often and like to stop in at the Metropolitan Museum of Art. Myatt had received several commissions

to paint knockoffs of Monet's *Morning on the Seine,* an image so popular that Walmart had marketed a lithograph version for $174.37. He spent hours in front of the original. He felt as if he were back in London in the old days, walking through the museums and basking in the light of the Turners and the Gainsboroughs and the Constables. He liked to get as close to the Monet as he could without attracting the guard.

One day, with his nose just inches away from the canvas, he noticed several hairs from Monet's brush stuck on the surface of the painting. Myatt had always made sure that his own work was hair-free, but this Monet follicle seemed to reach out to him. The message was clear: There really was no such thing as a perfect painting. Myatt swore that the next time he found a hair stuck to his canvas, he'd leave well enough alone.

AUTHORS' NOTE

When we first decided to chronicle John Drewe's nine-year-long "performance piece"—as it was dubbed by one of his associates—we realized that we would have to rely to some degree on the testimony of convicted criminals and an experienced fabricator. Therefore, we also gathered much of our information from dozens of interviews with the runners, dealers, archivists, researchers, art experts, and police officers who found themselves embroiled in the case. As with any investigation, documents also played a large role in our research. We reviewed thousands of pages of police evidence, testimony, and court transcripts. As part of the narrative, we have included passages of dialogue that are not necessarily direct quotations from interviews with us but are recollections of others who were present. The reader should not infer that all the speakers were our direct sources.

The forger John Myatt offered an extraordinary degree of cooperation and spent months with us discussing his decade-long personal

and professional relationship with Drewe. We found Myatt to be open, and his memory of events consistent throughout our interviews with him.

We also spoke with John Drewe by telephone. A decade after his conviction, he continues to claim both his innocence and the complicity of the British government—"those lying, conniving bastards"—in the convoluted scheme. "At the end of the day," he told us, "what we have is a story of many millions of pounds of deceit and murder . . . a political game of cat and mouse. . . . Is it provable? Absolutely."

Attempts to meet Drewe in person in London, where he promised to show us "stunning" documentation, were met with increasingly convoluted excuses.

We did have the advantage of access to a rich lode of material describing his actions and words throughout his career as the mastermind of the forgery scam. He was a compulsive writer and loved corresponding with members of the art world's aristocracy, either under his own name or under one of his many aliases. He wrote often to London newspapers, and several of his letters on various topics were printed in the London *Times*.

ACKNOWLEDGMENTS

There was an understandable reluctance by some to supply information about John Drewe. Thus, we truly appreciate those who did come forward and entrust us with their experiences and time. Drewe's path through the art world was labyrinthine, with illogical turns and sudden dead ends, and finding our way through it not only took longer than we expected but required many follow-up calls and e-mails over the years. This book would not have been possible without their help, and we are grateful for the many and repeated reality checks.

We are particularly grateful to John Myatt, who greeted every scheduled and nonscheduled interview with enthusiasm, warmth, and openness. His continued cooperation, and the help of his wife, Rosemary, was instrumental to the project.

We also appreciate the help from runners Clive Belman, Paul Redfern, and Andrew Wechsler, who provided detailed accounts of their foreshortened art marketing careers. Each is a natural storyteller.

ACKNOWLEDGMENTS

. . .

The art dealers Armand Bartos, Rene Gimpel, Adrian Mibus, and Peter Nahum were essential to our understanding the many characters and provenances Drewe created to sell forgeries. Their passion for art is palpable and infectious, and we appreciate the access they gave us.

Jennifer Booth, former Tate Gallery archivist, was also a tremendous resource, whose discussion of archives and review of parts of the manuscript were invaluable. We also thank Sir Alan Bowness, former director of the Tate Gallery, and Mary Lisa Palmer, director of the Alberto and Annette Giacometti Association. Palmer spent several days with us poring over the association's files on the Giacometti forgeries linked to Drewe. She is meticulous, knowledgeable, easy to talk to, and patient. We are also indebted to the association's assistant director, François Chaussende, and association member Jean-Yves Mock.

This book could not have been written, of course, without the help of the detectives, Dick Ellis, Richard Higgs, Charley Hill, Jonathan Searle, and Miki Volpe. Detectives Searle and Volpe, who were quick to acknowledge the work of the many other detectives and officers assigned to the case but not mentioned in the book, were gracious, generous, and wonderful hosts.

We owe debts to many others. The brief mention by no means reflects our gratitude. We thank Fathers Paul Addison and Bernard Barlow; Jonathan Broido; Terry Carroll; former ICA director Bill McAllister; ICA historian Lyn Cole; investigative reporter David Pallister; John Sperr; and Jane Zagel.

The American sportswriter Walter "Red" Smith once said there is "nothing to writing. All you do is sit down at a typewriter and open a vein." We thank our family members and friends who made the job less painful. Thanks to our parents, who babysat our daughter while we researched abroad, and to our friends at our writers' group, whose

endless support, encouragement, and comments always kept us on track. The staff at The Penguin Press was incredibly dedicated, and we thank in particular our editor, Jane Fleming, for her insight and confidence. Joy Johannessen read the penultimate draft of the manuscript and gave us outstanding editorial advice.

Above all, we thank Susan Rabiner, our literary agent, friend, and mentor, for her steadfast support throughout this endeavor.

BIBLIOGRAPHY

Selected Articles and Transcripts

Aston, Paul. "Artist Hypnotized by 'Conman.'" *The Birmingham Post,* Oct. 7, 1998.

Athineos, Doris. "The Book in Fakes." *Forbes,* Mar. 24, 1997.

Atkinson, Steve. "Artful Forger: Mad Genius Who Plotted the Biggest Art Fraud of the Century." *The Mirror,* Feb. 13, 1999.

Bailey, Martin. "The Biggest Contemporary Art Fraud of the Century." *Art Newspaper* 10, no. 90 (March 1999).

Bale, Joanna. "Mystery Man Made Fraud an Art" and "Art World Corrupted by Pounds 250 Fakes." *The Times* (London), Feb. 13, 1999.

Booth, Jennifer. "Dr. Drewe—A Cautionary Tale." *Art Libraries Journal* 28, no. 2 (2003).

Bradley, Theresa. "Painting Fakes: Art Forger John Myatt Became a Cult Hero—After Doing His Time in Prison." ABC News, Mar. 2003.

Buncombe, Andrew. "Art Fraud Suspect Dismisses Lawyers." *The Independent* (London), Sep. 25, 1998.

———. "Art Fraud of the Century Fooled Tate." *The Independent* (London), Feb. 13, 1999.

Cebik, L. B. "On the Suspicion of an Art Forgery." *Journal of Aesthetics and Art Criticism* 47, no. 2 (Spring 1989).

Cheston, Paul. "Art Fraudster Sold £1M Forgeries by Fixing Tate Records." *The Evening Standard* (London), Feb. 12, 1999.

Craven, Nick. "Faker's Picture Scam Undermined Art World." *The Daily Mail* (London), Sep. 24, 1998.

Davis, Douglas. "The Billion-Dollar Picture?" *Art in America* 76 (July 1988).

De Paulo, Bella et al. "Cues to Deception." *Psychological Bulletin* 129, no. 1 (2003).

BIBLIOGRAPHY

Dutton, Denis. "The Death of a Forger." *Aesthetics Online* (1996), found at denisdutton.com
/essays.htm.

———. "Artistic Crimes." *British Journal of Aesthetics* 19 (1979), found at denisdutton.com
/essays.htm.

Ede, Charisse. "Painter Jailed for Fraud of Century." *The Birmingham Post,* Feb. 16, 1999.

Ede, Charisse, and Martin Stote. "Portrait of the Artist as an Impressionable Conman." *The
Birmingham Post,* Feb. 13, 1999.

Esterow, Milton. "Fakes, Frauds, and Fake Fakers." *ARTNews* 104, no. 6 (June 2005).

Frey, Bruno. "Art Fakes? What Fakes: An Economic View." Institute for Empirical Economic
Research, University of Zurich, July 12, 1999.

Friedlander, Max. "On Forgeries." *Burlington* 78 (May 1941).

Gentleman, Amelia. "Fakes Leave Art World in Chaos." *The Guardian* (London), Feb. 13,
1999.

Gizmet, Richard. "Up Close: John Myatt." ABC News Transcripts, Jan. 17, 2003.

Glaister, Dan. "Which Is the Fake?" *The Guardian* (London), June 15, 1996.

Gleadell, Colin. "Artful Forger Convicted." *Art & Auction* 21, no. 13 (March 15–31, 1999).

———. "The Fake's Progress." *Art Monthly* no. 225 (April 1999).

———. "The Art Detective."*Daily Telegraph,* July 8, 2002.

Gray, Paul. "Fakes That Have Skewed History." *Time,* May 16, 1983.

Grubin, Don. "Commentary: Getting at the Truth About Pathological Lying." *Journal of
American Academy of Psychiatry and Law* 33, no. 3 (2005).

Harman, Alan. "Art Crime Linked to Drugs and Arms." *Law & Order* (May 1995).

Heartney, Eleanor. "Artists vs. the Market." *Art in America* 76, no. 5 (May 1988).

Hirschberg, Lynn. "The Four Brushmen of the Apocalypse." *Esquire,* March 1987.

Honigsbaum, Mark. "The Master Forger." *The Guardian* (London), Dec. 8, 2005.

Howe, Melvyn. "Puppet Master." *The Journal* (Newcastle), Feb. 13, 1999.

Hughes, Robert. "Sold!" *Time,* Nov. 27, 1989.

———. "Brilliant, But Not for Real." *Time,* May 7, 1990.

James, Marianne. "Art Crime." *Australian Institute of Criminology* no. 170 (October 2000).

Januszczak, Waldemar. "All Nash and No Bite—The ICA Has Become a Playground for a
Declining Civilization." *The Guardian* (London), Sept. 19, 1987.

Karpman, Ben. "From the Autobiography of a Liar." *Psychiatric Quarterly* 23, no. 3 (1949).

Katz, Donald. "Art Goes to Wall Street." *Esquire,* July 1989.

Kennick, W. E. "Art and Inauthenticity." *Journal of Aesthetics and Art Criticism* 44, no. 1
(Autumn 1985).

Koenigsberg, Lisa. "Art as a Commodity? Aspects of a Current Issue." *Archives of American Art
Journal* 29, no. 3/4 (1989).

Landsman, Peter. "A 20th-Century Master Scam." *New York Times Magazine,* July 18, 1999.

Lyall, Sarah. "After Stint of Crime, Art Forger Sells Genuine Fakes." *New York Times,* Mar. 4,
2006.

Moss, Stephen. "What's Wrong with This Picture?" *The Guardian* (London), Feb. 20, 1999.

Murphy, Marina. "The Art of Deception." *Chemistry & Industry* no. 19 (October 4, 2004).

O'Neil, Eamonn. "The Art of Deception." *The Scotsman,* July 6, 2002.

O'Sullivan, Eckman. "A Few Can Catch a Liar." *Psychological Science* 10, no. 3 (1999).

Patton, Lucy. "Hundreds of Forgeries Made a Million: Mastermind Who Fooled Art World." *The
Herald* (Glasgow), Feb. 13, 1999.

Phillips, Deborah. "Bright Lights Big City." *ARTNews* 84 (September 1985).

Polk, Kenneth. "Unveiling Secrets and Lies: Examining Threats to Collections of Art." Keynote
Address, University of Melbourne, Oct. 9, 2001, presented at the Australian Registrars
Committee Conference.

Poltz, Kim, and Maggie Malone. "Golden Paintbrushes." *Newsweek,* Oct. 15, 1984.

Riding, Alan. "Art Fraud's New Trick: Add Fakes to Archive." *New York Times,* June 19, 1996.

Rubin, Gareth. "I Could Still Dupe the Art World with My Forgeries But I'd Never Risk Going Back to the Hell of Jail." *The Express on Sunday* (London), Mar. 30, 2003.

Selling, Lowell. "The Psychiatric Aspects of the Pathological Liar." *The Nervous Child* 1, (1942).

Serafin, Amy. "Believe It or Not." *Art & Auction* 30 (2007).

Shaw, Adrian. "Conman Gets 6 Years for Pounds 1 Million Art Racket." *The Mirror,* Feb. 16, 1999.

Smith, Roberta. "Rituals of Consumption." *Art in America* 76, no. 5 (May 1988).

Spiegler, Marc. "The Giacometti Legacy: A Struggle for Control." *ARTNews* 103, no. 9 (October 2004).

Tooze, Steve. "How I Forged My Career as a Con Artist." *The Mirror,* Oct. 7, 2000.

Walker, Richard. "The New Grand Acquisitors." *ARTNews* 84 (September 1985).

Wallis, Stephen. "Dubuffet Fakes Make Foundation Target." *Art & Auction* 21, no. 18 (June 1–15, 1999).

Wood, Joe. "Pounds 1 M of Art Made With Mud, Salt and a Hoover Bag." *Daily Record* (Glasgow), Feb. 13, 1999.

Zemel, Carol. "What Becomes a Legend." *Art in America* 76, no. 7 (1988).

BOOKS

Burnham, Sophy. *The Art Crowd*. New York: D. McKay, 1973.

Checkland, Sarah Jane. *Ben Nicholson: The Vicious Circles of His Life & Art*. London: John Murray, 2000.

Clifford, Irving. *Fake! The Story of Elmyr de Hory—The Greatest Art Forger of Our Time*. New York: McGraw-Hill, 1969.

Cole, Lyn. *Contemporary Legacies: An Incomplete History of the ICA 1947–1990*, unpublished.

Dolnick, Edward. *The Rescue Artist: A True Story of Art, Thieves, and the Hunt for a Missing Masterpiece*. New York: HarperCollins, 2005.

Dutton, Denis, ed. *The Forger's Art: Forgery and the Philosophy of Art*. Berkeley: University of California Press, 1983.

Dutton, Denis. "Authenticity in Art." In *The Oxford Handbook of Aesthetics,* edited by Jerrold Levinson. New York: Oxford University Press, 2003; found at denisdutton.com/essays.htm.

———. "Art Hoaxes" and "Han van Meegeren." *Encyclopedia of Hoaxes,* edited by Gordon Stein. Detroit: Gale Research, 1993; found at denisdutton.com/essays.htm.

Ford, Charles. *Lies!, Lies!!, Lies!!!: The Psychology of Deceit*. Arlington, VA: American Psychiatric Publishing, 1999.

Gibson, Ian. *The Shameful Life of Salvador Dalí*. New York: W.W. Norton, 1998.

Godley, John. *Master Art Forger: The Story of Han van Meegeren*. New York: Wilfred Funk, 1951.

Goodrich, David. *Art Fakes in America*. New York: Viking, 1973.

Hayden-Guest, Anthony. *True Colors: The Real Life of the Art World*. New York: Atlantic Monthly Press, 1998.

Haywood, Ian. *Faking It: Art and the Politics of Forgery*. New York: St. Martin's Press, 1987.

Hebborn, Eric. *The Art Forgery's Handbook*. New York: Overlook Press, 1997.

———. *Drawn to Trouble: Confessions of a Master Forger*. New York: Random House, 1993.

Hoving, Thomas. *False Impressions: The Hunt for Big-Time Art Fakes*. New York: Simon and Schuster, 1997.

Jones, Mark, ed. *Why Fakes Matter: Essays on Problems of Authenticity*. Published for the Trustees of the British Museum. London: British Museum Press, 1992.

Jones, Mark, ed., with Paul Craddock and Nicolas Barker. *Fake? The Art of Deception*. Berkeley: University of California Press, 1990.

BIBLIOGRAPHY

Keating, Tom, Frank Norman, and Geraldine Norman. *The Fake's Progress: Tom Keating's Story.* London: Hutchinson, 1977.

Lacey, Robert. *Sotheby's: Bidding for Class.* London: Little Brown, 1998.

Lord, James. *Mythic Giacometti.* New York: Farrar Straus Giroux, 2004.

———. *Giacometti: A Biography.* New York: Farrar Straus Giroux, 1983.

Magnusson, Magnus. *Fakers, Forgers & Phoneys: Famous Scams and Scamps.* Edinburgh: Mainstream Publishing, 2006.

Mason, Christopher. *The Art of the Steal: Inside the Sotheby's–Christie's Auction House Scandal.* New York: Berkley Books, 2005.

Mellor, David, ed. *Fifty Years of the Future: A Chronicle of the Institute of Contemporary Arts.* London: Institute of Contemporary Arts, 1998.

Moss, Norman. *The Pleasures of Deception.* London: Chatto & Wirdus, 1977.

Polsky, Richard. *I Bought Andy Warhol.* New York: Bloomsbury, 2005.

Radnoti, Sandor. *The Fake: Forgery and Its Place in Art.* Translated by Ervin Dunai. Lanham, MD: Rowman & Littlefield, 1999.

Savage, George. *Forgeries, Fakes, and Reproductions: A Handbook for the Collector.* London: Barrie and Rockliff, 1963.

Schuller, Sepp. *Forgers, Dealers, Experts: Strange Chapters in the History of Art.* Translated by James Cleugh. New York: Putnam, 1960.

Sotheby's. *The Collection of Jean-Yves Mock.* London: Sotheby's, 2005.

Spencer, Ronald, ed. *The Expert Versus the Object: Judging Fakes and False Attributions in the Visual Arts.* New York: Oxford University Press, 2004.

Sylvester, David. *Looking at Giacometti.* New York: Henry Holt, 1994.

Watson, Peter. *From Manet to Manhattan: The Rise of the Modern Art Market.* New York: Random House, 1992.

———. *Sotheby's: The Insider Story.* New York: Random House, 1997.

Wright, Christopher. *The Art of the Forger.* New York: Dodd, Mead, 1984.

INDEX

ABOUT THE AUTHORS

Aly Sujo, who passed away late last year after this manuscript was completed, and Laney Salisbury were a husband-and-wife writing team. The son of a New York art gallery owner, Sujo was a journalist for twenty years, covering arts, entertainment, and foreign news for Reuters, the Associated Press, and the *New York Daily News*. A graduate of the Columbia School of Journalism, Salisbury worked for Reuters and the Associated Press, reporting from Africa, the Middle East, and New York. She is the coauthor of *The Cruelest Miles,* which is in development as a major motion picture. Salisbury lives with their daughter in upstate New York.